Opposite page: *Steel rabbit with overlaid gold, barbed- spring mechanism, 17th -18th century, height, 4.5 cm.*

Persian Locks
1500 Years of Iranian Padlocks

by

Parviz Tanavoli

"All crafts, when compared to lock-making, are nothing."

- Line of poetry engraved on 17th–18th century Esfahan shrine lock

ARTISAN IDEAS

Published by Artisan Ideas, 2021.

By Parviz Tanavoli

Layout: Lucia Campolmi and Andrea J. Blaho

Cover Design: Andrea J. Blaho

ISBN 978-1-7333250-1-1

Library of Congress Control Number: 2021931894

Printed in China.

Artisan Ideas is an imprint of **Artisan North America, Inc**

Tel: 800-843-9567

Info@ArtisanIdeas.com

Copyright © 2021 by Parviz Tanavoli

**For a selection of reference books on locks and keys visit our website:
www.ArtisanIdeas.com.**

Artisan North America
753 Valley Road
Watchung, NJ 07069-6120

QUANTITY SALES. Special discounts are available on quantity purchases by corporations, associations, and others. For details, contact the publisher at the address above.

For single copies, please try your bookstore first. If unavailable, this book can be ordered through: www.ArtisanIdeas.com.

To see our complete selection of books and DVDs on this and other subjects visit our website, www.ArtisanIdeas.com.

Authors!

**If you have an idea for a book please contact us at: Info@ArtisanIdeas.com.
We'll be glad to hear from you.**

www.ArtisanIdeas.com

Table of Contents

Locks from Iran:
A Few Words

Since childhood I have been keen on locks and whenever as a young boy I got my hands on a worn-out one, I would spend hours trying to fix it. At the end of our courtyard, we had a bathroom which was left unused. This gradually turned into my storeroom in which I used to collect and keep all kinds of discarded objects, among them keys and locks and a few hand tools.

One of the events which could drag me from the house into the street was the sound of a locksmith. In those days, itinerant peddler locksmiths would go around neighborhoods and call for people to bring out their locks to be repaired, calling out "locksmith" and "key maker". The locksmiths' tools were limited to a high stool on which they had mounted a bench grinder as well as a few files. But the significant part of their tools was their hand-made keys which they had threaded on a wire like a floral wreath which they would carry on their shoulders. In my opinion these keys were an unmatched treasure. Watching the locksmiths and seeing their work tools are among my best childhood memories.

But destiny eventually separated me from that house, that room and those locks. Several years later I went to Italy to study sculpture. There I learned of the unbroken history of sculpture and the legacy on which Italian artists could build. Every time I made a comparison between Italy and Iran, I felt more like an orphan. The fact that there was no "ancestor" in Iran in whose footsteps I might follow was something I found very hard to accept. I was searching for a key that would open a door to faithfully reflect my heritage. With every passing day I tried to shake off the influence of Italian culture and find a link to my own. One of the first things that I reconnected with were the locks of my youth. Destiny drew me to them again; this time with a different purpose—to collect them.

My occupation as a sculptor, in a country deprived of sculpture for over a thousand years, made me long for other three-dimensional substitutes of my ancestors, and locks filled that void for me. These artifacts, though they had not been made as sculptures, were imbued with such a quality and creativity that they were not any lesser than sculptures, and were a reminder and great support for me of my Iranian artistic heritage. Among a variety of three-dimensional objects, the works of locksmiths and steel smiths fascinated me the most, and fate was benevolent in bringing them across my path.

In 1976 I was asked to send my lock collection to the United States on the occasion of the American Bicentennial. The collection not only was shown in Washington, D.C., but was brought to several other states by the Smithsonian Institution Travelling Service (SITES) for two years. Prior to shipping the collection, I was asked to put all my knowledge of Persian locks on paper. Luckily the route to this task was paved and I managed to organize a team. It consisted of John Wertime, a young American who at that time was studying the Farsi language and Islamic theology in Tehran. John enthusiastically accepted to collaborate with me in documenting my experiences and my field trips. Houshang Adoarbehi, a young architect, tastefully made the illustrations of the mechanisms of the locks. All this information went into a catalog published in English in the U.S. in concurrence with the Locks exhibition. It was received by the American public well beyond expectations.

Another significant outcome of the Lock Exhibitions in the US was the organization of talks and seminars about these locks. One of these was a seminar on early Persian lock technology held at the University of Texas which led to the publication of a book on the subject.

Forty years later I decided to publish a revised book in Farsi, under the same title, "Locks from Iran." That book was the result of forty more years of experience and learning and had the aim of examining the role of locks in the culture and art of Iran. The void of Persian sculpture was partly compensated by the existence of these very locks, and the significant role of locks in early technologies. On the other hand the entanglement of locks with popular beliefs and people's spiritual needs has imbued these handmade artifacts with a unique appeal.

When in May 2019, Jim Blaho from the publishing house **Artisan Ideas** asked me to publish a new book on the locks, I happily accepted his offer.

Nearly half a century has passed since the first publication. During this long period many important pieces have been added to my collection. This edition contains a comprehensive variety of locks from Iran dating from the 5th century A.D. to the end of the 19th century.

Publisher's Notes

Persia or Iran?

It was the ancient Greeks, over 2500 years ago, who began the Western tradition of calling Iran, "Persia." The Iranian people, on the other hand, have always referred to their country as Iran. Today the term Persia is more closely associated with the empires, kingdoms and dynasties of centuries ago, and Iran with the more restricted geographical confines of the modern nation. As the provenance of many of the locks illustrated in this book are from the times of the old kingdoms and dynasties the term Persian is used in the title of this book.

The Persian/Iranian Empire

At its height, under Darius the Great (550–486 B.C.), the Persian or Iranian empire stretched from the borders of what are now present-day Bulgaria, Romania, and Ukraine, in Europe, all the way to the Indus Valley in India, and south to Egypt.

In the early Middle Ages, the period in which the oldest locks in this book were made, the empire was still vast, but smaller than it had been under Darius. Right up until 200 years ago or less Iran still included large parts of what are now independent countries such as Azerbaijan, Iraq, Afghanistan, Syria, parts of southern Russia and other areas. In referencing the place of origin of the older locks in this book, some were manufactured outside the political borders of present-day Iran (as explained in detail by the author on pages 36, 37), but within an area which is often referred to as Greater Iran.

Notes on this Book

- *Persian Locks* has its origins in a smaller publication which was published by The Smithsonian Institution in 1976. It was entitled *Locks from Iran: Pre-Islamic to Twentieth Century.*
- In the 1976 publication, most of the 213 photos were in black and white. In this book, save for a few exceptions, most of the 510 images are in full color.
- Locks, keys, and other photographs used in this book which do not belong to the Tanavoli Collection are labeled as **Figures (Figs.)**, while the locks and keys belonging to the Tanavoli collection are labeled as **Lock x** or **Key y**.

Map of the Major Lockmaking Centers of Iran

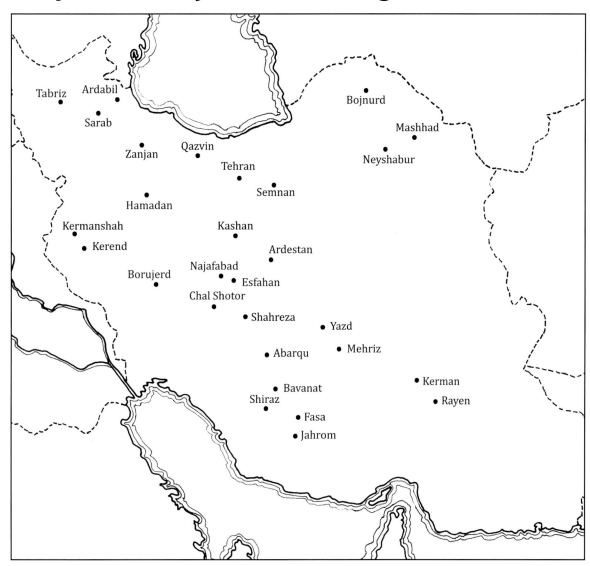

Chronology of Major Dynasties in Iran

Pre-Islamic Era		Islamic Era			
550–330 B.C.	Achaemenids	1038–1194	The Great Seljuks	1736–1795	Afsharids
312 B.C. – 224 A.D.	Seleucids and Parthians	1256–1353	The Il-Khanids	1750–1794	Zands
224–642 A.D.	Sassanians	1370–1506	Timurids	1779–1924	Qajars
642 A.D.	Beginning of the Islamic Era in Iran	1501–1732	Safavids	1924–1979	Pahlavis

The Lock and the Locksmith in the Traditional Culture of Iran: a Short Survey

Up to the early 20th century almost every bazaar in Iran had a section devoted to the manufacture and sale of locks. As everywhere else in the world, the need for security played a primary role in the flourishing profession of the locksmith. Security, however, was not the only reason why Iranians made and bought locks. Spiritual and psychological needs, which the inherent symbolism of locks helped to fulfill, were also important considerations.

With the far-reaching economic and social changes that have come about in Iran over the past century, the art of hand-making locks has all but disappeared. Imported machine-made locks have taken over, and the locksmith now confines himself chiefly to repairs and making keys.

A similar situation, though not as pronounced, exists in the case of the traditional uses of locks for purposes other than security. There too, however, it will not be long before the lock in Iran (as it is in the West today) will be devoid of all but its purely utilitarian aspect.

For the most part, our knowledge of the role of the lock and the locksmith in the traditional culture of Iran is derived from recent sources—the personal experiences of the older generation, direct observation of traditional practices still found today, and studies made during the first half of the past century. Information from and about earlier times is limited. Given the basic conservatism of traditional societies, however, it is reasonable to assume that much of what is said in the following pages is equally applicable to preceding periods of life in Iran.

The Locksmith

An insight into the number and importance of locksmiths in the past can be gleaned from what the few remaining practitioners of this craft recollect of former years. For example, the small town of Chal-Shotor, near Shahr-e Kord (southwest of Esfahan) was once an active center of lockmaking. In the 70s, when I began my research, it only had three locksmiths, all over the age of sixty (Figs. 1–3). According to them, only two decades prior to that, there were more than thirty locksmiths at work in Chal-Shotor.

A single surviving locksmith in Shiraz who made his living by making keys and repairing locks tells how the square in front of the Shah-Cheragh shrine in that city was once dominated by locksmiths' shops which catered to the needs of the pilgrims who came there.

Handmade locks of the past filled the shops of what used to be the locksmiths' section of the Hamadan bazaar, a testimony to its former prosperity. These old locks are now utilized as sources for spare parts for handmade locks in use today.

Familiar to the inhabitants of Tehran in earlier years were the numerous locksmiths busy making and selling locks in the small square in front of the Shah Mosque, near the bazaar. In the 70s only one representative of the old tradition was to be found there and he, like his colleagues in most parts of Iran, had to take up key making to support himself.

According to the locksmiths of Zanjan, about three hundred men were engaged in the making of locks for sale elsewhere in Iran in the late nineteenth century.

To cite one last example, Kerend, a large village near Kermanshah, used to have a population comprised mainly of locksmiths who were famous throughout Iran for their combination and puzzle locks. This village continues to be a center of handicrafts, but today its inhabitants make knives, sugar-cone cutters and other craft items.

In the towns of Iran, locksmiths were usually found in small shops clustered in one section of the central bazaar as well as near the shrine if there was one. They were also scattered about in the smaller bazaars of the different quarters that made up the town. Usually they dealt directly with their customers, who were from all classes of society. If a certain type or quality of lock was not available, it would be made to order.

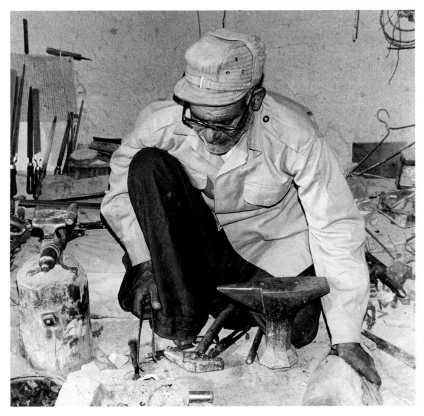
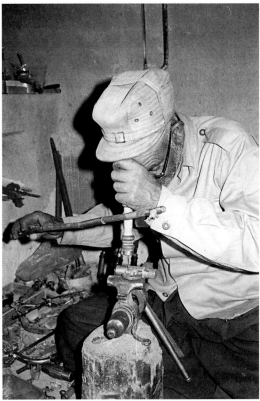

Fig. 1. Master locksmith Taqi Nikzad in Chal-Shotor in his workshop with a leather bellows and a small pot forge made of clay.

Fig. 2. Taqi Nikzad working his hand drill.

Locksmiths produced nothing but locks and their income came solely from this occupation. Others, however, were basically blacksmiths who made locks along with iron tools and other such objects. This is also true of the itinerant locksmiths, some of them gypsies, who visited the villages and worked among the migratory tribes.

For the most part, a locksmith made his own tools or inherited them either from his father, who was quite frequently a locksmith as well, or from the master whom he had served as an apprentice. Therefore it is not unusual for the implements still in use today among the few surviving locksmiths and repairmen to be several generations old. A medium-size furnace with a concertina bellows for forging the iron parts of the lock was also a normal part of the workshop as was a small pot forge for

9

brazing (Fig.1). Sometimes locks were made with the cooperation of one or more other craftsmen, such as bronze or brass casters, gold beaters, and calligraphers. Most locks, however, were the work of one man from beginning to end.

Little is known about the famous locksmiths of the more distant past. References to them and to their trade are very rare in Islamic and Western sources concerning Iran. Of particular interest, therefore, is the allusion to Mowlana Ostad Nuri Qoflgar (*ostad* means master or teacher and *qo/Igar* means locksmith) contained in the *Tohfeh-ye Sami* (p. 365), a work on poets and their poetry written by the Safavid prince, Sam Mirza, in the middle of the sixteenth century. In speaking of Mowlana Ostad Nuri the Locksmith, Sam Mirza says, "*He was among the great ones of his time and rare ones of his age. In the craft of lockmaking he was so outstanding that he made twelve locks of steel [each one of which], would fit inside the shell of a pistachio nut. And there was a key for each of these locks.*" Lock No. 190 is strongly reminiscent of such work.

The few locksmiths in Chal-Shotor talked to me about their own teacher, Ostad Hosayn, who had died in the 1960s. Ostad Hosayn himself was once the apprentice of Ostad Abdollah who, in addition to lockmaking, was well acquainted with other crafts such as gunmaking, architecture, and carpentry. Ostad Hosayn's former apprentices tell how Ostad Abdollah and six of his friends ran out of money while on a pilgrimage to Mecca and how, to support himself and his friends, took up lockmaking there. In this work he was so successful that he not only made numerous locks for the notables of Mecca but also had the honor of fashioning one for the door of the Ka'aba. During his one-year stay Ostad Abdollah earned enough to support himself and all of his friends and returned to Chal-Shotor with his pockets full of money.

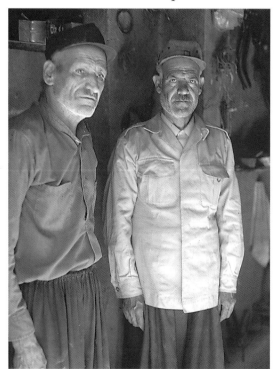

Fig. 3. *Master locksmith Taqi Nikzad (right) and master locksmith Ustad Ahmad (left) in Chal-Shotor*

Lock No. 295 with inlaid gold decoration could be the work of this master locksmith. It is very like one attributed to Ostad Abdollah in the Shrine of Imam Reza in Mashhad.

Starting in the last century, with the introduction of Western machine-made tools and equipment into Iran, many locksmiths began to find materials for their locks among the various parts and pieces of worn-out and discarded machines, pipes, automobiles, and so forth, rather than go to the trouble of producing locks from the raw materials formerly used. One of the consequences of this change was the increasing uniformity of the locks made in terms of both their shape (most are now tubular) and the materials used (frequently iron and steel).

With the rapid transformation of Iran brought about by modernization and industrialization, the traditional locksmith and his like have become old-fashioned in the minds of many and, even worse, economically obsolete. To support themselves most have turned to making keys for the products that have displaced their own, or they have taken up repairing locks, bicycles,

kerosene lamps, and so forth. Those who live in villages and more remote towns have found new work in the production of knives, agricultural implements, and the comb-like beaters used in rug weaving.

The Traditional Uses of Locks
Security

Most of the handmade locks of the past were made for security. They were intended for doors (Fig. 4), chests (Fig. 5), boxes (Figs. 6, 7) and similar objects, the particular construction and purpose of which had a direct bearing on the kinds of locks used with them. Of all these, the most frequently encountered is the door lock.

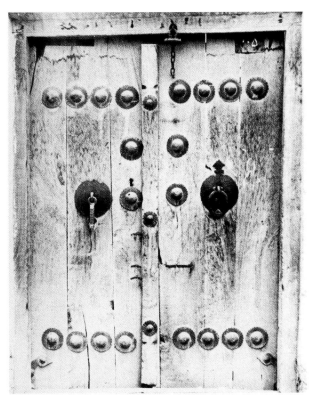

Fig. 4. *Typical Iranian door with padlock at top, in Kerman.*

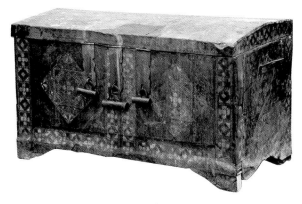

Fig. 5. *Wooden chest with padlocks.*

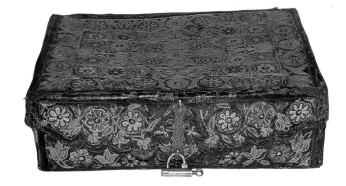

Fig. 6. *Bridal cosmetic chest, 18th century.*

Doors in Iran, whether for rooms inside a building or for a main entrance, have by tradition and preference most commonly been made of two panels of equal size, hinged on the sides, and opening in the middle (Fig. 4). Attached on the outside to the top of one panel is a chain, the end of which fits over a staple above the door. The panel without the chain is held shut from behind by latches. Instead of a chain, a hasp might be fastened to one panel and a staple to the other. Such doors sometimes have an outside bolt that locks the two panels together and is secured by an attached hasp that fits over a staple. The locks used on all of these are of the movable, or padlock, type.

Depending on the location and size of the door, locks made for security purposes can be elaborately decorated or plain, very strong and heavy or light and somewhat delicate, and worked by one key or several keys. Those that received the craftsman's greatest artistic effort and were fashioned partially or completely with precious metals were usually meant for places with religious significance, such as the numerous shrines found in Iran. In other locks, the need for security outweighed all other considerations and therefore one finds plain, sturdy locks intended for such things as the heavy gates of a town, quarter, or section of the bazaar. Where more than one person was to have access to the locked object or place, locks with several keys have also been used, which required the presence of each person before the lock could be opened.

The tendency to keep and preserve things, which is common among Iranians, necessitated different kinds of boxes, trunks, and closets for their possessions. Containers used to keep tea glasses and saucers were different from those for cosmetics and other articles. For each box a suitable padlock was needed to fasten the hasp or chain to the staple of the container. Particularly favored for the smaller boxes were locks in the form of an animal (Fig. 7).

Fixed locks have also been used on doors and containers in Iran, but not as frequently as the movable kind. When a fixed lock is found, it is normally on the main door of a house or other edifice, or on such things as garden gates. Rarely is it seen inside the house. Doors with fixed locks can consist of one panel hinged on one side only or, more often, of two panels that open in the center.

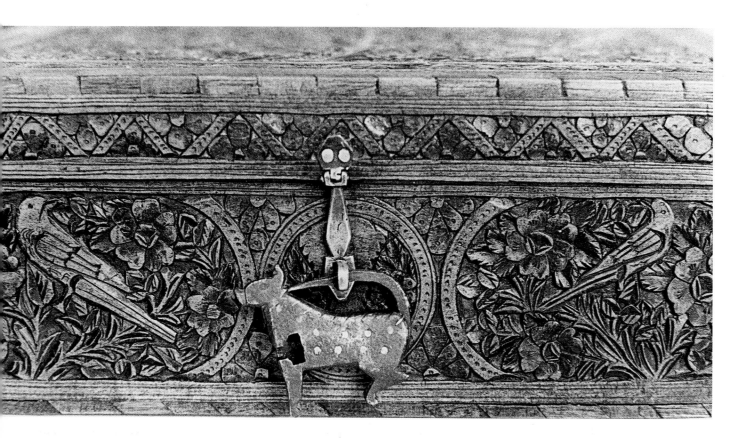

Fig. 7. Carved wooden box with animal-shape padlock.

Religion and Folk Beliefs: Talismans, Amulets, and Charms

In the popular culture of Iran, locks are thought to possess special powers which protect the user from harm or evil and assist in securing the fulfillment of certain wishes as well as in gaining happiness and good fortune. When used as amulets, a practice most common among women, locks are inscribed with prayers and religious expressions and attached to a garment or chain or, alternatively, worn next to the body. Most locks of this nature are made of steel or silver which are the metals traditionally considered to be the most powerful of all in terms of their magical qualities. Three elements seem to be involved: the power of the inscription, the metal used, and the lock's inherent symbolism of binding or protecting and releasing.

Amulets in the form of locks are traditionally used by pregnant women to prevent miscarriage. This custom employs a cord that goes around the waist and a lock that fastens the two ends together. When a woman has any bleeding or encounters any kind of danger, other women gather for the binding of this protective device. While someone reads the Ya Sin chapter of the Koran (chapter 36, which is devoted to the Prophet and the Revelation), seven knots are tied in the cord, one knot for each time the word *mobin* (clear) occurs. As each knot is tied, it is blown upon. Once the incantation is completed, the cord is put around the waist of the expectant mother and locked with a tiny padlock over which a *mullah* (a learned teacher of religious law and doctrines of Islam) has repeated a prayer.

At the beginning of the ninth month, the lock and cord are opened. Since these objects are in constant demand, they are lent from friend to friend.

Formerly, men in Iran were allowed by Islamic law to take as many as four wives if they were able to support each one adequately. Furthermore, except in rare cases, divorce was solely the man's prerogative. Under such circumstances, retention of the husband's affection was of particular concern to many women.

Fig. 8. *Love charm in the form of a padlock. Steel talisman with bent-spring mechanism, 18th–19th centuries; width 2.5 cm, height 4.5 cm.*

One of the ways that wives tried to assure their husbands' continued attention was through the use of various love charms, including the lock. In such cases, the lock might have an engraving of a couple sitting happily side-by-side or cheek-to-cheek in addition to the usual inscriptions (Fig. 8). Besides binding the love of husband and wife, such locks could also be meant to bind shut the tongues of those inclined toward backbiting and slander, a problem frequently exacerbated by a polygamous situation.

Girls unsuccessful in finding husbands had recourse to the lock and its special powers. Sadeq Hedayat relates on page 151 of his *Nirangestan* (a book on the popular customs of Iran) how such girls fasten a lock to a chain and put it around their necks on the evening before *Chahar Shanbeh*

Suri, the last Wednesday in the Iranian year. The lock is supposed to lie on the chest between the breasts. At sunset the girls would go to the nearest street corner and ask the first *sayyid* (descendant of Mohammad, the Prophet of Islam) who passes to come and open the lock so that their luck will no longer remain thwarted and, in particular, so that they will marry a *sayyid*. Once a suitor appears and the terms of the marriage contract between the future husband and wife are agreed upon by each of their families, the lock can play another role. This comes during the formal religious ceremony that seals the marriage contract, during which someone continually opens and closes a lock up to the last moment, at which time the lock is closed and not reopened until the night of the wedding celebration and consummation of the marriage. Since these last two occasions are not infrequently postponed for several months or more after the conclusion of the marriage contract, the aim of this final closing of the lock is to prevent the groom from having sexual relations with his new bride, or to bind him to her so that he does not become interested in another girl. Such a practice is normally carried out by a member of the bride's entourage. Should anyone secretly oppose the marriage, that person could employ the lock's sympathetic magic to "close" or "lock" the groom sexually, thereby making consummation of the marriage impossible and causing its dissolution.

As a sign of her virginity, submission, and surrender, the bride sometimes gives her husband a lock and key when he enters the bridal chamber to consummate the marriage.

Locks also figure in the chain of charms commonly worn by village women and children over one shoulder and across the chest or around the neck. The "prayer", a long strip of paper on which a chapter from the Koran or similar work is written, constitutes the most important element. It is placed in a small case of cloth, velvet, or leather along with such items as a salt crystal, a needle, and some earth brought from Mecca (in Saudi Arabia) or Karbala (in Iraq). These are the two great holy sites of pilgrimage in Islam. To the chain are fastened a rooster's spur mounted in silver and sundry other objects, including a small talismanic lock to ward off the evil eye.

Religion and Folk Beliefs: The Shrine, Mosque, and *Saqqakhaneh*

In every region of Iran there are tombs of saints and religious leaders of the past. Most important of all are the shrines of Imam Reza in Mashhad and that of his sister, Fatima or Ma'sumeh, in Qom. Besides these, there are numerous other ones known as *imamzadehs*, or tombs of the descendants of the original Twelve *Imams* (divinely guided spiritual leaders) of Twelver Shi'ism, the branch of Islam that has been the official state religion of Iran since the year 1501 A.D. when the Safavid dynasty came to power. Though antedating this period, the practice of pilgrimage to these shrines reached its pinnacle only after the majority of Iranians had become Shi'ite in the sixteenth century. In visiting the burial places of those known for their sanctity, Iranians have always sought both the blessing that emanates from the holy precinct as well as divine assistance in fulfilling certain wishes and reaching specific goals. During the customary circumambulation of the grill-enclosed tomb, the pilgrim says prayers and sends greetings and blessings to the Prophet and his family. Quite often invocations for help are made. As the pilgrim invokes such aid, he seizes the lock of the door of the tomb chamber or the grill that surrounds it in order to bring himself as close as possible to his intercessor. This shrine lock, usually made of steel or silver, is thought to possess special powers of healing. For those in need of help, water brought by the pilgrim is poured over the lock and

caught in another bowl below. Such water is preserved and dispensed with great care. The experiences of the pilgrimage and holding the lock are not forgotten once the visitor to the shrine has returned home. "By such and such an *Imam*, whose lock I have grasped (so many times)", is one of the ways of swearing to the truth of something among those who have made an important pilgrimage.

The making of vows is another commonly encountered practice during a pilgrimage. Instead of merely beseeching the help of the saint, the supplicant vows to perform some meritorious act or to give something to a charitable cause if his request is granted. At the same time that the vow is made, the pilgrim frequently tears off a small strip of fabric from his clothing and ties it to the grill forming the tomb chamber or, if he can afford it, attaches a lock to the grill (Fig. 11). Among other things, this signifies the binding of the supplicant to his intercessor and his vow, and also acts as a reminder to the intercessor of the pilgrim's request and promise.

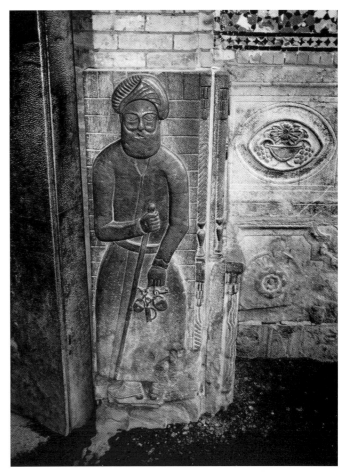

Fig. 9. *Stone relief showing a lock-selling peddler in the bazaar of the Shrine of Shah Abdol-azim, Rey, south of Tehran.*

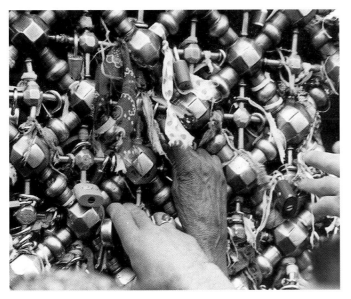

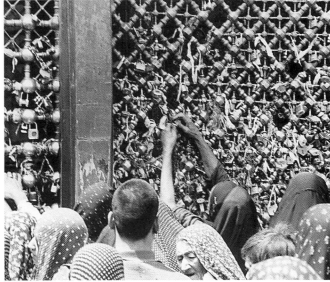

Figs. 10–11. *Locks and small strips of fabric torn from clothing and attached to the grillwork surrounding a tomb at the Shrine of Imam Reza in Mashhad.*

People who are desperate sometimes even bind themselves or their sick children to the grill until their needs are answered. This is usually done by tying one end of a rope to the grill and the other around the person's neck.

The grill of the tomb is not the only object to which locks are fastened. In the shrine of Imam Reza in Mashhad, for example, there is a grill, known as the "steel window," which faces the tomb chamber and separates it from the outer part of the shrine complex. This is a favorite place to hang locks, especially since it is now forbidden to do so on the grill that forms the tomb chamber proper. Another favored place to attach locks is the steel chain found at the entrance of many shrines and mosques (Fig. 12).

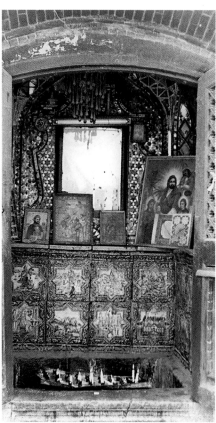
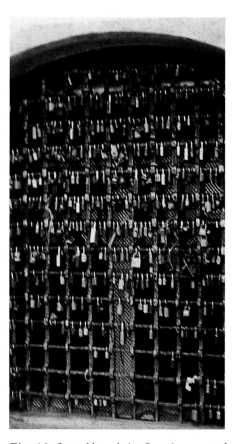

Fig. 12. *Locks and small strips of fabric torn from clothing and attached to the steel chain at the entrance of the Emad-al-dowleh Mosque in Kermanshah.*

Fig. 13. *The interior of a saqqakhaneh in the southern part of Tehran, showing locks attached to the grill-work top sections of the open doors.*

Fig. 14. *Saqqakhaneh in Qazvin, west of Tehran.*

A grill is also part of the *saqqakhaneh*, a niche in a wall where drinking water is provided to the public free of charge as an act of charity or in fulfillment of a vow (Figs. 12, 13). These commemorate the heroic efforts of Abo'l-Fazl to provide water for the thirsty children of his brother, Imam Hosayn, while in the desert of Karbala (in present-day Iraq) during the battle that led to the martyrdom of the Third Imam and his followers. Abo'l-Fazl (also called Abbas) is known as the "Door of Needs" by Shi'ites, and is called upon to intercede with God on behalf of the supplicant. For this reason, one finds the typical signs of vows made on the grills of the *saqqakhaneh*, whether located in a shrine, mosque, street, or bazaar. Once a supplicant's request has been answered, the lock may be taken away by the owner or it may be left hanging, on the assumption that it will miraculously open of its own accord.

Over a period of time an excessive number of locks attached to a grill may necessitate their removal by the responsible authorities. Locks, some of them made of precious metals, are sometimes put through the grill into the tomb chamber as a part of vows made or as anonymous gifts to the shrine in the same way that money and precious objects are often given. On occasion they are also given as formal bestowals.

One of the principal officials of the shrine is known as the "Keeper of the Key." He is responsible for the key to the lock of the tomb chamber, the most sacred part of the shrine. This key is usually kept in a box made especially for it (Fig. 15). The office of "Keeper of the Key" is often hereditary in one family and in some of the main shrines of Islam this office has been passed down from father to son for many generations. The tomb chamber is periodically opened for cleaning. This important occasion is marked by considerable ceremony in the major centers of pilgrimage. Shrines in the villages and in rural areas tend to be much simpler than those found in the larger towns and cities. Some of these shrines consist of nothing more than a sacred tree around which a low wall may be built. Small strips of fabric torn from clothing are normally tied to the branches of such trees, thus serving as reminders of the vows of the faithful. Locks are rarely found on these trees.

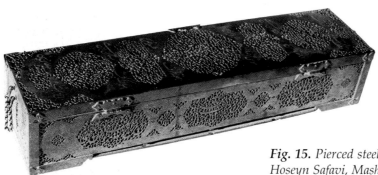

Fig. 15. *Pierced steel key box, 17th century, order of Shah Sultan Hoseyn Safavi, Mashhad Museum.*

Religion and Folk Beliefs: Moharram Ceremonies

The martyrdom of Imam Hosayn in the desert of Karbala was referred to previously in connection to Abo'l-Fazl and the *saqqakhaneh* (a niche in a wall where drinking water is provided to the public free of charge as an act of charity or in fulfillment of a vow). Each year, during the first ten days of the month of *Moharram*, extensive public mourning ceremonies in Iran commemorate the death of the Third *Imam* on *Ashura*, the tenth day of the month and the most solemn occasion of the entire religious calendar. An important role in the mourning ceremonies that takes place during this period is performed by groups of flagellants who move through the streets, bazaars, and squares whipping themselves with chains. In the past there were other groups in addition to these, some composed of men who struck their heads with short swords, and others of men who attached various kinds of metal objects to their bodies. As the most common of these was the lock, this custom is known as *qolf-zani* (lock wearing) in Persian (Figs. 16–18). Such a practice was widespread in Iran during the Qajar period, as various photographs and the late nineteenth-century painting over the entrance of the Ganj Ali Khan bath in Kerman attest (Fig. 18).

To prepare themselves for participation on *Ashura* the lock wearers, starting on the fifth of *Moharram*, would spend a considerable number of hours each day in the public bath, either immersing

themselves in a pool of water or in the ashes from the fuel that had been used for the bath's furnaces. This was to soften and loosen the skin in order to make it less difficult and painful to attach the objects. Final preparations came on the night before *Ashura*. To put them into a proper frame of mind for the next day and to distract their attention from the fastening of the locks, a professional reciter would read from the books about the Imam's death. Once the lock wearers were sufficiently moved by this reading, two assistants would begin the actual process of cutting the skin and attaching the metal objects. This continued until everyone had been prepared.

The lock wearers, unable to lie down, were obliged to remain seated until dawn, when they joined the other groups in a procession (Fig. 17). The sight of these men, boys, and their colleagues, greatly affected the spectators lining the streets and moved most of them to tears. Those who participated in the lock wearing did so for different reasons: for spiritual gain, to fulfill vows, or to express their grief for the Imam's martyrdom.

Throughout Iran on *Ashura* one encounters the *'alam*, a pierced-steel standard in the shape of a cypress tree, which is carried in the mourning procession as a symbol of the slain Imam and his followers (Fig. 20). In some regions of the country one also finds a heavy wooden structure called a *nakhl*, which symbolizes Imam Hosayn's coffin (Fig. 19). This is carried on the shoulders of chanting men.

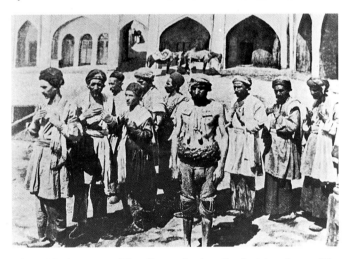

Figs. 16. *A group of flagellants during the first ten days of the month of Moharram, with a lock wearer in the center.*

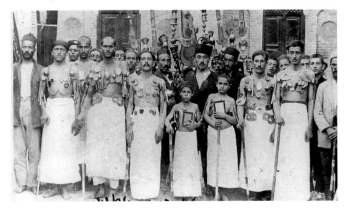

Fig 17. *Lock wearers on the morning of Ashura, the tenth day of the month of Moharram in the Islamic year. Photo courtesy of the Ministry of Culture and Art, Tehran.*

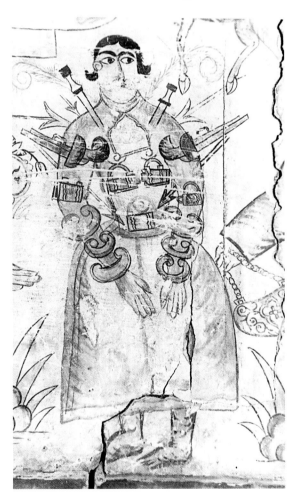

Fig. 18. *Detail of a late 19th-century painting depicting a lock wearer; over the entrance to the Ganj Ali Khan public bath in Kerman.*

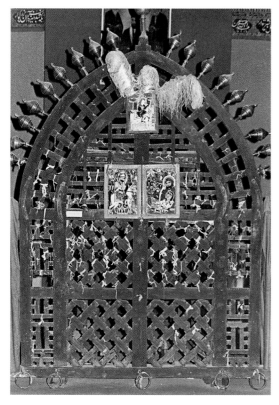

Fig. 19. *Nakhl, a symbol of the coffin of Iman Hosayn carried in processions on Ashura; late 19th century.*

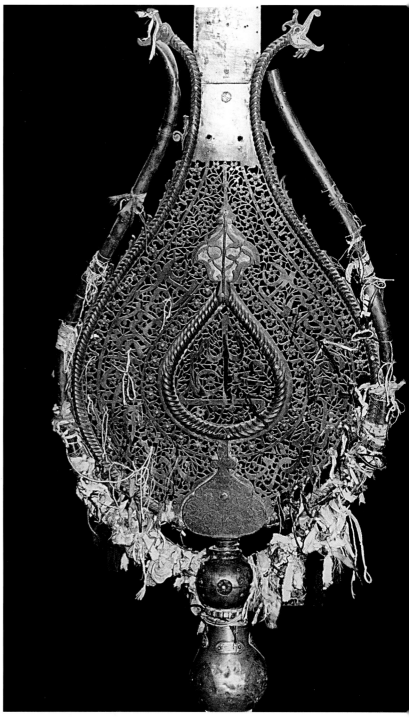

Fig. 20. *Pierced-steel standard ('alam) carried in processions on Ashura; 17th century.*

Quite often both the steel standard and the wooden grill of the *nakhl* are covered with small strips of fabric torn from clothing and an occasional lock, signs that the standard and the grill of the *nakhl*, like the grills of the shrines, are also considered to partake of the holiness and blessing associated with the Third *Imam*.

Prisoner Locks

Up to the early 20th century and the end of Qajar dynasty murderers and political captives, besides being imprisoned, were locked and chained too. Early photographs show how their necks and one of their hands were bound by a long and heavy chain. Among the existing photographs, that of Mirza Reza Kermani, the killer of Nasser-al Din Shah, the powerful king of Qajar, is noteworthy (Fig. 21). The other two men shown here were locked and chained for pro-constitutional activities (Figs. 22, 23).

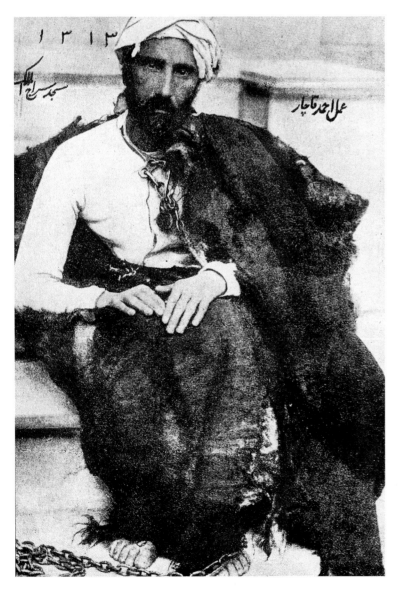

Fig. 21. Mirza Reza Kermani, the killer of Nasser-al Din Shah Qajar.

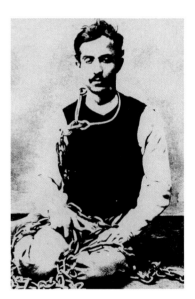

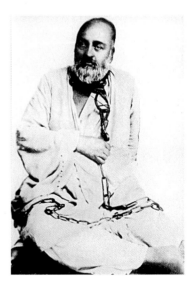

Figs. 22–23. Two of the pro-constitutional prisoners.

Shapes, Mechanisms, and Keys in the Locks of the Parviz Tanavoli Collection

The locks in this collection encompass a number of different shapes, mechanisms, and keys, the basic types of which are illustrated and explained below. Keys are pictured beside, or engaged in, the locks they operate.

I. Shapes

There are four principal elements to be considered in a padlock:
(1) **The Shackle**, (2) **the Lock Body**, (3) **the Mechanism**, which includes the locking piece, and (4) **the Key**.

The first two constitute the shape of the lock, while the third, the mechanism, can have an important determining or limiting influence on the shape and mode of operation of the other components.

By means of the shackle, the lock body (which normally contains the mechanism and space for the key) is attached to the staple, loop, or other element of the object to be fastened. As the heaviest part of the padlock, the lock body hangs below the shackle when closed. Two different orientations in the shape of padlock bodies are usually found: horizontal or vertical. Those with a horizontal axis tend to look tubular or rectangular, and those with a vertical axis are bulbous, squarish, or pendant-like.

The shackle is basically either curved or straight. Rounded, "U" or horseshoe-shape shackles almost always open and close at the top of the lock, and can be completely removable or attached on one side to the lock body by means of a hinge. Such an arrangement is called "top shackle" in this book. The shackle end or ends are gripped by some kind of catch inside the lock body.

When straight or straight-ish, the shackle enters the lock body laterally instead of from above, and is held in place at one of its ends by the locking piece, which fits into the lock body. At the other end, the shackle is secured by an extension of the lock body in the form of a ring, pierced bar, or arm projecting from its top. In the case of animal figures, this extension is the head or neck of the animal. The term employed in this book for this type is "side shackle."

In general, horizontal lock bodies can have either top or side shackles, whereas distinctly vertical lock bodies are rarely, if ever, accompanied by anything but top shackles.

II. Mechanisms and Keys

Barbed-Spring

Barbed-springs appear in locks of a variety of sizes and shapes, including some of the largest and smallest locks. The basic principle involved is simple: like a barb that moves forward easily but resists backward movement, the spring spreads out once in its final position, thus preventing removal until it is compressed.

The type of barbed-spring lock most commonly found in Iran (Figs. 24, 24a) consists of two parts: (1) a horizontal lock body and (2) a separate, removable locking piece that contains the flexible steel barbed-spring as well as part of the side shackle.

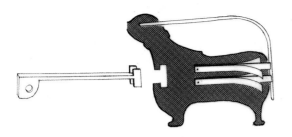 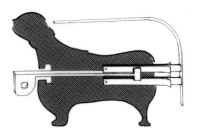

Figs. 24, 24a. Barbed-spring with side shackle and push key.

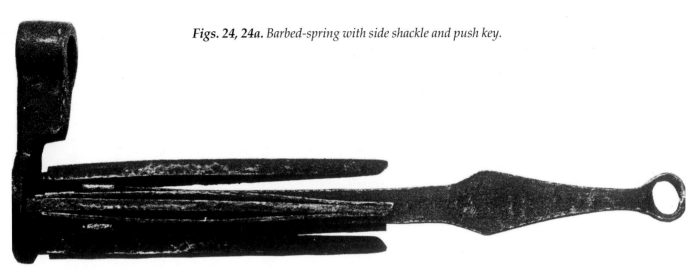

Fig. 25. Locking piece and push key of barbed-spring mechanism with five arms.

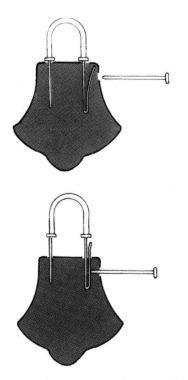

Figs. 26, 26a. Barbed-spring with removable top shackle and pin key.

On the arm to which the barbed-spring is attached there can be one or two springs. The arrangement of the arms themselves can differ; one above the other or both side-by-side. Sometimes one finds more than the usual two sets of arms carrying barbed-springs; and three, four, and five are also encountered (Fig. 25).

When the locking piece is inserted into the lock body, the springs spread out and the lock is fastened shut without the use of a key. To open it, the springs must be pressed together and the locking piece extracted from the lock body. These steps can be accomplished by several different types of keys.

Most common is the push key, which enters the lock from the end opposite the locking piece, then covers the springs and pushes the locking piece and attached side shackle out of the lock body and shackle holder respectively. Such keys are found in a variety of shapes.

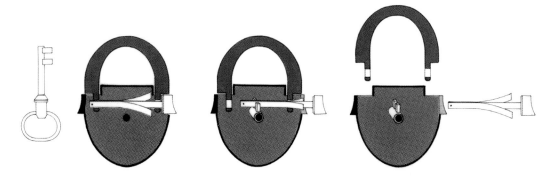

Figs. 27, 27a, 27b. Barbed-spring with removable top shackle and turn key with two bits.

Occasionally the push key has a screw at its tip. This must first pass through the threaded front of the lock body before it can function as a normal push key (Fig. 53 page 34).

Other barbed-spring locks open by means of a slide key (Figs. 29, 29a) which slides along the bottom or side of the lock body to compress the barbed-springs and push the locking piece and accompanying portion of the side shackle out of their resting places. At their simplest, these slide keys are shaped rather like a tuning fork with a tooth at the end of each prong. When the wards are added inside the lock, and sometimes outside, to prevent any but the right key from entering, the key becomes much more complex in shape. Slide keys can also be made of one solid piece; the two teeth are then placed one above the other or next to each other on a projecting arm.

There are locks in which a barbed-spring is fastened to the inner face of one side of a top shackle (Figs. 26, 26a). In such cases a pin key is used to press the spring shut in order to permit the withdrawal of the shackle from the lock body.

Another type of lock has a barbed locking piece that passes through the holes drilled in the ends of the shackle. A turn key with two bits is used here (Figs. 27, 27a, 27b). A single-bit turn key is shown with a side shackle lock in Figs. 28, 28a. One more version of the barbed-spring lock is seen in Fig. 29. The top shackle is secured by an arm attached to the locking piece and fitted through the hole in the shackle end (Fig. 29, 29a).

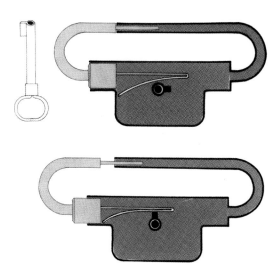

Figs. 28, 28a. Barbed-spring with side shackle and turn key with one bit.

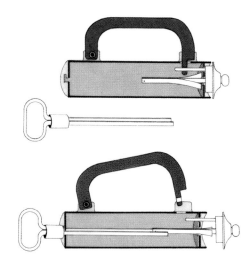

Figs. 29, 29a. Barbed-spring with top shackle and push key.

Bent-Spring

Like the barbed-spring, the bent-spring mechanism was widely used by Iranian locksmiths in the past. Locks operated by this mechanism are predominantly of this vertical-body, top-shackle type, and tend to be rather small and flat.

Placed behind a hook, which is attached to the lock body by a pin, the bent-spring exerts pressure in such a fashion that the hook is pushed into the notch of the shackle and held there until moved aside by the key which allows the shackle to open.

Keys for the bent-spring lock are normally of the pipe variety; hollow at the end of the shank with a bit attached below. Such keys fit onto a drill pin in the middle of the keyhole. A few bent-spring locks are found with a solid screw key which enters the lock body from the side instead of from the front face, and pushes the hook and spring back, as in Figs. 31, 31a.

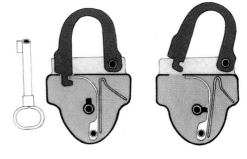

Figs. 30, 30a. Bent-spring with top shackle and turn key with one bit.

One of the locks in this collection has a mechanism resembling two bent-springs connected at the bottom. Each side controls an end of the removable top shackle, and two pipe keys are necessary to open the lock (Figs. 32, 32a, see also Lock 345, p. 118).

A keyless lock with a bent-spring is also found (Fig. 33, 33a). What resembles a keyhole cover is in fact a lever with an arm behind it inside the lock body. When moved, this pushes the hook and bent-spring aside allowing the shackle to open.

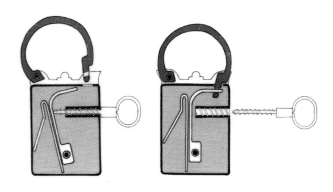

Figs. 31, 31a. Bent-spring with top shackle and solid screw key.

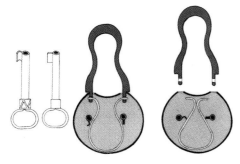

Figs. 32, 32a. Bent-spring with removable top shackle and two turn keys with one bit each.

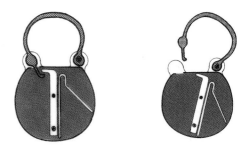

Figs. 33, 33a. Bent-spring with top shackle and no key.

Helical-Spring

Along with the barbed-spring and the bent-spring, the helical (i. e. spiral) spring is one of the most commonly encountered mechanisms in the traditional padlocks of Iran. Five similar but distinct arrangements of the helical-spring are seen in the locks of this collection. All are of the top-shackle variety with either a horizontal or vertical lock body. The former is by far the more common.

Helical-Spring with a Front Key

Entering the body of the lock from the end nearest the front, or free end, of the top shackle, a key with interior threads grips a solid male screw that is surrounded by a helical-spring (Fig. 34). At the free end of the spring is a washer with an arm coming out of it. This fits over the end of the screw and rests against the spring. When the key is turned tight up to its shoulder, the washer and attached arm are pushed back against the spring and the arm is removed from the hole in the end of the shackle, thus enabling the shackle to be opened. To close the lock, the key is unscrewed, and the spring then pushes the washer and attached arm forward until the arm engages the end of the shackle. It remains in this position until opened again.

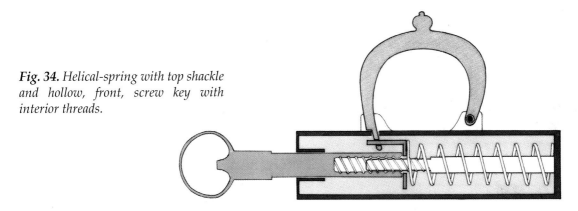

Fig. 34. Helical-spring with top shackle and hollow, front, screw key with interior threads.

The key for such a device can be solid or hollow. When hollow, it has interior threads that fit the exterior threads of the solid screw inside the lock. When solid, the position of the threads on the two elements is reversed.

Helical-Spring with a Back Key

Here the key enters the end of the lock nearest the back (or hinged part) of the top shackle and grips the threaded screw in the middle of the helical-spring (Fig. 35). Fixed to the end of the screw closest to the front of the shackle is either a hook that fits into a notch in the shackle, or an arm that goes through a hole in the shackle.

To release the hook or arm, the key is turned up against its shoulders. Instead of exerting a pushing action as in the case of the front key, the back key pulls the hook or arm back against the spring and out of the shackle. When the key is unscrewed, the spring pushes the locking piece forward into the shackle once again.

As is true of the previous mechanism, this variety works with either a solid key with exterior threads or a hollow key with interior threads. A third variation (Fig. 36) exists when the tube with interior threads inside the body of the lock has a guide pin in the center. The exterior-threaded key must then be hollow in order to fit the guide pin.

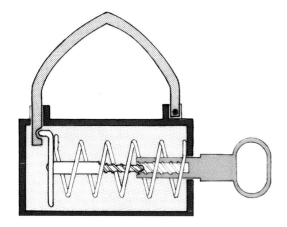

Fig. 35. Helical-spring with top shackle and hollow, back, screw key with interior threads.

Helical-Spring with Removable Screw and Key

Virtually identical to the helical-spring lock with a back key, this differs in only one respect; the solid screw with exterior threads is removable (Fig. 37) instead of being permanently fixed inside the locking body as it is in Fig. 36. In order to open the shackle, the hollow key must be inserted in one end and the solid screw in the other. The meshing of the hollow key and solid screw causes the latter to be drawn into the former, thus bringing the hook or arm out of the shackle at the same time. Once released, the helical-spring returns to its normal expanded state; the shackle is then secured, and the solid screw and key are removed and carried off by the owner.

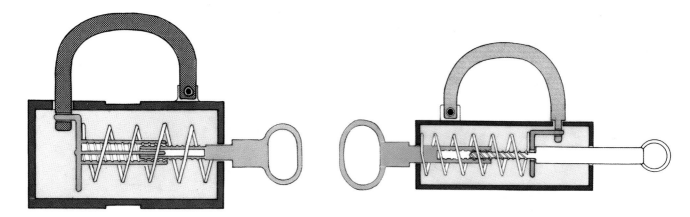

Fig. 36. Helical pull spring with top shackle and solid screw key with exterior threads.

Fig. 37. Helical-spring with top shackle; removable screw; and hollow, back, screw key with interior threads.

Helical Pull Spring

The helical pull spring (Fig. 38) works from the back of the lock as does the helical-spring, but instead of entering a tube with interior threads, this key screws into the hook at the end of the spring. When this is done, the hook and adjacent spring must be drawn back by pulling on the engaged key in order to effect the shackle's release. The key has exterior threads at the end.

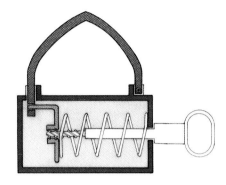

Fig. 38. Helical-spring with top shackle, removable screw, and hollow, back, screw key with interior threads.

Helical Back Spring

Two solid screw keys are needed to operate one type of helical-back-spring lock (Figs. 39, 39a, 39b). To open the lock, when the shackle is engaged, the first (longer) key is inserted. It moves directly through the hole in the shackle end and pushes the helical-spring and its attached locking piece back to the point where the second (smaller) key can be inserted at right angles to the first. This holds the spring and locking piece stationary. Then the first key is withdrawn, and the shackle can be lifted out.

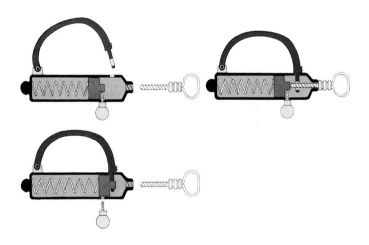

Fig. 39, 39a, 39b. Helical back spring with top shackle and two solid screw keys with exterior threads.

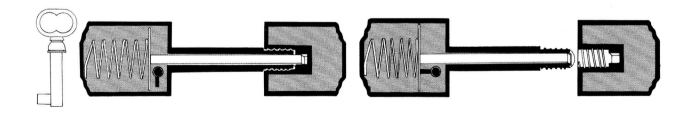

Figs. 40, 40a. Helical back spring with removable end and turn key with one bit.

With the unscrewing of the smaller key, the spring and locking piece are released and snap back to their expanded position, locking the shackle in place.

A helical back spring is also found in a lock that resembles a weightlifter's barbell (Figs. 40, 40a). One of the weight-like ends is detachable. The interior of this detachable end is hollow; the front part near the mouth is cylindrical and is threaded; and the back (deep inside) part is square. The remainder of the lock (one piece in construction) contains the helical back spring located in the other weight-like end, out of which comes a hollow center bar. At the projecting end of this hollow center bar are exterior threads. The expanded helical back spring presses on a solid rod running through the hollow bar.

The tip of the rod is square and constitutes the locking piece. This fits precisely into the hollow, square space of the detachable end.

To close the lock, the locking piece must first be pulled back into the center bar by means of a pipe key inserted in the keyhole and turned so that the bit presses on the plate next to the spring. The detachable end is then screwed onto the center bar. When the key is turned to release the spring, the square-ended locking piece is thrust into the hollow square space deep inside the detachable end of the lock, thus making rotation and removal impossible.

Shackle-Spring

A small number of locks that are flat, thin, and lightweight have a tiny, hook-like spring inserted into the free end of their top shackle (Figs. 41, 41a). When the shackle is pressed down, the shackle-spring catches on a notch just inside the horizontal or vertical lock body. The key resembles a flat, thin needle with a bit. With a mere turn, its bit releases the shackle-spring. This type of mechanism provides little protection because the shackle-spring can be opened by hand without the aid of a key if a little force is used.

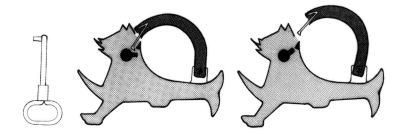

Figs. 41, 41a. Shackle-spring with top shackle and turn key with one bit.

Notched-Shackle

The top shackle itself can also act as a kind of spring when made of flexible steel or brass (Figs. 42, 42a). Firmly gripping the lock body from underneath, the notched part of the shackle in the sturdier pieces is so well fitted and protected that it is impossible to pull the shackle up by hand. A pin or nail-like key (Figs. 43, 43a) or a turn key with a bit (Figs. 42, 42a) is used to push it up and out of its catch.

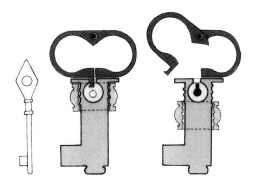

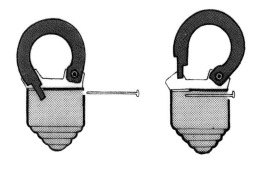

Figs. 42, 42a. *Notched-shackle with top turn key with one bit.*

Figs. 43, 43a. *Notched-shackle with pin key.*

Hook and Revolving Catch

This is seen in a horizontal lock body (Fig. 44). The lock has a U-shape side shackle with a hooked-tooth locking piece at one end, and an arm that joins to complete the shackle at the other. The two hooked teeth fit into catches placed one above the other between disks on a partially revolving drum inside the lock body. The key, which comes into the bottom of the drum from below, turns the drum so that the hooked teeth engage the catch. A short rotation of the drum by means of a key disengages the hooked teeth from the catch.

Fig. 44. *Hook and revolving catch with side shackle and rotating key with two prongs.*

Notched-Shackle and Rotating Disks

The body of this type of lock (Figs. 45, 45a) is accompanied by a removable top shackle or by a shackle fastened with a hinge at one end. On the inward-facing side or sides of the shackle are grooves into which disk-like plates fit, thereby preventing the shackle from being raised. The shape of the core carrying these plates or catches is elliptical. When the key is inserted from below, a partial revolution of the core moves the plates out of the teeth just far enough to permit the removal of the shackle.

Figs. 45, 45a. *Notched-shackle and rotating disks with removable top shackle and turn key with double bit.*

Combination

The traditional horizontal combination lock (Fig. 46) has the following parts:

1. An end piece with a barrel attached to the bottom and with part of the side shackle connected to the top.
2. An end piece for the opposite side, to which the remainder of the shackle is attached at the top and a flat shaft with notches in it at the bottom.
3. Lettered or numbered hollow cylindrical rings closed at one end by a thin plate with a circular hole in the middle and a rectangular notch on top of the circular hole.
4. Wide-rimmed washers perforated to match the holes of the lettered or numbered hollow, cylindrical rings.

To assemble and operate this combination lock, the rings and washers are alternately placed on the barrel, then the shaft with notches is fitted into the barrel and passed through the cylindrical rings and their washers. These must be turned in such a way that the notched rim of the shaft does not catch on them anywhere. Once these are together, the end holding the shaft is pushed in tight, and the rings are turned in order to alter the alignment and prevent the lock from opening. The rings and adjacent washers revolve freely in the notches of the shaft but cannot move laterally until they are properly aligned by the right combination.

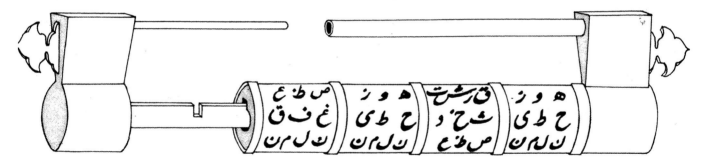

Fig. 46. Horizontal combination with top shackle and no key.

Vertical combination locks (Figs. 47, 47a, 47b) have the same parts as those with a horizontal axis but are arranged somewhat differently. The barrel is fixed to the bottom of a round plate, and the shackle to the top. Attached by a hinge to the free end of the shackle is the notched shaft, which fits into the barrel when the shackle is closed and comes out of it completely when the shackle is open. The rings and washers rotate horizontally instead of vertically.

Very different from the above in shape and mechanism is the dial combination lock (Figs. 48, 48a). A total of eight dials are seen in this lock body, four with numbers on the front and four plain ones on the back. Connecting, and rotating with each pair of front and back dials, is a solid cylindrical rod that is notched so that the two ends of the cylindrical shackle can pass by it into the lock body without being blocked. The shackle itself has notches on each side to match the adjacent unpierced half of the connecting rods. When rotated, the latter fill the shackle notches, thereby preventing the removal of the shackle.

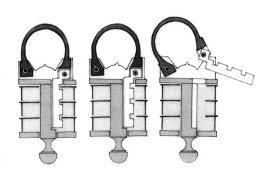

Figs. 47, 47a, 47b. Vertical combination with top shackle and no key.

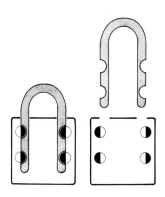

Figs. 48, 48a. Dial combination with removable top shackle and no key.

Multiple Mechanisms and Keys

Most locks with more than one mechanism and key have a main locking apparatus of a barbed or bent-spring controlling the shackle, as well as one or more auxiliary mechanisms, normally of the helical-spring type. These prevent the main key from being used or they keep the locking piece in place.

One particular arrangement (Figs. 49, 49a), found in a bird-shape lock, consists of a bent-spring and a helical-spring, the former located in the bird's breast, and the latter in its tail. Access to the keyhole of the bent-spring mechanism is blocked by a cover in the form of a wing. This wing is held shut when a notch under it is engaged by an arm placed at the end of the helical-spring. To open the lock, the wing-shaped keyhole cover must first be released by the key operating the helical-spring, then the second key—for the bent-spring—can be used to open the top shackle.

Seen in Figs. 50, 50a is a lock with three mechanisms and keys. Once again, the mechanism controlling the top shackle is a bent-spring. The screw key with interior threads that enters the bottom of the lock is for a helical-spring. As in the case of the lock in Figs. 49, 49a, this releases the cover of the main keyhole. A second helical-spring (a pull spring, shown at the left side in Figs. 50, 50a) prevents the spring that fills the area around the drill pin of the main keyhole from being pushed back. The arm attached to the end of this second helical-spring must be drawn back by means of another screw key with interior threads before the third and final key. A turn key with one bit, illustrated at the far left in Figs. 50, 50a can be employed to operate the bent-spring mechanism controlling the top shackle. Instead of a bent-spring controlled top shackle, one finds a barbed-spring operated top shackle in Figs. 51, 51a. The arm at the end of the helical-spring on the bottom left prevents the push key with a screw on its front end from entering the lock body. The one on the bottom right keeps the barbed-springs from moving. Both auxiliary mechanisms must be released before the main barbed-spring locking piece can be withdrawn.

The arrangement of the lock seen in Figs. 52, 52a, 52b, is similar to that of Figs. 51, 51a in terms of the shackle and main mechanism, however, no auxiliary mechanisms are involved. Instead, there are four cylindrical plugs with exterior threads which have to be removed with a straight key (on the left in Fig. 30) before the push key with an exterior-threaded end can enter the lock body and before the barbed-spring locking piece can be withdrawn. An unusual piece (Figs. 52, 52a, 52b) contains a barbed-spring as its main locking mechanism, but has the additional features of a screw and notched arm to impede misuse of the lock.

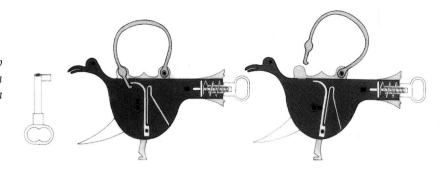

Figs. 49, 49a. Multiple mechanism (top shackle) and key: one bent-spring with turn key with one bit; and one helical-spring with hollow, back, screw key with interior threads.

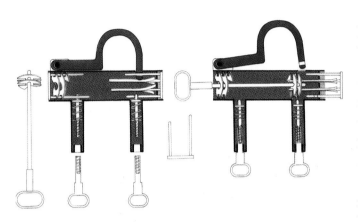

Figs. 50, 50a. Multiple mechanism (top shackle) and key: one barbed-spring with push key; and two helical-springs with two hollow, back, screw keys with interior threads.

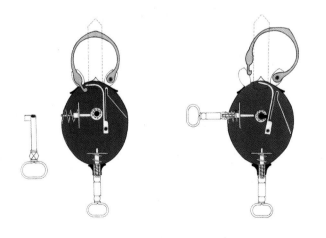

Fig. 51, 51a. Multiple mechanism (top shackle) and keys: one bent-spring with turn key with one bit; and two helical-springs with hollow, back, screw keys with interior threads.

Attached to the bottom of the side shackle is a locking piece consisting of two horizontal arms. Each arm has two barbed-springs, one above the other. These catch on the upper and lower inside rims when pushed in and spread. At the top of the side shackle, which is shown at the right side in Figs. 52, 52a, 52b (unshaded), is a long solid screw with exterior threads. This fits into a tube (in the lock body) with interior threads; the tube is rotated by means of a nut at the end (top left in Fig. 52). When the tube is turned, the male screw of the side shackle is drawn into the female tube, at the same time bringing the barbed-springs into place. Once they have entered and cleared the rims, the barbed-springs open and the lock is secured.

As an additional precautionary measure, the second of three teeth at the bottom of the lock screw into the plate protecting the slide key slot. This exerts pressure on an arm, at the end of which is a notch (at the far left-hand end in Figs. 52, 52a, 52b). The notch catches on the lock body (just inside the inner rim) and prevents the bottom plate from opening.

To unlock this piece, one must first remove the center screw at the bottom and pull back the plate hiding the slot for the slide key. Then the slide key is inserted and pulled as far as it will go. At this point, the nut at the top left is turned and the male screw comes out of the female, moving with it the side shackle with compressed barbed-springs out of the lock body.

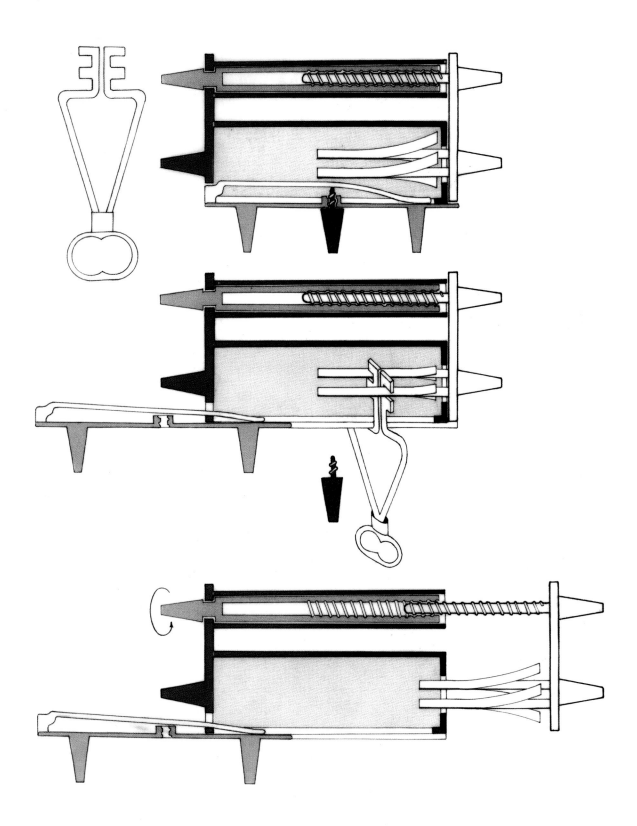

Figs. 52, 52a, 52b. *Multiple mechanism (side shackle) and key: one barbed-spring with slide key, revolving female screw, solid male screw, and sliding keyhole cover.*

33

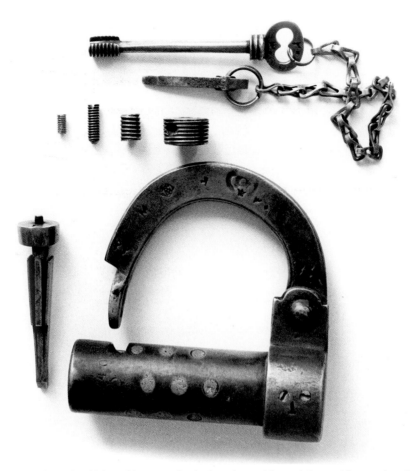

Fig. 53. *Multiple mechanism (top shackle) and key: one barbed-spring with push key with exterior threaded end and four exterior threaded plugs with straight key.*

III. Historical Development: an Overview

The oldest mechanism used in Iranian padlocks is the barbed-spring. In the earliest stages of its known history it was made with a horizontal body and a removable side shackle, operated by a push key or, less frequently, by a turn key with a bit. The use of the slide key for this kind of lock seems to have been a later development. The first examples contained in the Tanavoli collection were made sometime between the fifth and seventh centuries A.D. Later developments are the variations in the barbed-spring mechanism and corresponding shackle and lock-body types described and illustrated previously. When these first appeared in Iran cannot be determined precisely at present. As lock No. 46 (p. 56) would seem to indicate, the helical-spring mechanism with a back key was being employed by the Iranian locksmith at least as early as the fifteenth to seventeenth centuries. The extensive use of this mechanism, however, evidently came about a few centuries after that period. Such a conclusion is based on the frequency with which this is found in the locks of the Tanavoli collection. With the mechanical principle once established, there seems to be little reason why the other varieties of the helical-spring could not have been developed at a point far earlier than the last two hundred years, from which time the locks of this collection with these three mechanisms come. Older specimens no doubt exist.

The locks in this collection with bent-spring mechanisms date from the sixteenth to seventeenth centuries, while an example of a hook-and-revolving-catch mechanism appears about a century earlier, in the fifteenth or sixteenth century (Lock 251, p. 100). The earliest date for the use of the shackle-spring would be about the mid-eleventh to thirteenth centuries in accordance with the probable date of the brass figural locks discussed on pp. 81–84. The notched-shackle is found in this collection in locks from the eighteenth to nineteenth centuries, but this mechanism may be considerably older if what is called a "key" from tenth-century Bojnurd (in Khorasan) now in the Victoria and Albert Museum in London, is in fact a lock in the shape of a key, as are most of the later ones with the notched-shackle mechanism.

Combination locks were being made in Iran during the fifteenth century if not earlier. This is established by a combination lock of Iranian origin bearing the Islamic date 889 (1483 A.D.) in the Keir collection in England (Fehervari, *Islamic Metalwork*, No. 149). Lock 399 of the Tanavoli collection on page 130 is similar to this but is probably from the following century.

The notched-shackle with rotating disks appears in the locks of the Tanavoli collection by the eighteenth century at the earliest.

The Problems of Origin, Identification and Dating

With very few exceptions, the locks in this book were acquired within the borders of present-day Iran. In certain cases, a number of locks of the same type were found in one region or even in one town. Where this is true, it has been assumed that they represent the products of a local tradition and can safely be attributed to that place. This assumption has been corroborated in some instances by the local locksmiths and inhabitants familiar with the locks of the area. In other cases, locks were found in the market in Tehran. Some of these were perhaps made there in the past, while others were brought there from other parts of Iran to be sold. When the latter case seems probable, the problem of identifying the origin of a piece assumes a greater complexity.

If there is sufficient similarity of style, materials, and mechanisms to any of the established groups, a piece can, with some justification, be classified within one of these groups. When this is not possible, and no other information is available, the question of provenance remains an open one, and the assumption then is that the lock originated somewhere in Iran or at least within the area that was at one time part of the Iranian empire or under strong Iranian cultural influence. This would include such regions as much of modern Afghanistan, Russian Azerbaijan, the southern Caucasus, and, to an extent, Russian Central Asia, in particular the area bounded by Khiva, Bokhara, and Samarkand south to the Oxus River.

It must be pointed out, however, that given the present lack of information concerning the locks not only of Iran but also of the surrounding countries such as Pakistan, India, Turkey, and the Arab lands, the possibility that some of these locks might have come from areas outside of Iran or its sphere of cultural influence cannot be dismissed. Only when much more is known about the locks of this vast region, and its metalwork in general, will the most questionable cases be more easily solved.

Iranian locksmiths seldom signed or dated their work. Without a signature, the identity of the maker of a particular piece is lost forever. Nor is much help forthcoming from the Islamic written sources relating to Iran—chronicles, biographical dictionaries, and so forth—or from the early European travelers' accounts, in which references to lockmaking and locksmiths are very rare. As a result, few of the names of famous locksmiths of the past have come down to us.

Since only a very limited number of items in this collection bear dates of any sort, and few dated locks of Iranian origin are known in general, the question of dating must be approached in a variety of ways.

In Iran itself there is a certain body of knowledge among antique dealers, collectors, and connoisseurs which may or may not be helpful in identifying and dating an object. Since their information is usually based more on firsthand experience acquired through living in the culture in which these locks originated and through handling numerous specimens rather than solely on formal study and scholarship, there is much to be learned from people with this kind of background. At the same time, however, opinions offered by those who have gained their knowledge in this fashion must be carefully considered, and acceptance or rejection should be made only after all factors are weighed. Obviously, where a certain consensus exists, one is perhaps on somewhat safer ground than when opinions differ widely.

In some cases, help in dating can also come from stylistic similarities found in other types of metal objects, or even in objects made of other materials, that are of a known period. This applies to surface decoration as well as the shapes. On rare occasions, a minimum age or a fairly precise age can be established through various sorts of records or evidence, such as archaeological excavation, date of acquisition, and dated paintings, tiles, and photographs that actually show locks.

For the local traditions of lockmaking, the knowledge and personal experience of the lockmakers themselves and older members of the local community are frequently invaluable. Since the profession was usually handed down from father to son, the products of an area and sometimes adjacent areas are recognized and dated by the descendants of earlier craftsmen and by those who knew them and used what they made. While this type of information is normally trustworthy for a period of no more than several generations, it nevertheless adds a dimension of certainty and confidence which is often lacking for many of the older locks.

In summary, given the current state of knowledge of the locks of Iran, much of what is said in this book about provenance and age must be taken not as the final word but rather as a first step in attempting to deal with these questions, and as a basis for further discussion and learning.

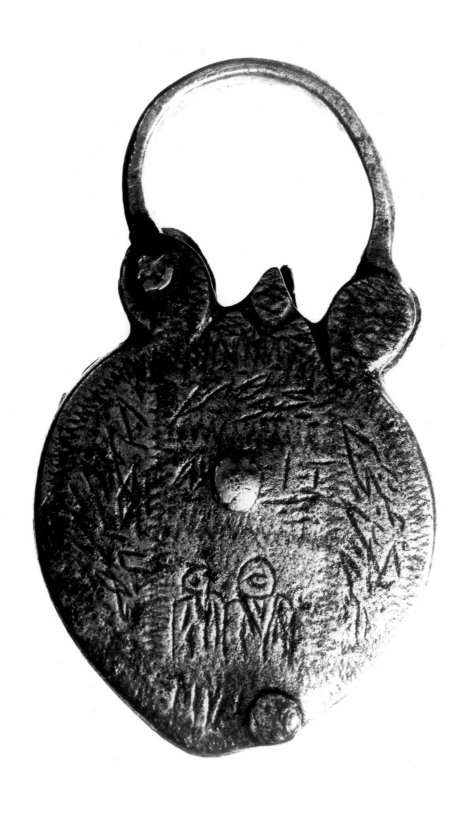

The Evolution of Lock Types in Iran

Locks and keys have been used by man from at least the beginning of the second millennium B.C., and the earliest surviving specimens come from Mesopotamia and Egypt. In addition to actual examples, there are references to locks and keys in the ancient literature of peoples as far apart as China and Greece. Within this vast area a number of lock types and mechanisms originated and spread, but where and when these developments took place are questions that elude satisfactory answers at present.

The oldest locks are fixed ones; the padlock apparently was a later invention. Once it was established, however, there is a striking continuity in the tradition of lockmaking from ancient times right up to the twentieth century in many parts of the world. This is also true in Iran.

Fixed Locks

The most ancient lock that has been found in Iran was excavated at the *ziggurat* (a rectangular shaped tower) of Choga Zanbil on the Khuzestan plain. Dating from the thirteenth century B.C., it consisted of a stone bolt and tumblers, and was most probably employed on a wooden door. This type is sometimes known as the "Egyptian lock" because of its extensive use in that country. Tumbler locks were seen in all regions of Iran by Wulff, who illustrates one of these entirely of wood, built into a garden wall in the Esfahan area (Wulff, *The Traditional Crafts of Persia*, p. 69). Entering the lock through a hole in the wall, the key pushes the tumblers up and out of the bolt from underneath, thus freeing the bolt, which is then drawn back by means of the engaged key.

With the availability of steel and iron from the late 19th century onwards tumbler locks with metal keys became more prevalent (Figs. 56, 57).

Also of great antiquity is the toothed-bolt lock (Wulff, pp. 66, 67) which resembles the somewhat simpler Homerian lock of ancient Greece. Instead of being moved by a primitive sickle-shaped key as in ancient Greece (Eras, *Locks and Keys throughout the Ages*, photos pp. 42, 43), the bolt in the examples found by Wulff is controlled by a conventionally shaped iron bit key with wards. The key engages in the notches sawed into the wooden bolt.

Quite possibly it was this type of mechanism that secured the stone door of the tomb of Artaxerxes III (359–338 B.C.), one of the Achaemenian rulers interred in the crypts hewn out of the mountainside above Persepolis in southwestern Iran.

Now in the Persepolis Museum, the somewhat damaged door consists of two solid slabs of stone (about 1.5 meters high by 1.5 meters wide) with upper and lower corner pivots that revolved in round holes in a stone lintel and sill. The only traces that remain of the mechanism are a circular keyhole about 6 cm in diameter on one panel and a boxlike catch that juts out of the back of the other stone panel. Given the size of the keyhole and its placement in the door panel on the same level as the catch, it can be assumed that the only type of bolt that could have worked under such circumstances was a toothed one, probably made of metal or wood, though possibly of stone.

A third type (Wulff, pp. 68, 69), seen mainly in Azerbaijan, works on a principle completely different from those of the first two. Here a pair of strong springs protrude from an iron box and engage on both sides of a catch hook attached to the door jamb. The key, which has a double bit, spreads the springs out so that they are freed from the back of the catch, thereby permitting the door to be opened.

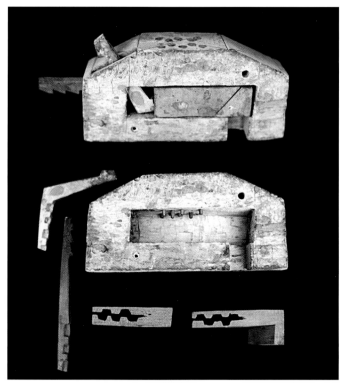

Fig. 54. Tumbler lock and key, all wood, early 20th century.

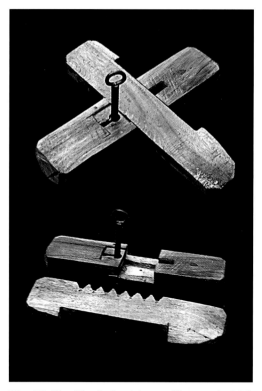

Fig. 55. Tumbler lock with metal key, early 20th century.

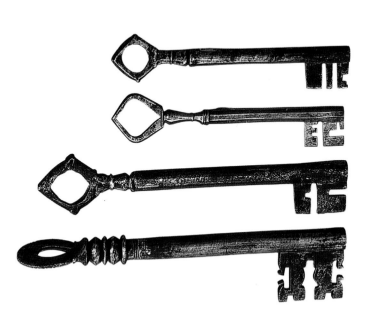

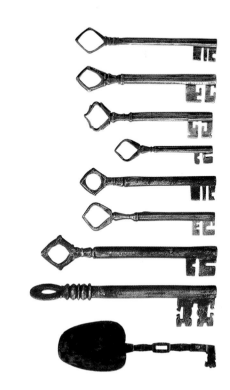

Figs. 56, 57. Metal keys for tumbler locks, late 19th, early 20th century.

The three types of locks described by Wulff were traditionally used for main doors, garden gates, and so forth. Normally they are of very crude construction and were left undecorated, though their simplicity of course did not limit their effectiveness. Small boxes and trunks were sometimes secured by means of fixed locks, and these too were usually devoid of ornamentation. Only rarely did the Iranian locksmith take more than a passing interest in this type, of which there are just two examples in this collection.

The first, probably made for a rather large container, has a flat steel front plate which resembles a fish when viewed from the left and, when the eye concentrates on the right, a *botteh* (the motif that looks like a pear with a curved tip, most familiar to Westerners as the decorative design in Kashmir, or "Paisley," shawls, and a favorite motif in Middle Eastern art in general, including carpets). Its engraved surface nicely complements both impressions.

The mechanism—a toothed-bolt turned by a bit key—is very simple. This unusual lock may date from the sixteenth to seventeenth centuries.

The second fixed lock (No. 2) is made of silver and is engraved in a style common in the late eighteenth century and the first half of the nineteenth, to which period it is to be attributed. Given its size, it was probably meant for a small box of some sort. A bent-spring operates the locking mechanism.

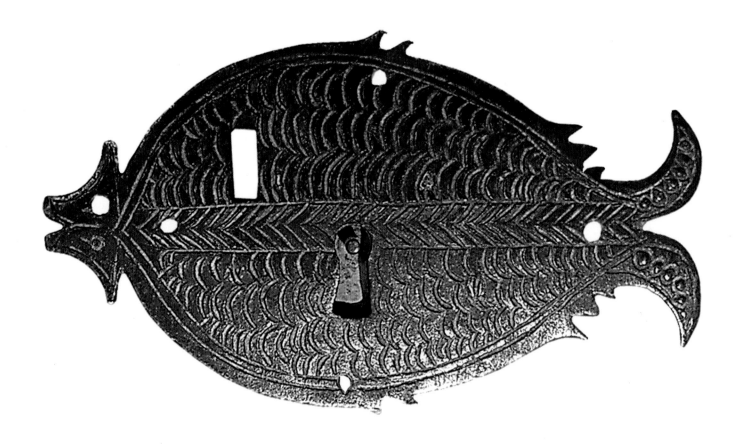

Lock 1. *Steel fixed lock with toothed-bolt mechanism, 16th–17th centuries. Width 11 cm, height 6 cm.*

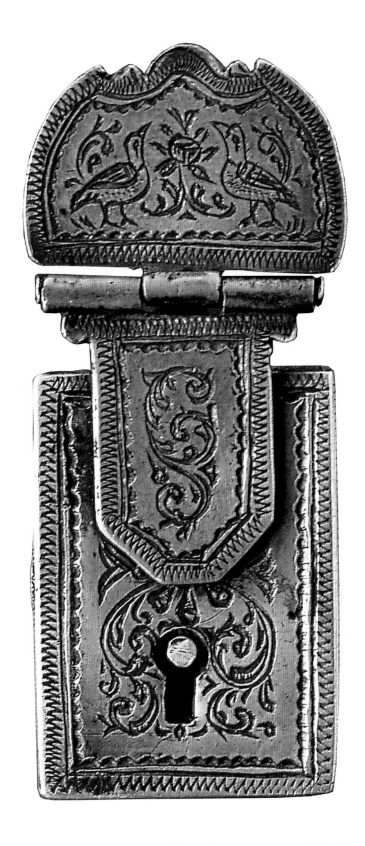

***Lock 2**. Silver fixed lock with bent-spring mechanism, late 18th, early 19th centuries. Width 2.5 cm, height 6 cm.*

Padlocks

The Pre-Islamic Era

The oldest Iranian padlock that can be dated with some certainty comes from a pre-Islamic site in the Rudbar area of Gilan not far from the Caspian Sea. In 1966, during the excavations undertaken by a team of Iranian archaeologists, a lock and key were uncovered in a tomb one-and-a-half-meters below the surface of the ground in close proximity to Sassanian bowls and coins of the fifth and sixth centuries A.D. The lock (No. 3), now in the Iran Bastan Museum, Tehran, measures 20 cm in width and 5.5 cm in height and is made of steel with a small segment in the center of the lock body cast in one piece from bronze with a high copper content. The key, 16 cm long, is made entirely of steel and is of the push type for a barbed-spring mechanism and removable side shackle. Still on the shackle are steel loops which served as the hook and the staple for the large wooden coffin that was secured by the lock. With the passing of time the wood of the coffin has disintegrated, leaving the loops in their present position on the lock.

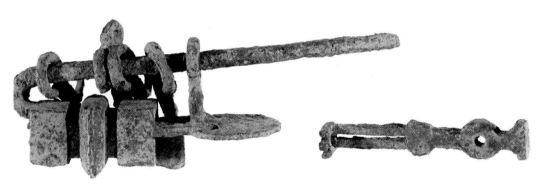

Lock 3. Left: padlock of steel and high-copper bronze, width 20 cm, length 5.5 cm. Right: steel push key for the barbed-spring mechanism and removable side shackle, length 16 cm. Once used on a wooden coffin. Late Sassanian period, 5th or 6th century A.D. National Museum of Iran, Tehran.

The shape of the lock body and key, as well as the fact that the key was placed inside the coffin, might be of some religious significance. With the exercise of some imagination the key, which resembles a tightly wrapped corpse, seems to be swallowed or eaten by an insect-shaped or fish-shaped lock body.

Similar in many ways to lock No. 3 are locks Nos. 4–7, all uncovered in northwest Iran, not far from no. 3, all made of the same metal (steel).

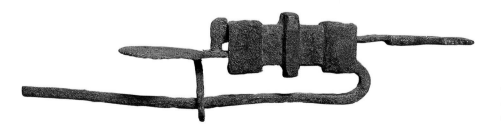

Lock 4. Padlock and key of steel, width 29 cm, length 6 cm, barbed-spring mechanism, 5th or 6th century A.D.

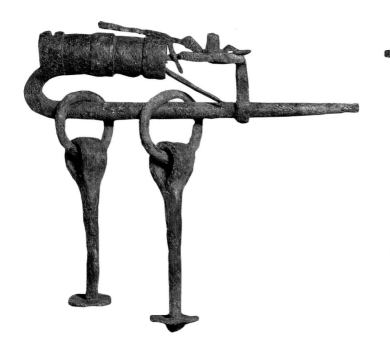

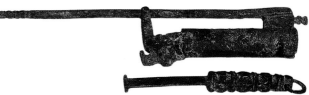

Lock 6. Padlock and key of steel, width 29 cm, height 3.8 cm, barbed-spring mechanism, 5th or 6th century A.D.

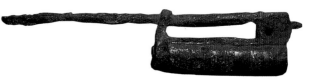

Lock 5. Padlock and steel key, width 24 cm, length 6 cm (excluding rings and nails) barbed-spring mechanism, 5th or 6th century A.D.

Lock 7. Padlock of steel and brass, width 24 cm height 2.7 cm, barbed-spring mechanism, 5th or 6th century A.D.

Somewhat similar to locks No. 3 and 4 is a much smaller bronze piece, No. 9 (next page). The main part of this lock was cast in a single mold as were the center parts of locks 3 and 4. On the basis of this technical feature, as well as on that of style, the author believes that this too could be pre-Islamic. By just how much it might antedate the beginning of Islam in Iran (second half of the seventh century A.D.) is difficult to determine

The main body of lock 9 is carved with finely engraved "X's" running from the "eye" in the front to the "tail" in the back. The hole, which appears on one side only, is suggestive of an eye, and could have had some connection with the mechanism, since there is room for a pin to pass through the hole at an angle and press a single barbed-spring shut. In this case, the front end would not have taken a push key.

The Sassanian lock (No. 3) in the Iran Bastan Museum, Tehran, may have been made as early as the sixth century A.D., and could be even older than that. If the greater simplicity of the all-bronze lock (No. 9) is an indication of greater age, it would have to be placed somewhere in the sixth century or earlier. If not, it could be late Sassanian (the sixth or early seventh century).

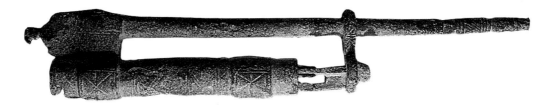

Lock 8. Steel padlock, width 31 cm, height 2.8 cm, barbed-spring mechanism, 5th or 6th century A.D.

Whereas a fish shape is merely suggested by the lock body of No. 13, and also to an extent by that of lock No. 3, this form is quite clear in the third example (No. 140, p. 78). Such an evolution could well be an indication of a very late Sassanian or even early Islamic (seventh to ninth centuries) date for this bronze fish-shape lock, as one finds the complete development and widespread use of entire locks in animal form by the eighth to tenth centuries. Another point of similarity between No. 10 and the figural locks of the eighth to thirteenth centuries is that they were all sand cast in two pieces rather than in a single mold. This is also true of No. 10, which shares with the bronze fish-shape lock the additional characteristic of having a barbed-spring mechanism worked by a turn key with a bit. The area of the keyhole of locks 10 and 140 is similar, but the rest of the lock bodies differ substantially.

Despite strong resemblances, the lock body of No. 10 and the locking piece shown with it are in fact from two different locks. They must be from the same period, however, as the decorative use of a small animal is almost identical in both. Given the apparent trend toward fully figural lock bodies that culminated in the products of the early Islamic period, this bronze lock body and locking piece with tiny perched animals should perhaps be dated somewhat before the bronze fish (No. 140). The keyholes of Nos. 10 and 140 were once each covered by a hinged door, something seen in other kinds of metal objects in the Sassanian period.

One more lock that could well be pre-Islamic is No. 8, which was found in Azerbaijan. It is of the barbed-spring, push-key type and is made entirely of steel that has become highly corroded by the elements over a long period of time. An eagle's head protrudes from the end above the keyhole (at the far left in the illustration), bringing to mind the incidental use of tiny animals on No. 10. As is the case of the other early locks, the side shackle bar in Nos. 9 and 10 is quite long.

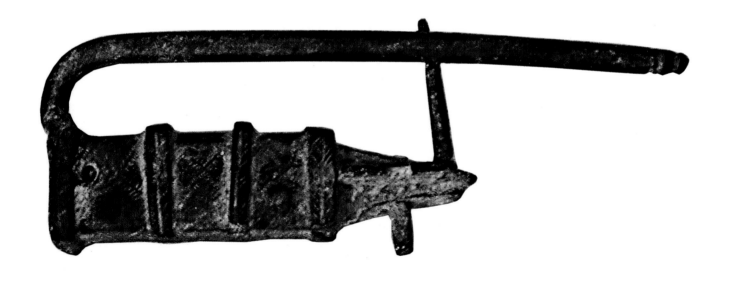

Lock 9. Bronze semifigural lock, width 12.3 cm, heigth 4.8 cm, barbed-spring mechanism, 7th or 8th century A.D.

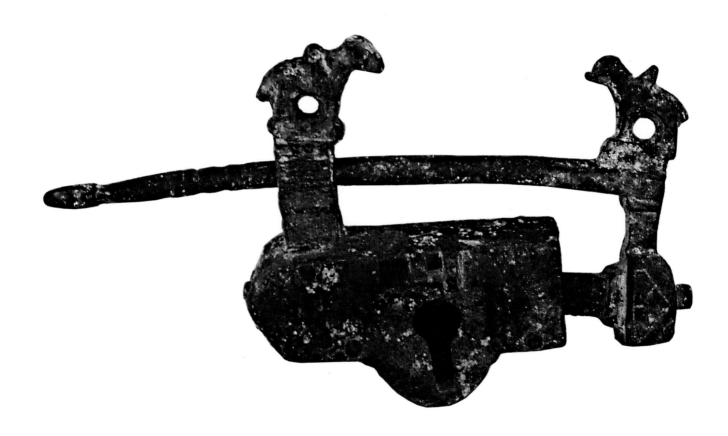

Lock 10. *Bronze semifigural lock, lock body, width 5.4 cm, height 7 cm. Locking piece width 12 cm, height 5 cm, barbed-spring mechanism, pre-Islamic era.*

In a discussion of the earliest padlocks of Iran, the door of the tomb of the biblical characters Esther and Mordecai in Hamadan is of particular interest. The present building covering the tomb is from the Seljuk period, but the door (Fig. 58, a, b, c, d, next page) is most likely much older. Those responsible for the maintenance of the tomb claim that the door is from the original, smaller structure built in the time of Xerxes I (485–465 B.C.). If this is so, the question of how the door was originally locked is very significant.

The present method of securing the door consists of an iron rod which rests inside the wall when the door is open, and which comes out of the wall across the back of the door when it is locked. A loop comes out of the opposite wall to meet the rod. The ends of these two are fastened together by means of a padlock, and the door is thus prevented from opening. To gain entry, the person outside must reach the padlock with their arm through the hole in the door. If the tomb and its door are Achaemenian, and if this is the original way of locking the tomb, then the padlock in Iran would be considerably older than the examples presently known.

It is also quite possible that this door was initially secured by a fixed lock of the pin-tumbler type, which is often reached through a hole in the door or in the adjacent wall. As no holes or signs of such a device are seen on the present door, however, one would have to postulate the existence of the pin-tumbler lock on an adjacent door panel or in the wall itself.

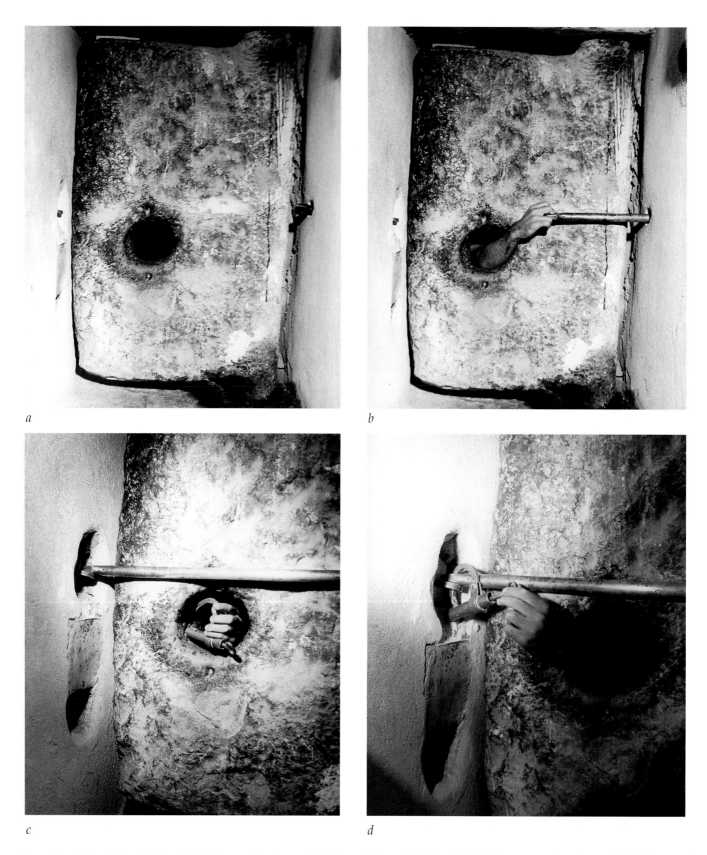

a

b

c

d

Figs. 58, a, b, c, d. Door believed to be from a structure of the time of Xerxes I (486—465 B.C.); now used on the tomb of Esther and Mordecai in Hamadan, of the Seljuk period (c. 1000—1157 A.D.).

Islamic Period

Early Islamic Locks

The reason for the scarcity of locks in the early centuries of Islamic Iran has remained obscure. The finding of several well-crafted pre-Islamic/Sassanian locks further raises the question of scarcity of locks in the early Islamic period, from the 7th to 10th century A.D.

Although the advent of Islam in Iran in the 7th century A.D. led to significant and fundamental changes in all aspects of the Iranian way of life, it is not wise to assume that it put a halt to the making of daily utilitarian objects such as locks. On the contrary it seems safe to suppose that during that period of war-time chaos and crisis, locks would have been more in demand.

In the course of my research in the mid-1970s and afterwards, I came across lock No. 3 at the pre-Islamic section of the National Museum of Iran. I was fascinated by its proportionate shape and advanced mechanism. That lock was unquestionable proof of the advanced level of locksmithing in the region prior to Islam, leading me to believe in the existence of more examples, which I then decided to find. As the proverb goes, "where there's a will there's a way". I began to look for other examples and managed to find more than a dozen in the decades that followed. In order to study these locks, I divided them into two categories based on the quality of their craftsmanship. The first category encompasses the pre-Islamic locks of higher quality, made by master locksmiths, from the 5th to 7th century A.D. (Nos. 3–8, pp. 42, 43) while the second category includes early Islamic locks, (8th–11th centuries) which were crafted soon after the advent of Islam. Any comparison between the categories immediately reveals the supreme quality of the pre-Islamic Sasanian locks and the decline in quality of early Islamic locks.

Among the early Islamic locks, Nos. 11, 12, 13, 14 are good examples. Like the rest of the Sasanian copper alloy locks (Nos. 9, 10), all four are made of high copper alloys and all four have barbed-spring mechanisms with side shackle bars. On the surface of all three locks, there are some engravings; an unskilled attempt at Islamic calligraphy and arabesque. On the shackle bar of lock no. 13, there is a horse-like animal similar to that of No. 10.

Another lock that may be from this period, is No. 15. Like many Sasanian objects and utensils, the surface of the box-like body of this lock is decorated with animals and the shackle is formed by two lions standing on their back paws and touching their faces and paws together.

Lock 11. Bronze lock, length 7.8 cm, height 5.3 cm, barbed-spring mechanism, 8th–9th century A.D.

Lock 12. Bronze lock, length 8.9 cm, height 4.3 cm, barbed-spring mechanism, 9th–11th century A.D.

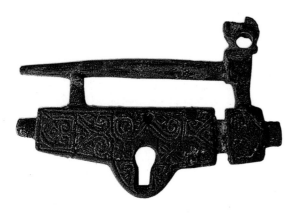

Lock 13. Bronze lock, length 11.8 cm, height 7.3 cm, barbed-spring mechanism, 9th–11th century A.D.

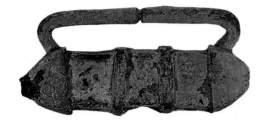

Lock 14. Bronze lock, length 7.6 cm, height 6.3 cm, barbed-spring mechanism, 9th–11th century A.D.

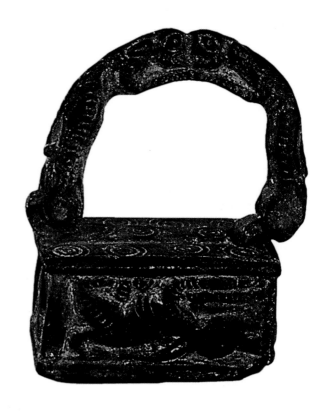

Lock 15. Bronze lock, length 5.2 cm, height 5.6 cm, toothed-bolt mechanism, 8th–9th century A.D.

Figural Locks

From at least early Islamic times until the present there has been a tradition of figural lockmaking in Iran. Most of the subjects chosen by the locksmith were animals, but purely human and mixed animal and human forms were occasionaly represented as well. Judging from the locks in this book, certain motifs were in vogue at particular times only and were not made in earlier or later periods.

In other cases, we find examples of the same figure in virtually every century following its initial use. This is true of the lion.

While a few of the earliest locks are from the first centuries of the Islamic era, the great majority come from the eleventh to thirteenth centuries, when Iran was under Seljuk and Mongol rule.

Almost all of these are made of copper alloy (mainly brass), the material generally favored by metalworkers in Iran (and elsewhere in the Islamic world) at that time, and have a barbed-spring mechanism operated by a push, turn, or slide key. As they were most often sand cast in two parts rather than made in a single mold, it is not uncommon for half of the lock to be missing when found today. A large number of these early figural locks are highly oxidized from having been underground for a considerable length of time.

In succeeding periods bronze continued to be used for figural locks in Iran but was soon joined by brass, steel, and, occasionally, silver or gold. Likewise, while the barbed-spring mechanism was employed in certain types of animal bodies right up to the present, several others—especially the bent-spring and helical-spring—also came into common use for figural locks.

Stylistically there are wide differences in the rendition of the various figural forms, the great majority of which were produced in very small dimensions; an average size is 5 cm in width by 3.5 cm in height. Those made between the beginning of the Islamic period, in the mid-seventh century, and the fifteenth century have certain features in common, as do those from the fifteenth and sixteenth centuries onward.

A high degree of stylization is characteristic of the bronze animal-shaped locks of the early period, especially those from the eleventh to thirteenth centuries, one of the most creative periods in Iranian history, when metalwork enjoyed great patronage. Most of these animal forms have rather flat, rectangular bodies that contrast sharply with very articulated front and hind quarters. The modeling that does exist is found primarily in the head and neck areas; the rest is almost two-dimensional. Surface decoration ranges from very elaborate to minimal. In the most beautiful examples the shape of the animal and its surface motifs complement each other harmoniously; in some cases skillfully strengthening the impression of motion, and in others contributing to a feeling of repose.

A few animals differ somewhat from the figural shapes just described, principally water buffalos, which may represent the local style of Azerbaijan rather than Khorasan, where most of the eleventh to thirteenth century figural locks originated. These tend to be more rounded and three-dimensional, with softer, smoother lines than the geometric forms made by the locksmiths of eastern Iran at roughly the same time.

A trend toward modeled shapes is apparent in the locks made after the thirteenth century, and culminates in the much more naturalistic locks of the fifteenth and sixteenth centuries and later. Surface ornamentation also gives way to the depiction of physical features such as manes, eyes, and ribs. This is particularly true of figural locks cast in bronze or brass.

A greater degree of stylization continues, however, in many of the figural locks shaped by hammer from steel and silver sheets. Sharp lines and flat, largely unmodeled surfaces are the rule, and shape is significantly influenced by the material. Shared by all figural locks regardless of age, material, and place of manufacture is the symmetry so characteristic of Iranian art in general. This shows itself in the way legs, horns, and so forth are always mirrored and balanced on both sides, and in surface decoration which is normally the same on both flanks.

A classification and discussion of the figural locks contained in the Tanavoli collection follows.

Horse Locks

Date range: 11th—20th centuries; *Place of manufacture*: eastern Iran (11th—13th centuries), western Iran (14th–20th centuries); *Materials*: bronze, steel, brass, silver; *Mechanisms*: barbed-spring, bent-spring; *Size range*: (width) min. 4.5 cm, max. 7.5 cm (height) min. 3 cm, max. 6.5 cm.

Judging from the relative abundance of horse locks, it can be assumed that this animal constituted one of the most favored motifs among Iranian locksmiths throughout the Islamic era. Four basic styles can be seen in these locks. Those of the first group (Nos. 16–21) tend to have thin, delicate necks and legs which often suggest forward motion. Many of these carry saddles. Especially beautiful in form and surface ornamentation is No. 17.

The second group is composed of Nos. 22, 23. They have heavier limbs and necks that confer them with a greater feeling of strength, and less motion than in the lighter, more nimble horses of the preceding group. No. 24 combines features of both groups. These horses do not have saddles but in some instances do have bridles. Both groups date from the eleventh to thirteenth centuries.

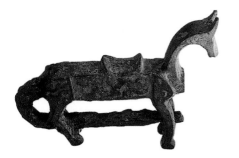

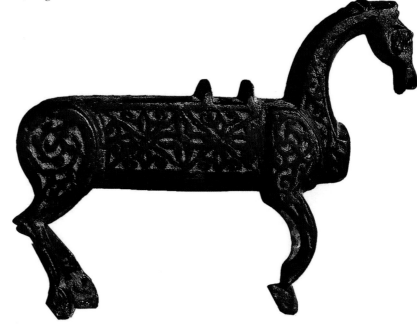

Lock 16. Bronze horse with barbed-spring mechanism, 11th–13th centuries. Width 7.5 cm, height 5.5 cm.

Lock 17. Bronze horse with barbed-spring mechanism, 11th–13th centuries. Width 7.8 cm, height 5.5 cm.

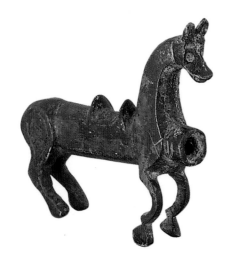

Lock 18. Bronze horse with barbed-spring mechanism, 11th–13th centuries. Width 7.3 cm, height 8.3 cm.

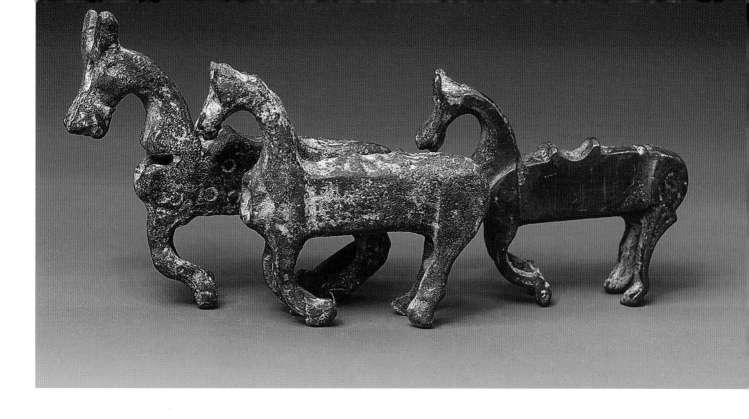

Locks 19–21. *Three bronze horses with barbed-spring mechanisms, 11th–13th centuries.*

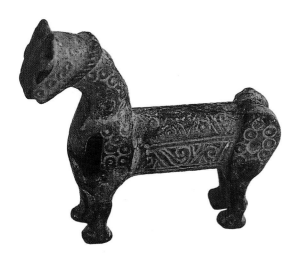

Lock 22. *Bronze horse with barbed-spring mechanism, 10th–12th centuries. Width 6.5 cm, height 5.8 cm.*

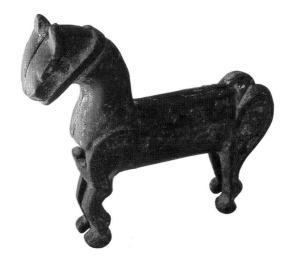

Lock 23. *Bronze horse with barbed-spring mechanism, 10th–12th centuries. Width 6.5 cm, height 5.3 cm.*

No. 26 represents the third style. Pudginess and a static quality have replaced the lightness of the first group and the strength of the second. This style is probably to be dated after the thirteenth century. All but one of these horse locks have a barbed-spring mechanism. Protruding from the locking piece of some are what appear to be the head and front legs of a colt in the process of being born (No. 24). The tail of No. 16 runs through the horse's legs. This might have been the way the removable locking piece was placed when the lock was not in use.

The last group (Nos. 27–35) covers the eighteenth century to the present. Realism has taken over and the proportions and decoration are much more natural than in the earlier horses. Of special interest is the only silver horse in this collection (No. 35). It is slightly bigger than the others and has colored stones inlaid in the saddle and eyes. The maker, one Habiballah, has signed it, and placed the Persian number seven or eight on the saddle as well.

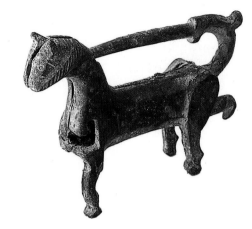

Lock 24. Bronze horse with barbed-spring mechanism, 11th–13th centuries. Width 7 cm, height 5.2 cm.

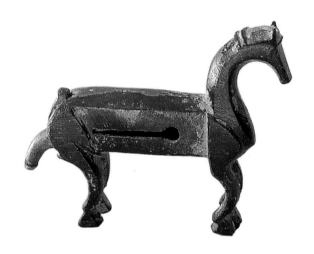

Lock 25. Bronze horse with barbed-spring mechanism, 11th–13th centuries. Width 4.5 cm, height 4 cm.

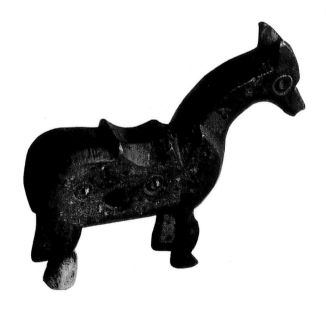

Lock 26. Bronze horse with barbed-spring mechanism, 14th–15th centuries. Width 4.5 cm, height 3.5 cm.

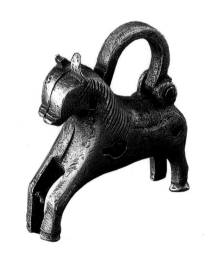

Lock 27. Brass horse with bent-spring mechanism, 19th century. Width 5.3 cm, height 4.5 cm.

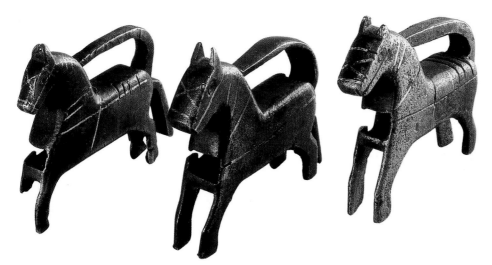

Locks 28–30. Three steel horses with barbed-spring mechanisms, 18th—19th centuries.

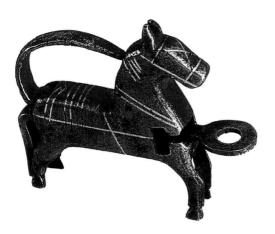

Lock 31. Steel horse with barbed-spring mechanism, 18th–19th centuries. Width 7.5 cm, height 6 cm.

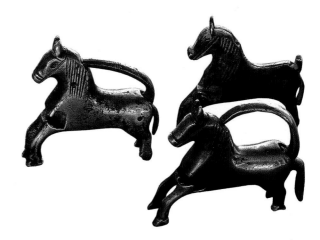

Locks 32–34. Three brass horses with barbed-spring mechanisms, 19th century.

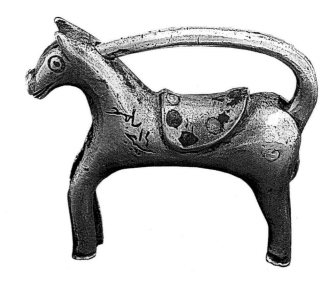

Lock 35. Silver horse with inlaid colored stones, barbed-spring mechanism, 18th–19th centuries; signed in Persian script. Work of Habiballah. Width 6.5 cm, height 6 cm.

Lion Locks

*Date range: 11th–20th centuries; **Place of manufacture**: all regions of Iran; **Materials**: bronze, steel, brass, with cut glass; **Mechanisms**: barbed-spring, helical-spring, bent-spring; **Size range**: (width) min. 2 cm, max. 9.5 cm, (height) min. 2 cm, max. 7 cm.*

The lion was native to Iran until very recent times. Over the millennia Iran has had a close relationship with the king of beasts which is clearly reflected in its art, literature, and religion. In view of this fact, it is hardly surprising that the lion has such a prominent place among Iran's figural locks. Examples of lions from virtually every period since the eleventh century give a good idea of the locksmith's treatment of this significant motif.

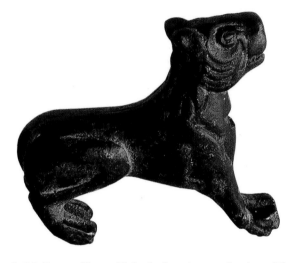

Lock 36. Bronze lion with barbed-spring mechanism, 8th–9th centuries. Width 4.4 cm, height 5 cm.

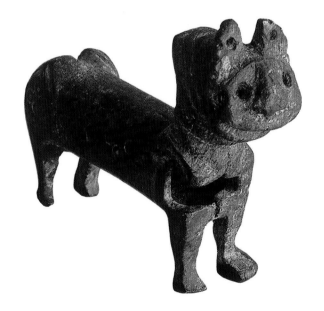

Lock 37. Bronze lion with barbed-spring mechanism, 11th–13th centuries. Width 6.5 cm, height 5.5 cm.

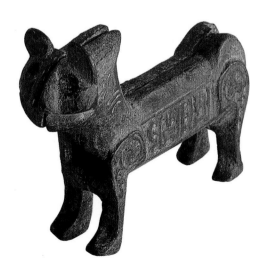

Lock 38. Bronze lion with barbed-spring mechanism, 11th–13th centuries. Width 6.5 cm, height 5 cm.

Ranging from fierce to amusing, the stylistic diversity in these locks is greater than in any other figural form. Especially noteworthy is lock 36, which is different in many ways. Unlike the other figural locks, this lock is cast in one piece. Also, like some of pre-Islamic sculptures, it is more realistically modeled showing details of the lion's face as well as its toes. In comparison to other lion locks, this one could have been made before the others, especially because the percentage of copper in its alloy is higher than in the later locks. The majority of the lion locks, like the horse locks, are from the 11th century onwards and they can be divided into several groups. The first group includes those with a hump-like mane and open mouth; rather benign looking and almost wearing a smile (locks 37–42). All these locks depict male lions, with a heavy body and a thick neck. Lock 43, instead, seems to be a lioness with a slender body and a longer neck.

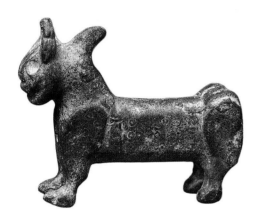

Lock 39. Bronze lion with barbed-spring mechanism, 11th–13th centuries. Width 6 cm, height 5 cm.

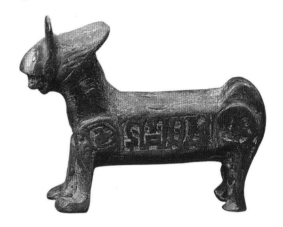

Lock 40. Bronze lion with barbed-spring mechanism, 11th–13th centuries. Width 6.5 cm, height 5.5 cm.

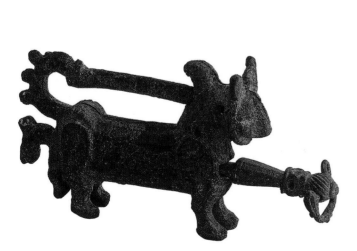

Lock 41. Bronze lion with barbed-spring mechanism, 11th–13th centuries. Width 12.5 cm. (including key), height 5.5 cm.

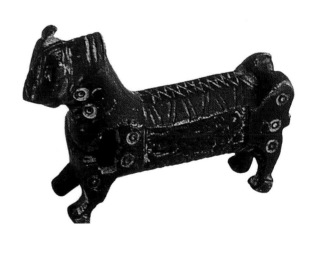

Lock 42. Bronze lion with barbed-spring mechanism, 12th–13th centuries. Width 6.5 cm, height 4.8 cm.

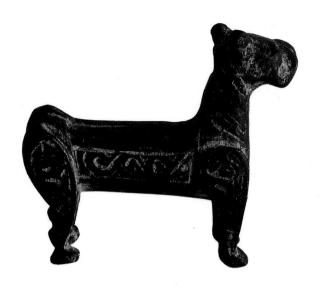

Lock 43. Bronze lioness with barbed-spring mechanism, 12th–13th centuries. Width 6.5 cm, height 5.5 cm.

Locks 44 and 45 portray two lions at rest. Both express a feeling of repose and refinement which is captured by the craftsman both in their overall shapes and in their harmonious surface decoration.

Lock No. 44 is a complete lock, but No. 45 is only half a lock. Fortunately, this is sufficient to provide the viewer with a good impression of its particular quality. Both were made between the eleventh and thirteenth centuries.

The second group depicts lions with less apparent manes and are from a later period; from the 14th to the 16th century (Nos. 46–51).

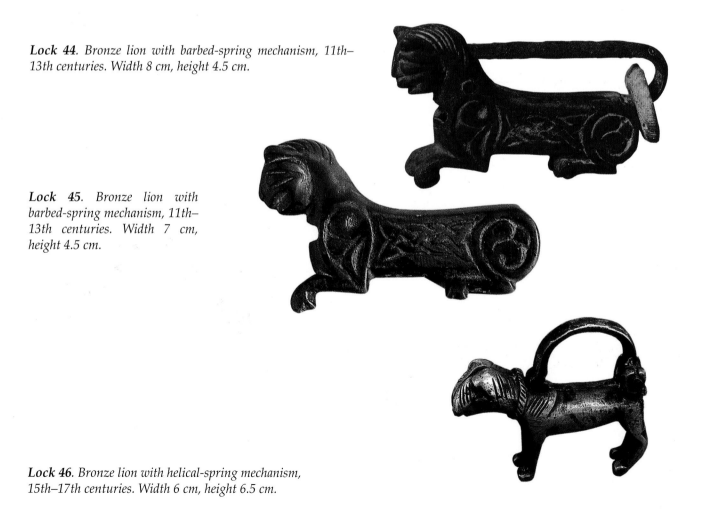

Lock 44. Bronze lion with barbed-spring mechanism, 11th–13th centuries. Width 8 cm, height 4.5 cm.

Lock 45. Bronze lion with barbed-spring mechanism, 11th–13th centuries. Width 7 cm, height 4.5 cm.

Lock 46. Bronze lion with helical-spring mechanism, 15th–17th centuries. Width 6 cm, height 6.5 cm.

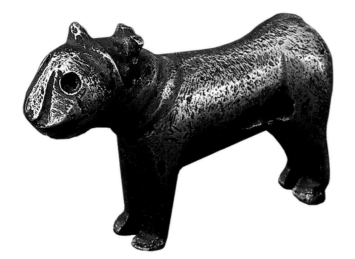

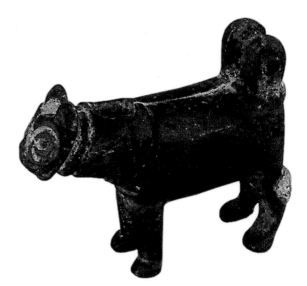

Lock 47. *Bronze lion with barbed-spring mechanism, 15th–17th centuries. Width 6 cm, height 4.5 cm.*

Lock 48. *Bronze lion with barbed-spring mechanism, 14th–15th centuries. Width 5 cm, height 4.5 cm.*

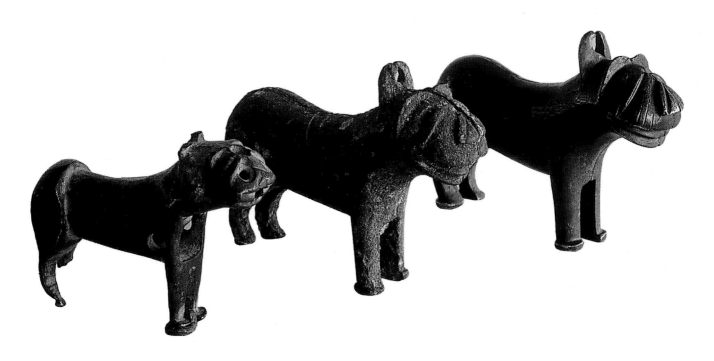

Locks 49–51. Bronze lions with barbed-spring mechanisms, 15th–17th centuries.

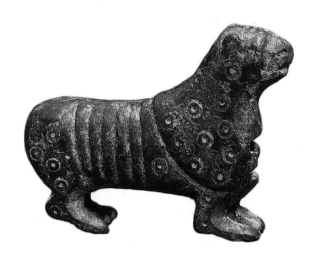

Lock 52. Bronze lion with barbed-spring mechanism, 15th–16th centuries. Width 5 cm, height 3.2 cm.

The third group consists of brass lions (Nos. 52–63). In both dates and in shapes, these vary greatly. The oldest ones are from the 16th to the 17th century (Nos. 52, 53), and the most recent ones are from the early 20th century (Nos. 56–60). A larger group of them have short legs and small heads (Nos. 52, 53 and Nos. 56–60).

A smaller group has bolder bodies that are in motion (Nos. 54, 55). Lock No. 54 is more modeled than any of the preceding examples; it was cast in brass in two pieces. It is unequalled in strength and vigor by any of the other locks in this group. This is probably from the early Safavid period (sixteenth century).

Lock 53. Brass lion with barbed-spring mechanism, 16th–17th centuries. Width 5.5 cm, height 3 cm.

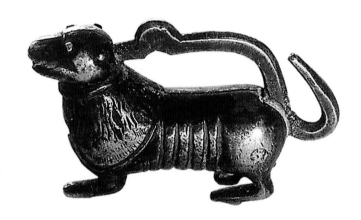

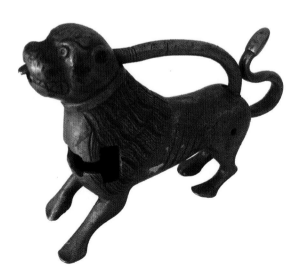

Lock 54. Brass lion with barbed-spring mechanism, 16th–17th centuries. Width 9.5 cm, height 6 cm.

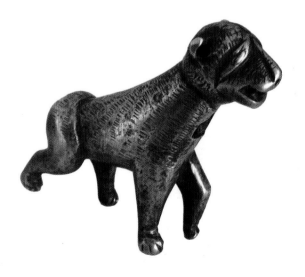

Lock 55. Brass lion with barbed-spring mechanism, 17th–18th centuries. Width 9.7 cm, height 7 cm.

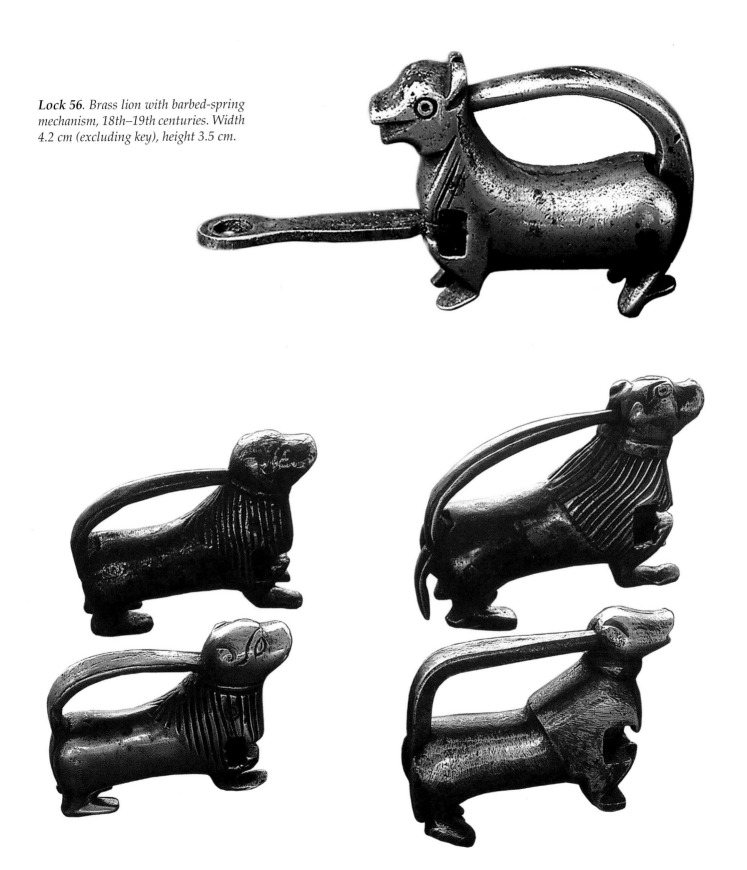

Lock 56. Brass lion with barbed-spring mechanism, 18th–19th centuries. Width 4.2 cm (excluding key), height 3.5 cm.

Locks 57–60. Brass lions with barbed-spring mechanisms, 18th–19th centuries.

Among the brass lion locks, No. 61 is the most peculiar. Made some time during the sixteenth to eighteenth centuries, it represents a warrior seated on a lion's neck carrying a shield in his right hand and, in his left, a lock which rests on the lion's head. A bird sits facing backward on the lion's tail. This unusual arrangement may well have some special significance. The lion-headed locks Nos. 62, 63 work on the bent-spring principle. Their moonlike faces are cleverly framed by manes which form the lock body. The cut-glass eyes of both still remain in place and a cut-glass mole, traditionally a sign of beauty in Iran, is found between the eyebrows of each.

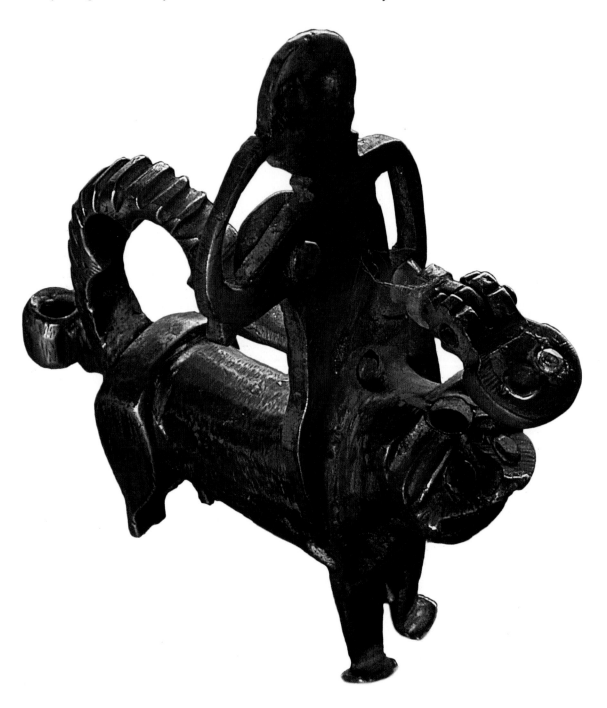

Lock 61. *Brass lion and man with barbed-spring mechanism, 16th–18th centuries. Width 6.5 cm, height 8.5 cm.*

Very different from the bronze and brass lions are the steel lions (Nos. 64–72). Their stance and shape remind one of the stone lions (Fig. 59) carved for the tombs of brave warriors in western and southern Iran (see Tanavoli, *Lion Rugs: The Lion in the Art and Culture of Iran*). As do the tombstone lions, these have a collar around the neck. On the basis of material and style these three starkly beautiful lion locks can be said to come from a later period than the bronze locks mentioned previously. The author proposes a date from the fourteenth to the fifteenth century for locks 64, 65 & 66.

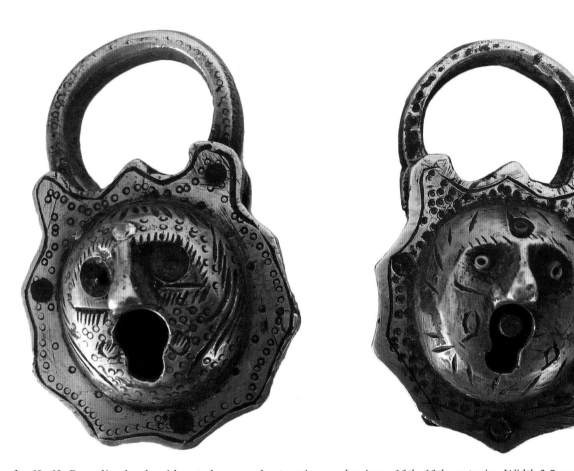

Locks 62, 63*. Brass lion heads with cut glass eyes, bent-spring mechanisms, 18th–19th centuries. Width 3.5 cm, height 6 cm.*

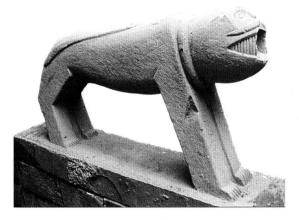

Fig. 59*. Tombstone lion, 18th century, 136 cm x 84 cm x 33 cm.*

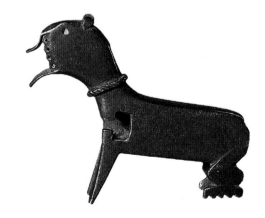

Lock 64*. Steel lion with barbed-spring mechanism, 15th–16th centuries. Width 10 cm, height 7 cm.*

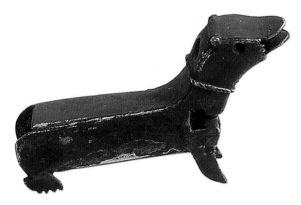

Lock 65. *Steel lion with barbed-spring mechanism, 15th–16th centuries. Width 8.5 cm, height 5 cm.*

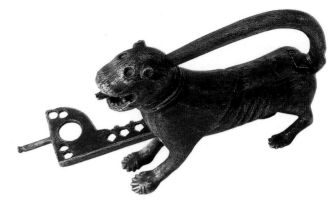

Lock 66. *Steel lion with barbed-spring mechanism, 16th century. Width 13 cm (including key), height 5.5 cm.*

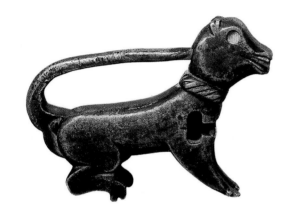

Lock 67. *Steel lion with barbed-spring mechanism, 17th century, Width 13 cm (including key), height 5.5 cm.*

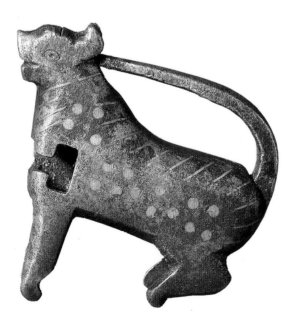

Lock 68. *Steel leopard with barbed-spring mechanism, 17th–18th centuries, Width 4.5 cm, height 4.5 cm.*

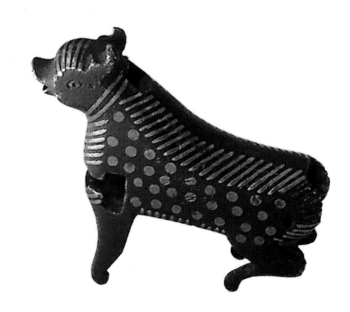

Lock 69. *Steel leopard with barbed-spring mechanism, 17th–18th centuries, Width 4.5 cm, height 3.8 cm.*

The last group of "lion" locks actually consists of leopard locks. Although their shape and their surface decoration is that of a leopard, among the locksmiths they are known as lion locks. This is also true in Iran with Lion Rugs. Many lion rugs resemble tigers or leopards, but their weavers generically call them lion rugs.

All of the locks mentioned above have barbed-spring mechanisms. Locks in the form of lions were also produced in India and China and later in Russia. In some instances these have strong resemblances to Iranian locks from the 17th to the 19th centuries. Given the great numbers in which bronze, brass and steel lion locks from this period turn up in Iran, an Iranian provenance for the pieces shown in this book can be assumed with a good degree of assurance.

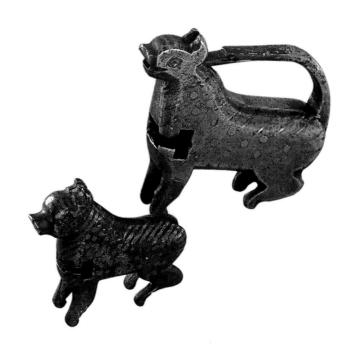

Locks 70, 71. Steel leopards with barbed-spring mechanisms, 17th–18th centuries.

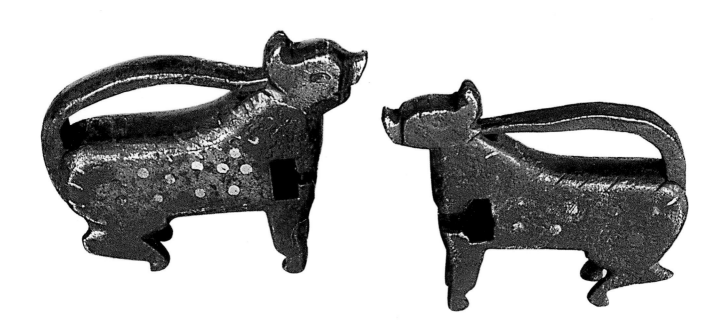

Locks 72, 73. Steel leopards with barbed-spring mechanisms, 17th–18th centuries.

Water Buffalo, Ox and Cow Locks

Date range: 8th–15th centuries; *Place of manufacture*: Azerbaijan and northern regions of Iran; *Material*: bronze; *Mechanism*: barbed-spring and bent-spring; *Size range*: (width) min. 4 cm, max 6.5 cm (height) min. 3 cm, max. 4.5 cm.

One of the oldest animal locks in this collection is lock No. 74, a water buffalo whose elaborate tail emerges from the locking piece and functions as the shackle. Possibly dating from the 8th to 10th centuries, this tiny piece conveys a feeling of massiveness and strength not quite captured by the later examples, most of which are missing their locking pieces. The water buffalo motif evidently fell out of use shortly after the fourteenth century and was never again used by the Iranian locksmith.

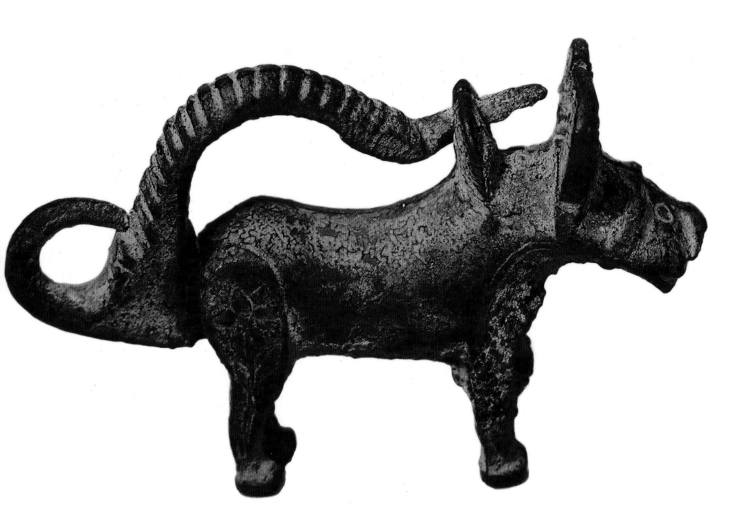

Lock 74. Bronze water buffalo with barbed-spring mechanism, 8th–10th centuries. Width 6.5 cm, height 4.5 cm.

Two other examples from later dates are Nos. 75 and 76. This animal itself is still found in Iran, most particularly in Azerbaijan Province, Khuzestan, and along the Caspian Sea in Gilan. Perhaps an ox is represented in No. 77 which is a smaller lock. Lock No. 78 is the only example of a cow-lock that has come to light.

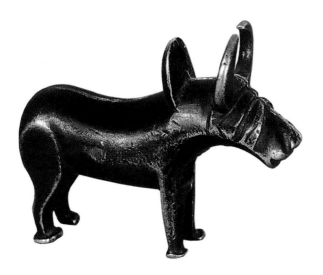

Lock 75. Bronze water buffalo with barbed-spring mechanism, 13th–14th centuries. Width 5 cm, height 4.5 cm.

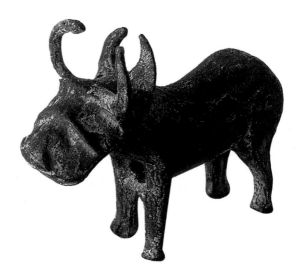

Lock 76. Bronze water buffalo with barbed-spring mechanism, 10th–12th centuries.Width 5 cm, height 4.5 cm.

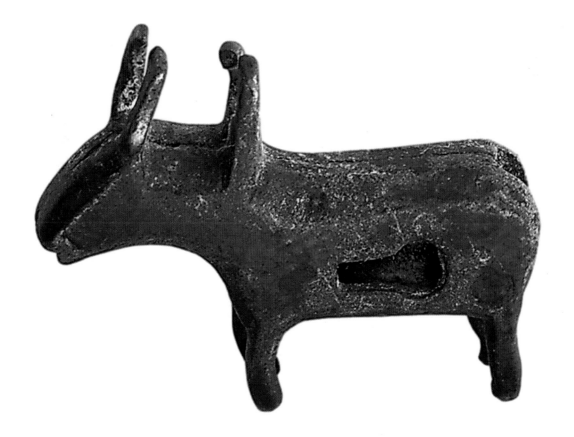

Lock 77. Bronze ox with bent-spring mechanism, 13th–14th centuries. Width 4 cm, height 3 cm.

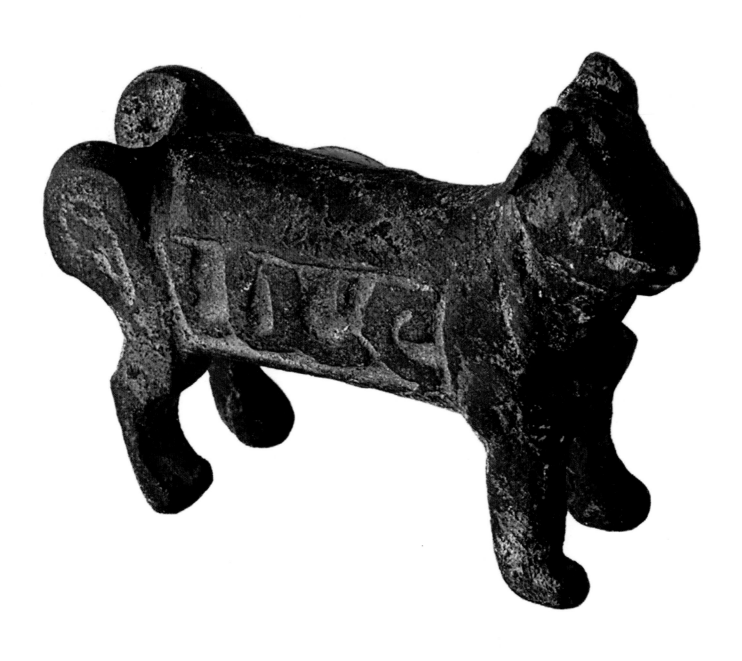

Lock 78. *Bronze cow with barbed-spring mechanism, 11th–13th centuries. Width 5 cm, height 4 cm.*

Goat, Sheep, Fawn, Rabbit and Camel Locks

Date range: 11th–18th centuries; *Place of manufacture*: all regions of Iran; *Materials*: bronze, steel, brass; *Mechanisms*: barbed-spring, bent-spring; *Size range*: (width) min. 4.5 cm, max. 7.5 cm (height) min. 3 cm, max. 5.5 cm.

Four early goats (Nos. 79–82) share the basic features of style, mechanism, and material common to the locks of the eleventh to thirteenth centuries. No. 79, however, is somewhat unusual in that it has a black patina instead of the usual green. The simplicity of its lines might mean that it is older than the others, perhaps even pre-Seljuk.

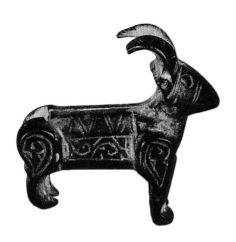

Lock 79. Bronze goat with barbed-spring mechanism, 11th–12th centuries. Width 4.5 cm, height 4.5 cm.

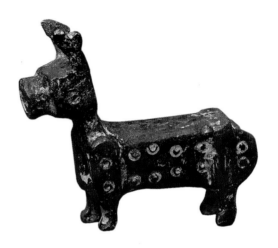

Lock 80. Bronze goat with barbed-spring mechanism, 12th–14th centuries. Width 5 cm, height 4 cm.

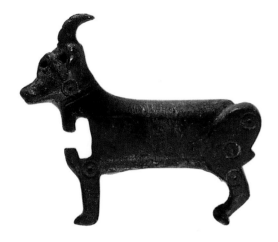

Lock 81. Bronze goat with barbed-spring mechanism, 12th–14th centuries. Width 5 cm, height 4.5 cm.

Lock 82. Bronze goat with barbed-spring mechanism, 12th–14th centuries. Width 4.5 cm, height 4 cm.

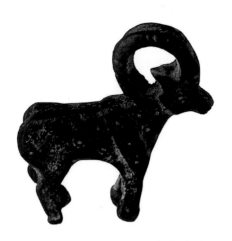

Lock 83. Bronze mountain goat with barbed-spring mechanism, 12th–14th centuries. Width 4.5 cm, height 4.5 cm.

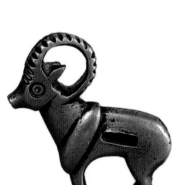

Lock 84. Brass mountain goat with bent-spring mechanism, 17th–18th centuries. Width 4 cm, height 4.5 cm.

Locks Nos. 83, 84 depict two mountain goats. No. 84 is unusually flat, yet with a functional mechanism. Similar figures are found in the art of ancient Iran, most particularly in that of the Achaemenians and Scythians, of which one is reminded by this small brass lock.

Lock No. 88 closely resembles the three brass goats (Nos. 85–87) of the same shape but with different material, ornamentation, and construction. They are doubtlessly from the same region and period. While most of the barbed-spring figural locks have a side shackle that fits into the back of the animal's neck or head, the three goats—one made of steel with inlaid brass dots (No. 88) and three made entirely of brass (Nos. 85–87), each have a side shackle that is inserted into the mouth of the animal's backward facing head. These three brasses are especially well finished. They were found in the cities of Zanjan and Qazvin, which are not far from each other. Their elegant simple design reminds one of figures on terra-cotta vessels from ancient sites in Iran such as Sialk and Amlash.

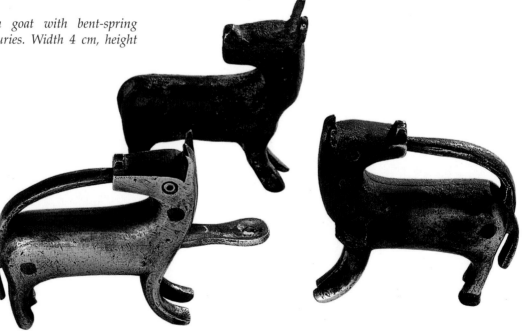

Locks 85–87. Brass mountain goats with barbed-spring mechanisms, 17th–18th centuries. Width 4 cm (excluding key), height 4 cm.

Lock No. 89, with no horns, is perhaps a sheep but it is hard to tell what kind of an animal No. 90 is, with an open mouth and void of any surface decoration.

The two faws are most likely from the twelfth to fourteenth centuries (Nos. 91, 92). The two rabbits (Nos. 93, 94) are also from the same period or perhaps a bit later.

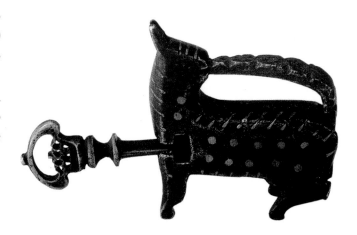

Lock 88. Steel goat with barbed-spring mechanism, 17th–18th centuries. Width 7 cm (including key), height 4 cm.

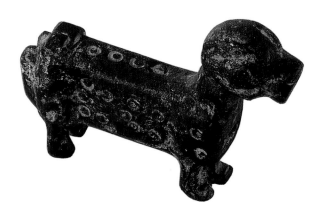

Lock 89. Bronze sheep (uncertain) with barbed-spring mechanism, 12th–14th centuries. Width 4.5 cm, height 3 cm.

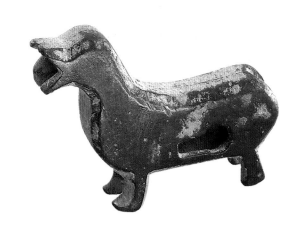

Lock 90. Bronze sheep (uncertain) with bent-spring mechanism, 12th–14th centuries. Width 4.5 cm, height 3.5 cm.

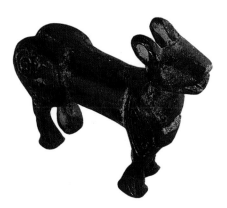

Lock 91. Bronze fawn with barbed-spring mechanism, 14th–15th centuries. Width 4 cm, height 3.5 cm.

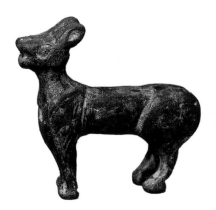

Lock 92. Bronze fawn with barbed-spring mechanism, 14th–15th centuries. Width 4 cm, height 3.5 cm.

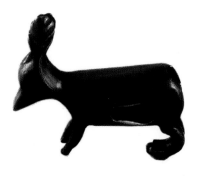

Lock 93. Bronze rabbit with bent-spring mechanism, 14th–15th centuries. Width 4 cm, height 3.5 cm.

Similar unifying features point to a common origin of ten steel goats and camels, with bent-spring mechanisms (Nos. 95–104). All are from the seventeenth to eighteenth centuries and were made in Esfahan and Shiraz. Although at first glance Nos. 95–104, look very similar, No. 104 is distinctly a camel with a longer muzzle and no horns, and with the shackle forming its hump.

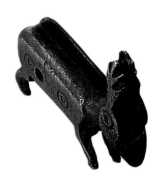

Lock 94. Bronze rabbit with bent-spring mechanism, 14th–15th centuries. Width 4 cm, height 3.5 cm.

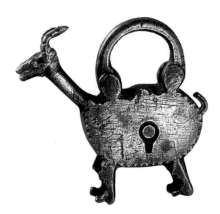

Lock 95. Steel goat with bent-spring mechanism, 17th–18th centuries. Width 6 cm, height 5 cm.

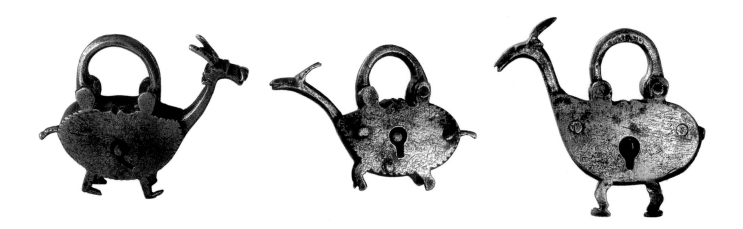

Lock 96. Steel goat with bent-spring mechanism, 17th–18th centuries. Width 6.3 cm, height 5 cm.

Lock 97. Steel goat with bent-spring mechanism, 17th–18th centuries. Width 6.5 cm, height 5.5 cm.

Lock 98. Steel goat with bent-spring mechanism, 17th–18th centuries. Width 8 cm, height 6.5 cm.

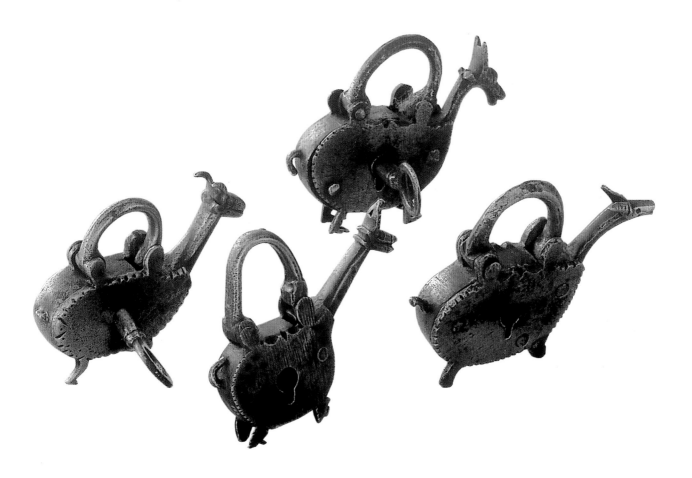

Locks 99–102. *Steel goats with bent-spring mechanism, 17th–18th centuries.*

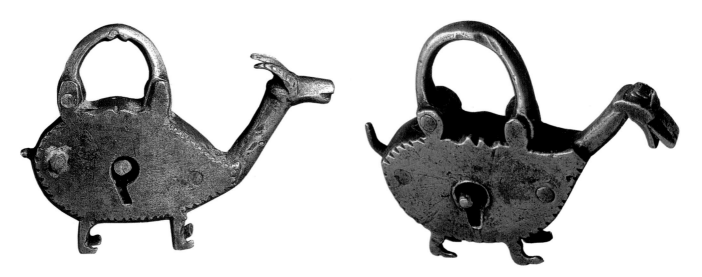

Lock 103. *Steel goat with bent-spring mechanism, 17th–18th centuries. Width 7.5 cm, height, 5.5 cm.*

Lock 104. *Steel camel with bent-spring mechanism, 17th–18th centuries. Width 7.5 cm, height, 5 cm.*

Bird Locks

Date range: 11th–19th centuries; *Place of manufacture*: *all regions of Iran*; *Materials*: *bronze, steel, silver, brass*; *Mechanisms*: *barbed-spring, helical-spring, bent-spring*; *Size range*: *(width) min. 2.5 cm, max. 10 cm, (height) min. 4 cm, max. 7.5 cm.*

This collection contains birds made of bronze, steel, silver, and brass. Typically, the oldest (Nos. 105–107) are bronze with barbed-spring mechanisms. The first two, from the eleventh to thirteenth centuries, have a sternness and severity of line that is transformed into a much softer, meeker quality in the latter locks, which are doubtless of later date.

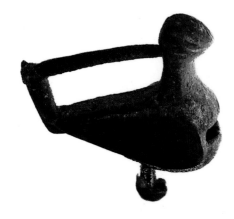

Lock 105. Bronze bird with barbed-spring mechanism, 11th–13th centuries. Width 4 cm, height 4 cm.

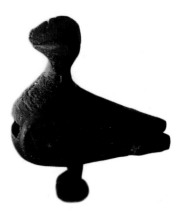

Lock 106. Bronze bird with barbed-spring mechanism, 11th–13th centuries. Width 4 cm, height 4.5 cm.

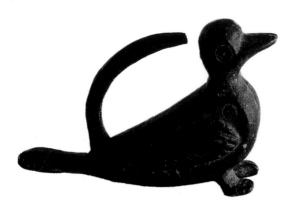

Lock 107. Bronze bird with barbed-spring mechanism, 12th–14th centuries. Width 5 cm, height 3.5 cm.

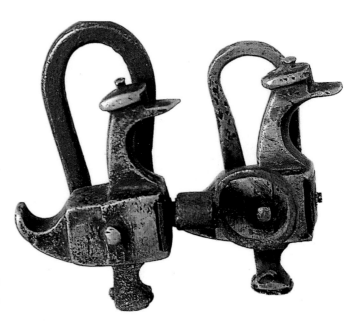

Locks 108, 109. (108, brass and steel, 109, brass) birds with helical-spring mechanisms, 15th–16th centuries. Width 2.5 cm, height 4.5 cm.

This collection also includes a pair of brass birds (Nos. 108, 109) each of which has a back shackle instead of the usual side or top one. The back shackle is attached at one end and rotates laterally to open and close. Both of these have helical-spring mechanisms.

Of much interest are the steel and silver birds of the sixteenth to nineteenth centuries (Nos. 111–132). Mostly made in Shiraz, they represent an important facet of the local tradition of lock-making in that city of famous poets, beautiful roses, cypress trees, and nightingales.

Two types are seen: one flattish with a single bent-spring mechanism (Nos. 124–132) and the other more modeled in appearance because of the wings covering the keyhole that controls the shackle (Nos. 111–122). The latter type is called *bolbol* (nightingale) by the people of Shiraz, where this favorite motif is found even on mosque and minaret tiles. In some of these locks, both wings open up; in others, only one opens.

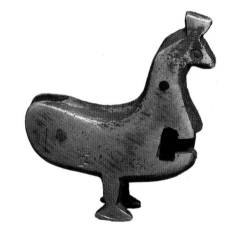

Lock 110. *Brass bird with barbed-spring mechanism, 18th century. Width 4 cm, height 4 cm.*

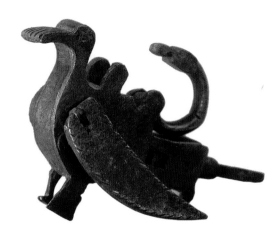

Lock 111. *Steel bird with multiple mechanisms, 17th–18th centuries. Width 10 cm, height 7.5 cm.*

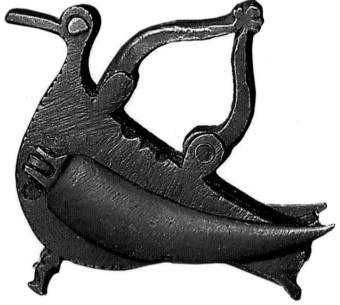

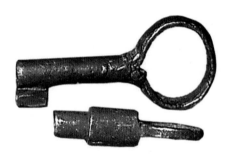

Lock 112. *Steel bird with multiple mechanisms, 17th–18th centuries. Width 9 cm, height 7.8 cm.*

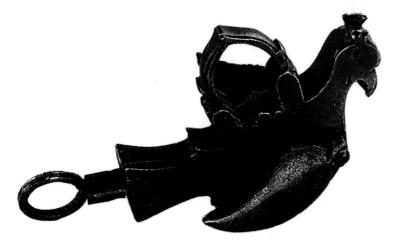

Lock 113. Steel bird with multiple mechanisms, 17th–18th centuries. Width 7.3 cm (including key), height 4 cm.

Locks 114, 115. Steel birds with multiple mechanisms, 17th–18th centuries.

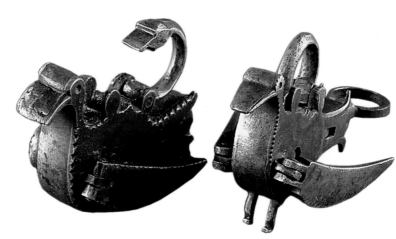

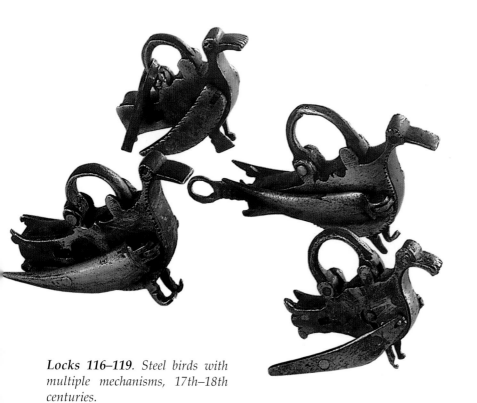

Locks 116–119. Steel birds with multiple mechanisms, 17th–18th centuries.

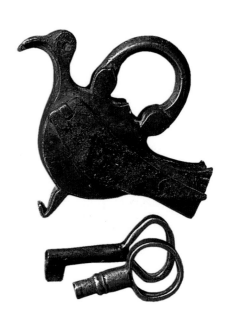

Lock 120. Steel bird with multiple-spring mechanisms, 17th–18th centuries. Width 7 cm, height 6.7 cm.

When the wing/wings is/are released by a key operating a helical-spring located in the bird's tail, a strong spring under the wing causes it to snap open as if the bird is about to take off in flight. Next, a second key of the pipe variety turns the bent-spring that secures the top shakle. Lock No. 124 is somewhat unusual in that its wings are an integral part of the body instead of being attached by hinges.

The last type of steel bird lock (Nos. 131, 132) has a body that closely resembles a dervish bowl (see p. 96, Locks 237–239).

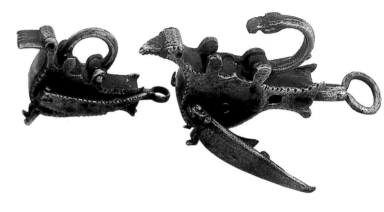

Locks 121, 122. Steel birds with multiple mechanisms, 17th–18th centuries.

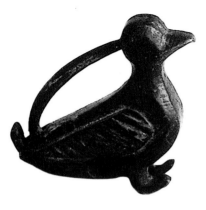

Lock 123. Bronze bird with barbed-spring machanism, 14th–15th centuries. Width 5cm, height 3.5 cm.

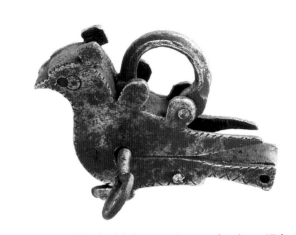

Lock 124. Steel bird with bent-spring mechanism, 17th–18th centuries. Width 8.6 cm, height 9 cm.

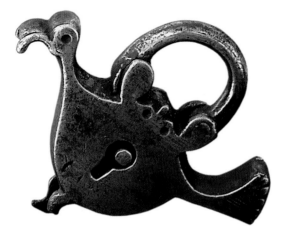

Lock 125. Steel bird with bent-spring mechanism, 17th–18th centuries. Width 4.5 cm, height 4 cm.

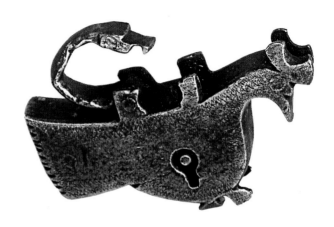

Lock 126. Steel bird with bent-spring mechanism, 17th–18th centuries. Width 4.5 cm, height 3.7 cm.

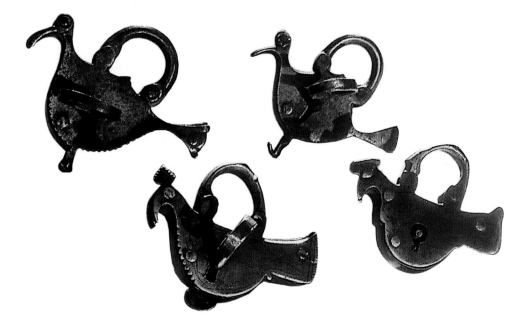

Locks 127–130. Steel birds with bent-spring mechanisms, 17th–18th centuries.

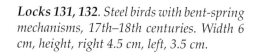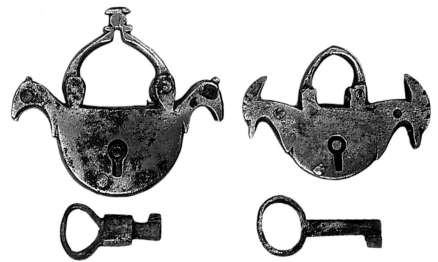

Locks 131, 132. Steel birds with bent-spring mechanisms, 17th–18th centuries. Width 6 cm, height, right 4.5 cm, left, 3.5 cm.

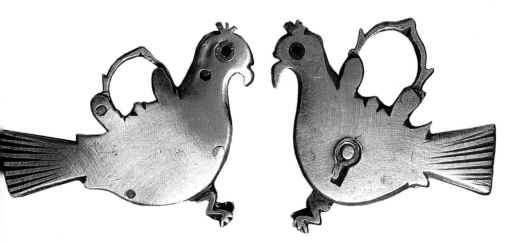

Locks 133, 134. Silver birds with bent-spring mechanisms, 17th–18th centuries. Width 5 cm, height 3.5 cm.

When made of silver, the flat type of figural bird lock mentioned previously often resembles a pigeon (Nos. 134–137). Some of these have legs and some do not, as is true of the nightingales. Locks 138, 139 represent a pair of two-headed eagles made of brass and steel. No. 138, has a rotating back shackle; the other has a top shackle. The two-headed eagle locks probably come from northern Azerbaijan, and are reminiscent of an imperial Russian coat of arms.

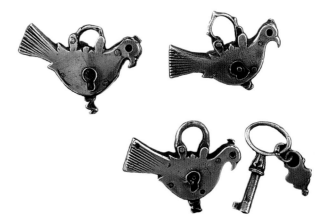

Locks 135–137. Silver birds with bent-spring mechanisms, 17th–18th centuries.

Lock 138. Brass eagle with helical-spring mechanism, 18th century. Width 2.5 cm, height 4.5 cm.

Lock 139. Brass and steel double-headed eagle with helical-spring mechanism, 19th century. Width 5 cm, height 7 cm.

Fish Locks

Date range: *8th–19th centuries;* ***Place of manufacture***: *northeastern, central, and southern Iran;* ***Materials***: *bronze, brass, steel;* ***Mechanisms***: *barbed-spring, bent-spring;* ***Size range***: *(width) min. 2 cm, max. 7 cm, (height) min. 3 cm, max. 5 cm.*

Between the fish-shaped bronze locks (Nos. 140, 141) and the later examples of the Islamic period, there is a large time gap. Beginning sometime in the seventeenth or eighteenth century, (mostly) horizontal fish forms were produced in brass and steel. The gap is somewhat recompensed by brass lock No. 142.

Lock 140. Bronze fish with barbed-spring mechanism, 8th–10 century. Width 9.5 cm, height 4 cm.

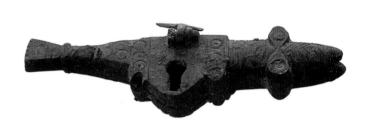

Lock 141. Bronze fish with barbed-spring mechanism, 8th–10 century. Width 9.5 cm, height 2.7 cm.

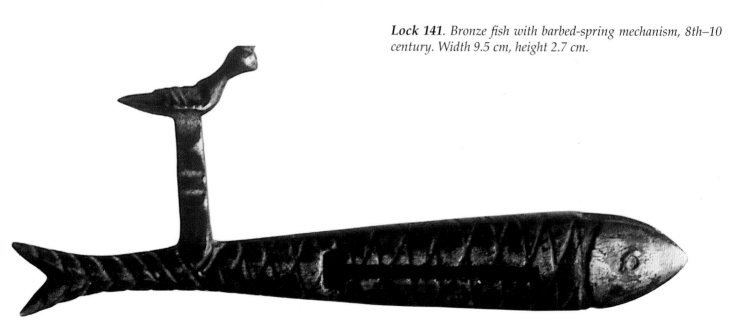

Lock 142. Brass fish with barbed-spring mechanism, 14th–15th century. Width 8.7 cm, height 4 cm.

Lock No. 143 is different from all the rest because it has a brass body, while the locking piece and shackle are steel, and its mechanism works on the barbed-spring principle, while Nos. 144 and 145 work on the bent-spring principle. All three are more naturalistic than the others. Of these, steel was the metal most commonly used by the locksmith. The steel fish locks are flat and thin and have bent-spring mechanisms. Surface ornamentation is minimum in these locks with some engraved designs (Nos. 146–153).

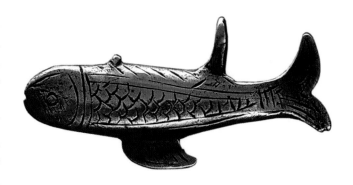

Lock 143. Brass and steel fish with barbed-spring mechanism, 18th–19th century. Width 6 cm, height 3 cm.

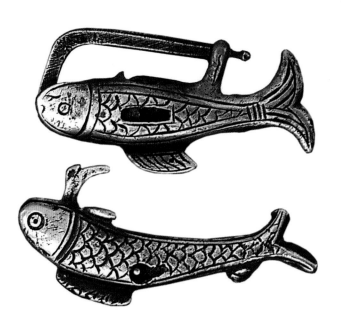

Locks 144, 145. Brass fish with bent-spring mechanisms, 18th–19th century.

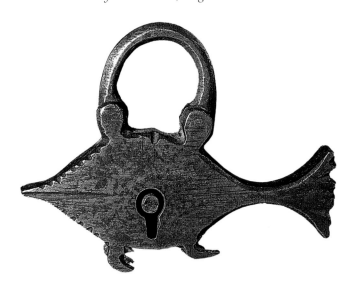

Lock 146. Steel fish with bent-spring mechanism, 17th–18th century. Width 5.5 cm, height 4.5 cm.

Lock 147. Brass fish with bent-spring mechanism, 17th–18th century. Width 6 cm, height 3 cm.

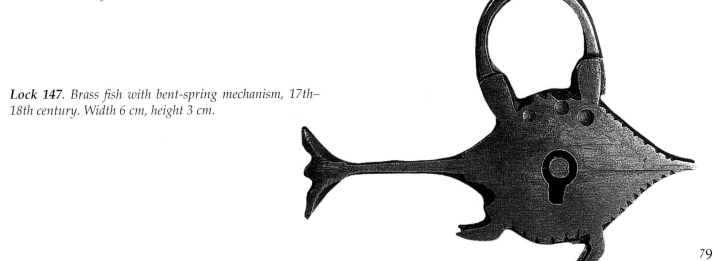

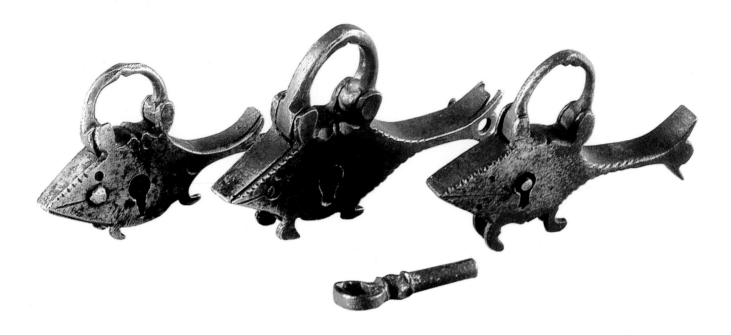

Locks 148–150. Brass fish with bent-spring mechanisms, 17th–18th century.

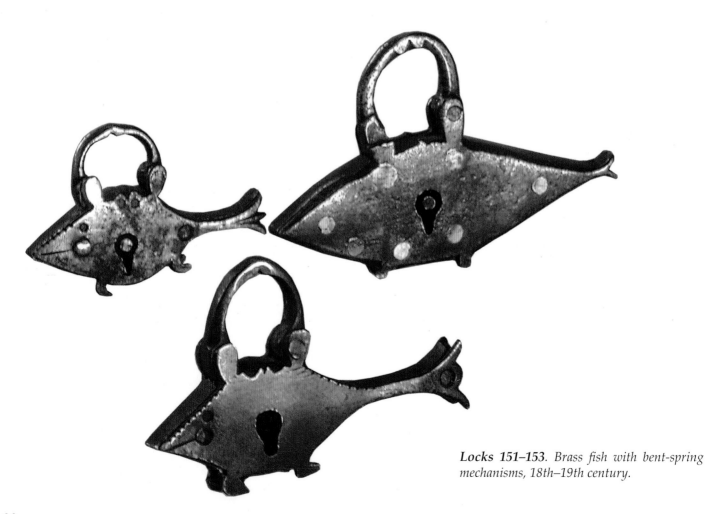

Locks 151–153. Brass fish with bent-spring mechanisms, 18th–19th century.

Brass Figural Locks

Date range: 16th–19th centuries; *Place of manufacture*: (probably) eastern Iran; *Material*: brass; *Mechanisms*: shackle-spring, notched-shackle; *Size range*: (width) min. 2 cm, max. 5 cm, (height) min. 3 cm, max. 7 cm.

Among the figural locks in this collection few are more interesting than the small group called here "brass figural" for want of a better term. Two types can be distinguished: one flat and very thin with a shackle-spring mechanism (Nos. 154–158), the other more three-dimensional and with a notched-shackle (Nos. 160–163)

In both types the lock body and the shackle were sand cast, each as a separate, one-piece component. The lock bodies of both types were engraved after the casting process. Other than their having been found in Iran, there does not seem to be any significant connection between these two types.

The shackle-spring group has three similarly shaped figures: a lion, a lion with a human face and beard, and a lion head and forequarters with a body that tapers into a fish tail. The other two in that group consist of a bird with a female face and a male figure clothed in a coat and knee britches.

The author knows of four published pieces of the same type as the shackle-spring group. One, a man riding a horse whose hindquarters are in the form of a fish tail, appears in *Locks and Keys throughout the Ages* by Vincent J.M. Eras (reprinted in 2019 by Artisan ideas, lock 50, page 50), where it is called a Hindu padlock. The horse's fishtail is decorated with the same kind of incised marks seen in locks Nos. 154 and 155.

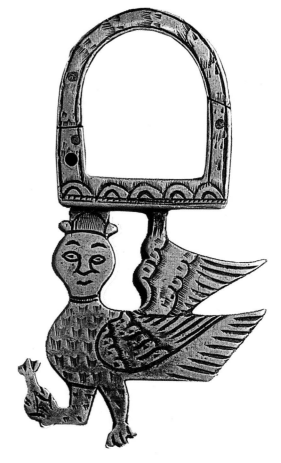

Lock 155. Brass bird with human head with shackle-spring mechanism, 16th–17th century. Width 4 cm, height 6 cm.

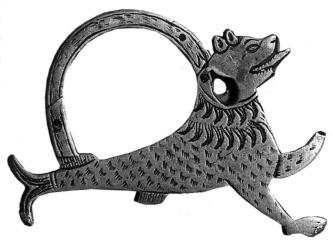

Lock 154. Brass half-lion and half-fish with shackle-spring mechanism, 16th–17th century. Width 5.5 cm, height 5 cm.

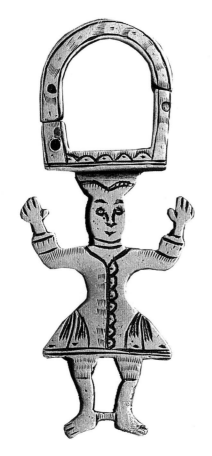

Another brass figural lock with a shackle-spring appears in Pankofer's *Schlussel und Schloss* (pp. 38, 39), in the form of an eagle. Pankofer calls it merely "Oriental." The third published lock is a lion and the fourth is a centaur shooting a bow and arrow. Both are illustrated in *Du Khorassan au pays des Backhtiaris: Trois mois de voyage en Perse* (Vol. II, photos following p. 88), by Henry René d'Allemange, who evidently bought them in Iran while traveling there. He calls them eighteenth to nineteenth century Iranian. In addition to these four published locks there is an unpublished lock in the Ethnological Museum in Tehran that is very like No. 155. Given the similarity of style, workmanship, and quality of engraving as well as the identical materials, mechanisms, and construction that all the above cited locks seem to have, there can be little doubt that they were all part of one tradition of lock-making.

Lock 156. Brass standing man with shackle-spring mechanism, 16th–17th century. Width 3 cm, height 7 cm.

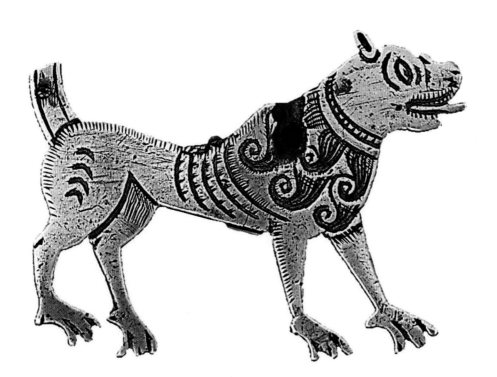

Lock 157. Brass lion with shackle-spring mechanism, 16th–17th century. Width 4.5 cm, height 4 cm.

In assessing the available evidence concerning provenance and dating, the first thing that comes to mind is the fact that most of these were found in Iran. The frequency with which many of the motifs of these locks turn up in the art of Iran, especially that of the eleventh century onwards, would also suggest an Iranian origin, and a rather early one at that. This is particularly true of the human-headed bird (harpy) and quadruped (sphinx) which, according to Eva Baer (*Sphinxes and Harpies in Medieval Islamic Art*, p. 81), enjoyed considerable popularity for about two hundred years until the middle of the thirteenth century when new fashions attending the establishment of Mongol power in western Asia came into being.

Fig. 60. Kaykavoos (or Kay Kāvus), mythological figure, 19th century.

Fig. 61. Lion, astrological sign of Leo, 17th century.

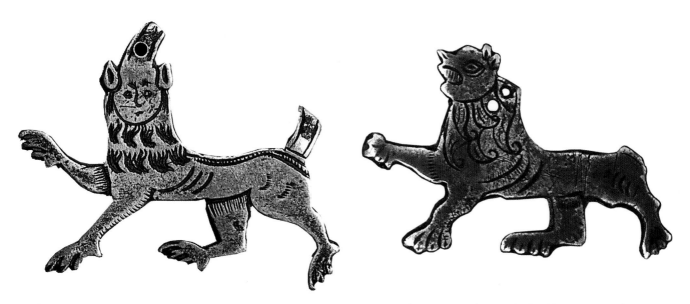

Lock 158. Brass lion with shackle-spring mechanism, 16th–17th century. Width 5.2 cm, height 3.5 cm.

Lock 159. Brass lion with shackle-spring mechanism, 16th–17th century. Width 5 cm, height 3.5 cm.

The human-headed bird was also an astrological symbol, representing Gemini, a sign of the zodiac (Baer, pp. 69–75). Also current at that time in the Islamic world, including Iran, were the representations of Sagittarius and Cetus (the whale), two constellations, as a centaur shooting a bow and arrow (cf. the D'Allemagne lock cited previously), and a creature with the scaled body of a fish and the torso, forelegs, and head of a quadruped (cf. lock 155; see p. 81) respectively (see Atil, *Art of the Arab World*, pp. 58, 59).

The brass figural locks made in these shapes are probably to be dated in the mid-eleventh to thirteenth centuries. This must also be true of those of other shapes, which are doubtless of the same period and place of manufacture, most likely eastern Iran.

The four brass figural locks with a notched-shackle (Nos. 160–163) are much more recent. They were probably made in the eighteenth or nineteenth centuries. D'Allemange illustrates (in his book, photo following p. 88) a lock in the form of a female head that is virtually identical to locks 161–163 of the Tanavoli collection.

Lock 160. Brass grapes with notched-shackle mechanism, 18th–19th century. Width 2 cm, height 3.5 cm.

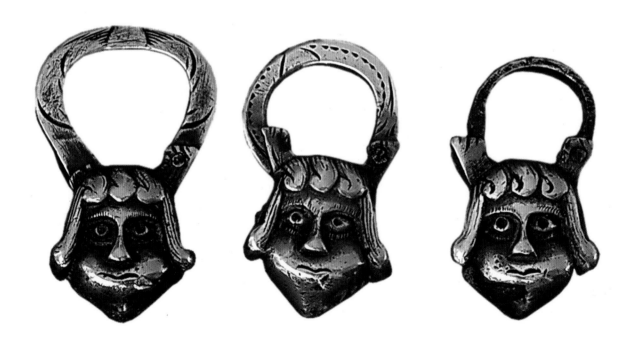

Locks 161–163. Three brass human heads with notched-shackle mechanisms, 18th–19th century. Width 2 cm, height 3.5 cm.

Semi-Figural Locks

A small group of locks do not fall either into the figural locks, or into the geometric or none figural groups, yet they possess the characteristics of both groups.

Through the existing examples in this collection, one could find several samples of such locks and the attempts of locksmiths to combine the two groups in different ways (for example see Nos. 241, 315, 323, 324). However, in this section, we are only showing a few distinguished examples which represent the features of both groups thoroughly (Nos. 164–168).

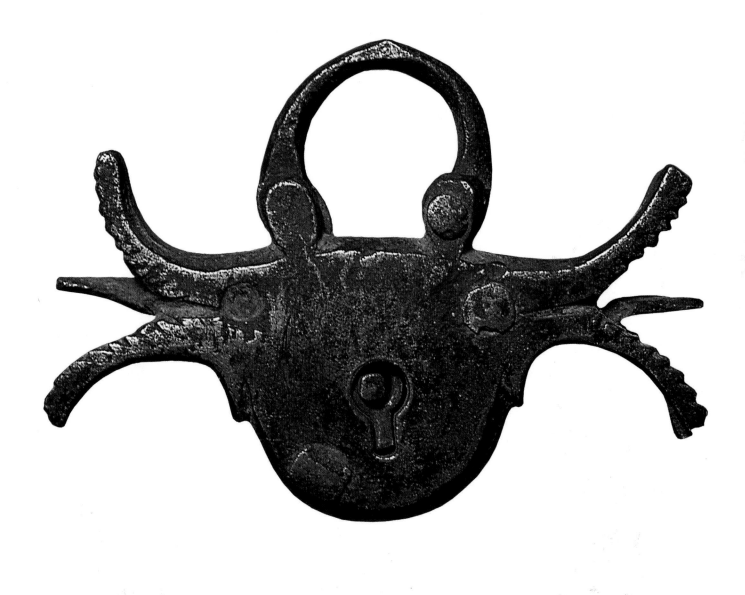

Lock 164. Steel two-headed dragon with bent-spring mechanism, 18th–19th century. Width 6.5 cm, height 4.5 cm.

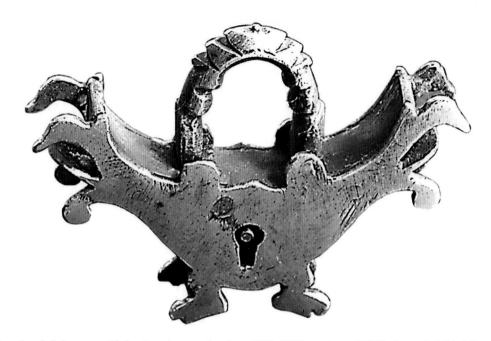

Lock 165. *Steel two-headed dragon with bent-spring mechanism, 18th–19th century. Width 6 cm, height 4.3 cm.*

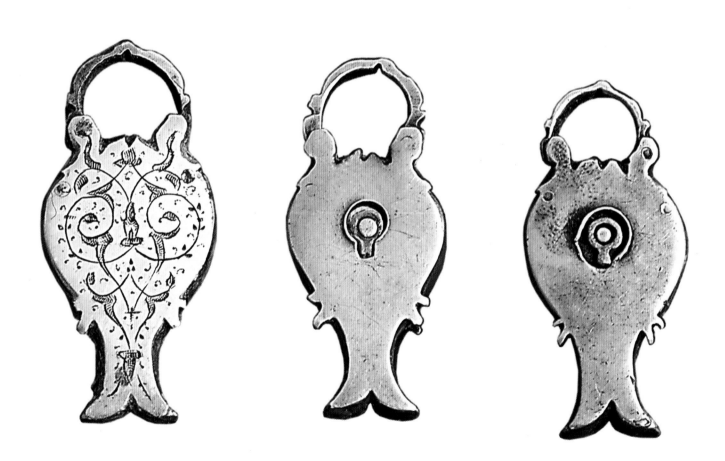

Locks 166–168. *Three silver fish with bent-spring mechanisms, 18th century. Width (left) 2 cm, height 6 cm.*

Non-Figural Locks

Compared to the figural locks in the Tanavoli collection, the non-figural examples from the Islamic period are generally of much more recent manufacture. Indeed, there are only a few non-figural locks in this collection that can be dated as early as the eighth to eleventh centuries (Nos. 11–15). Why this should be the case is somewhat mystifying.

Many non-figural locks have shapes that closely resemble objects which were once a part of daily life in Iran, or that come from nature. The size range in these locks is much greater than in the figural ones. A number of them were made for large doors, gates, and so forth, as well as for small containers and for religious purposes. One of the reasons for their abundance as compared to figural locks may in fact have to do with certain religious practices in which the non-figural lock played a traditional role—making vows. The major growth and expansion of these religious practices goes back primarily to the early sixteenth century when Iran, then ruled by the Safavid dynasty, underwent a religious transformation that saw the establishment of Twelver Shi'ism as the official religion of that state.

Unlike the figural locks, the non-figural variety is made mostly of steel, with a smaller percentage of brass and silver. Bronze pieces are rare. No single mechanism predominates; the various sorts of helical-, bent-, and barbed-spring mechanisms are widespread. Quite often each region or, in some cases, a city developed its own distinctive style, though some types are found all over Iran.

The names used below are ones customarily heard in Iran itself, except in those few cases where no specific lock names are used. In the descriptions that follow, the non-figural lock types are discussed in an order determined by the age of the oldest example of each group.

Cradle

Date range: 15th–18th centuries; **Place of manufacture**: central Iran (?); **Material**: steel; **Mechanism**: barbed-spring; **Size range**: (width) min. 4.5 cm, max. 10.5 cm, (height) min. 5 cm, max. 8.5 cm.

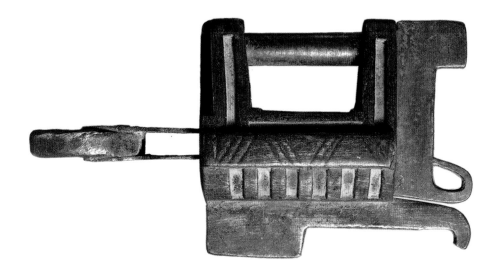

Lock 169. Steel cradle with barbed-spring mechanism, 15th–16th centuries. Width 10.5 cm (excluding key), height 8.5 cm.

The locks in this group, which resemble a type of cradle commonly used in Iran in the past, are among the oldest non-figural locks of the Islamic period in this collection. Two of them have wide grooves which remind one of wooden slats. No. 170 has small, cylindrical holes punched in it and a surface decoration of dots surrounded by circles reminiscent of ornamentation seen on some of the eleventh to thirteenth century figural locks.

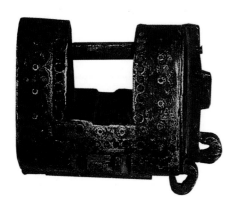

Lock 170. Steel cradle with barbed-spring mechanism, 16th–17th centuries. Width 10.5 cm, height 8 cm.

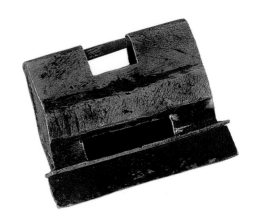

Lock 171. Steel cradle with barbed-spring mechanism, 17th–18th centuries. Width 4.5 cm, height 5.5 cm.

Suitcase

Date range: 16th–19th centuries; *Place of manufacture*: central Iran; *Materials*: steel, brass; *Mechanisms*: helical-spring, bent-spring; *Size range*: (width) min. 3 cm, max. 6.5 cm (height) min. 4 cm, max. 6.5 cm.

The type that is called "suitcase lock" in Iran ranges from narrow to wide and often has guard-like projections at the corners. One of the oldest, No. 172 (sixteenth to seventeenth centuries), is covered on the front by a brass plate with circles cut out of it. Three false keyholes are seen in No. 174 and a border of lightly engraved zigzag lines adorns No. 175.

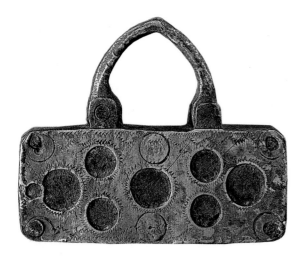

Lock 172. Steel and brass suitcase with helical-spring mechanism, 16th–17th centuries. Width 6.5 cm, height 5 cm.

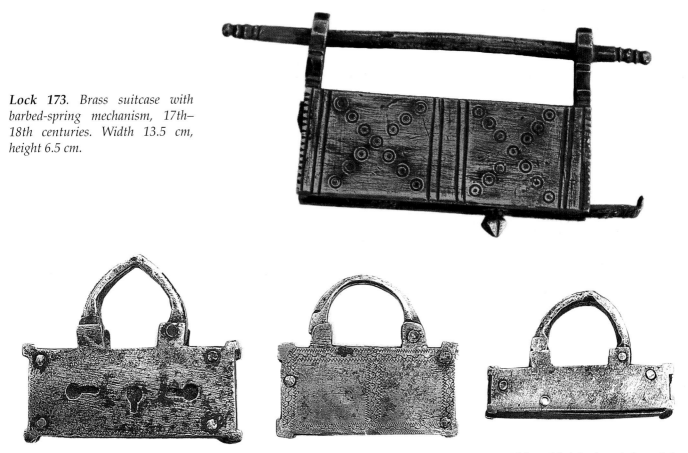

Lock 173. Brass suitcase with barbed-spring mechanism, 17th–18th centuries. Width 13.5 cm, height 6.5 cm.

Locks 174–176. Three steel suitcases with helical-spring mechanisms, 17th–18th centuries. Width and height from left to right, 5.8 x 5.1 cm, 6.7 x 5.8 cm, 6.2 x 3.8 cm.

Chest

Date range: *17th–19th centuries;* **Place of manufacture**: *central and western Iran;* **Material**: *steel;* **Mechanism**: *helical-spring;* **Size range**: *(width) min. 5 mm, max. 10 cm, (height) min. 5 mm, max. 14 cm.*

These were made in various towns of central and western Iran primarily for large boxes and chests. They have lock bodies that are roughly three-quarters of a cylinder. Comb-like ridges or teeth have been added to the bodies of a group of these locks. Very large locks of this type were also produced, as is apparent from an eighteenth or nineteenth century lock in the Ethnological Museum in Tehran (p. 91 Fig. 62). The lock was used on the main door of Iran's first bank, the Imperial Bank, in Tehran, founded in 1889.

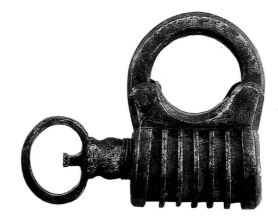

Lock 177. Steel chest lock with helical- spring mechanism, 18th–19th centuries. Width 17 cm (including key), height 14 cm.

The bodies of another group of these locks are plain and lack the comb-like ridges (No. 187). The third group has one or two grooves in the middle of their bodies (Nos. 188–191). A pair of the smallest locks in the collection can fit inside a pistachio nut shell (Nos. 196, 197). Reminiscent of Mowlana Ostad Nuri Qoflgar (master locksmith of the 16th century) who was so outstanding that he made twelve locks of steel, each one of which could fit inside the shell of a pistachio nut. There was a key for each of these locks (See p. 91).

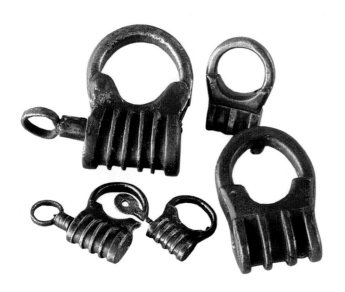

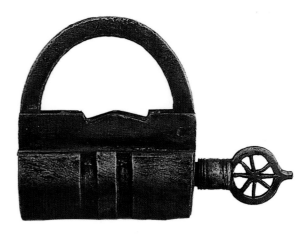

Lock 186. Steel chest lock with helical-spring mechanism, 18th–19th centuries. Width 17.5 cm (including key), height 13 cm.

Locks 178–182. Five steel chest locks with helical-spring mechanisms, 18th–19th centuries.

Locks 183–185. Three steel chest locks with helical-spring mechanisms, 18th–19th centuries.

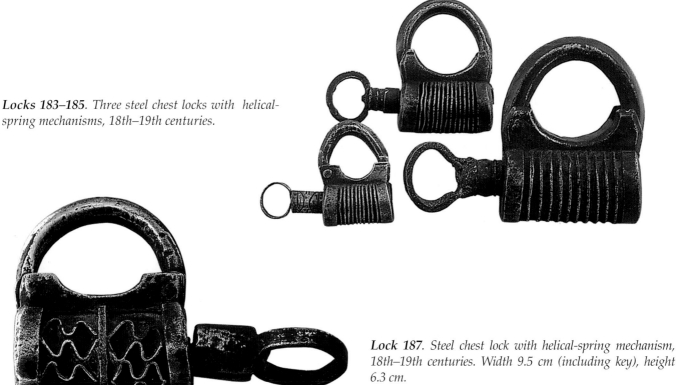

Lock 187. Steel chest lock with helical-spring mechanism, 18th–19th centuries. Width 9.5 cm (including key), height 6.3 cm.

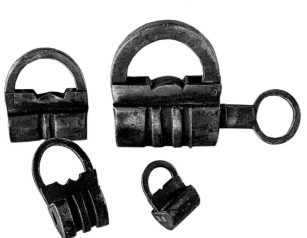

Locks 188–191. *Four steel chest locks with helical-spring mechanisms, 18th–19th centuries.*

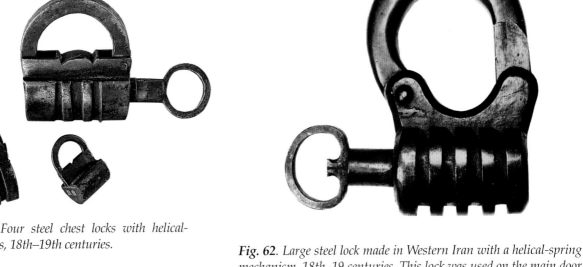

Fig. 62. *Large steel lock made in Western Iran with a helical-spring mechanism, 18th–19 centuries. This lock was used on the main door of Iran's first bank, the Imperial Bank in Tehran, founded in 1889.*

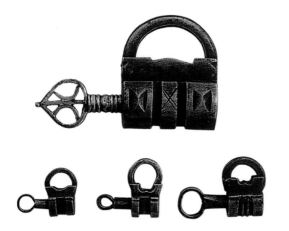

Locks 192–195. *Four steel chest locks with helical-spring mechanisms, 18th–19th centuries.*

Actual size

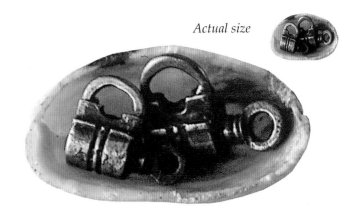

Locks 196, 197. *Two steel chest locks inside of a pistachio nut shell, with helical-spring mechanisms, 17th century, width 5mm, height 7 mm.*

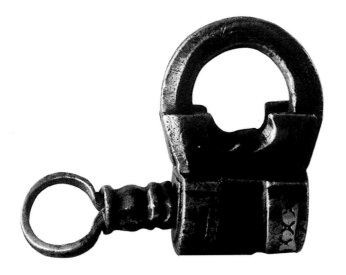

Lock 198. *Steel chest lock with helical-spring mechanism, 18th–19th centuries. Width 3.3 cm (including key), height 3 cm.*

Handbag

Date range: *18th–20th centuries;* ***Place of manufacture***: *central Iran;* ***Material***: *steel;* ***Mechanisms***: *helical-spring, bent-spring;* ***Size range***: *(width) min. 2 cm, max. 5.5 cm (height) min. 3 cm, max. 8.5 cm.*

There are three types of "handbag locks" in this collection. The first type is the covered-keyhole variety (Nos. 199–204). Most of these have hinged keyhole covers on the front and back, and extra keyholes on the bottom. They have doors that open on the front face from the top. These extra features are to confuse the would-be thief. The second type of "handbag lock" is rectangular or squarish (Nos. 205–210). The last type has a side key (Nos. 211–215). The lock body of No. 211 is decorated with a pierced wheel plaque and the lock body of No. 215 with a soldered embossed brass lion.

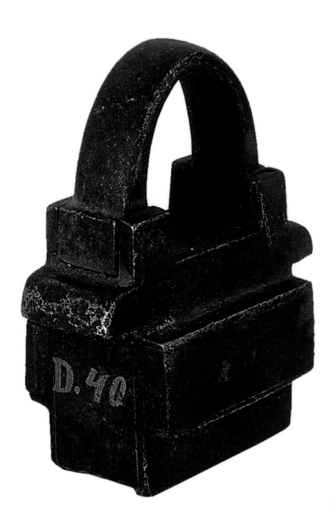

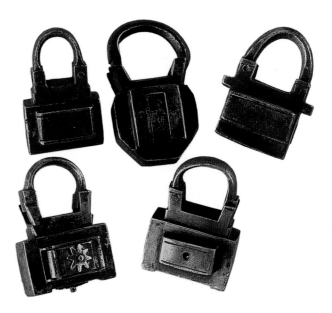

Locks 200–204. Five steel handbag locks with bent-spring mechanisms, 19th–20th centuries.

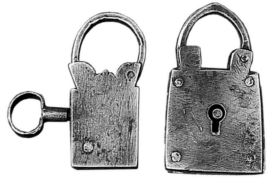

Lock 199. Steel handbag lock with bent-spring mechanism, 19th–20th centuries. Width 4.5 cm, height 6.5 cm.

Locks 205, 206. Two steel handbag locks, (left) with helical-spring mechanism, (right) with bent-spring mechanism, 19th–20th centuries., (left) width 6.5 cm (including key), height 6 cm, (right) width 4.2, height 6 cm.

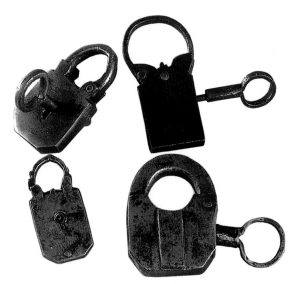

Locks 207–210. *Four steel handbag locks, (left) with bent-spring mechanisms, (right) with helical-spring-mechanisms, 19th–20th centuries.*

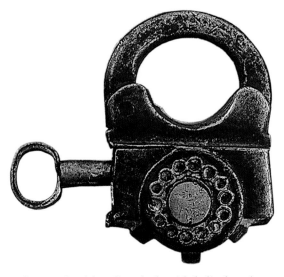

Lock 211. *Steel handbag lock with helical-spring mechanism, 18th–19th centuries. Width 9 cm (including key), height 6.5 cm.*

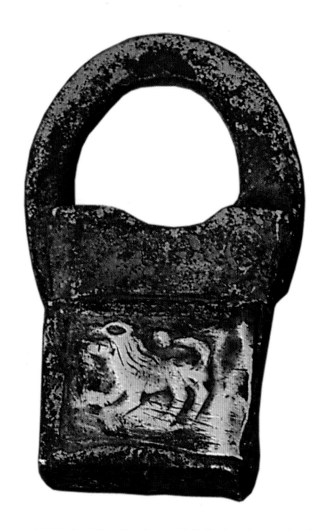

Lock 215. *Steel handbag lock with helical-spring mechanism, 18th–19th centuries. Width 2.5 cm, height 4 cm.*

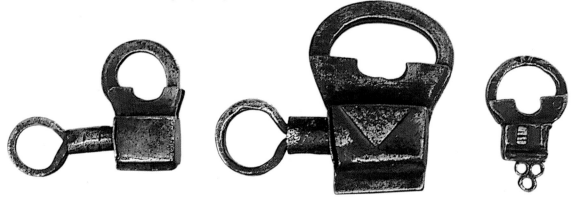

Locks 212–214. *Three steel handbag locks with helical-spring mechanisms, 18th–19th centuries.*

93

Kettle

Date range: 18th–20th centuries; **Place of manufacture**: Hamadan and central Iran; **Material**: steel; **Mechanisms**: notched-shackle and revolving disks, helical-spring; **Size range**: (width) min. 2.5 cm, max. 9 cm (height) min. 4 cm, max. 12.5 cm.

Some of these have notched-shackle and revolving-disk mechanisms. No. 217 resembles a large kettle and is the biggest and heaviest of all the locks of this group. Similar locks were also made in Russia in the past, and it's not known whether this type first originated there, in Iran, or elsewhere. The Russian-made "kettle" locks are usually signed and sometimes carry dates.

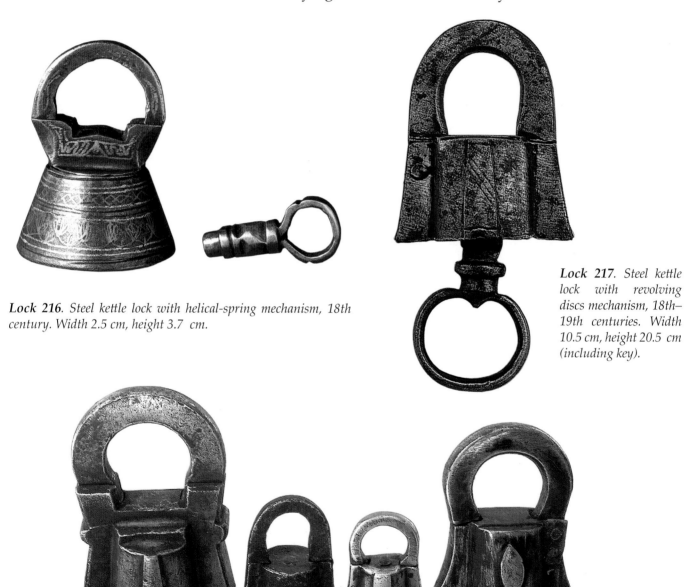

Lock 216. Steel kettle lock with helical-spring mechanism, 18th century. Width 2.5 cm, height 3.7 cm.

Lock 217. Steel kettle lock with revolving discs mechanism, 18th–19th centuries. Width 10.5 cm, height 20.5 cm (including key).

Locks 218–221. Three steel kettle locks and one brass kettle with revolving-discs mechanisms, 18th–19th centuries.

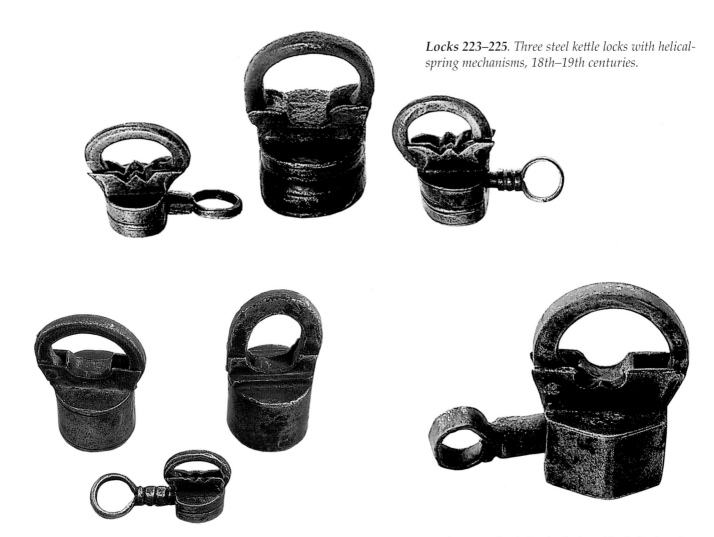

Locks 223–225. Three steel kettle locks with helical-spring mechanisms, 18th–19th centuries.

Locks 226–228. Three steel kettle locks (the two on top) with revolving-discs mechanisms, (the one below) with helical-spring mechanism, 18th–19th centuries.

Lock 222. Steel kettle lock with helical-spring mechanism, 18th–19th centuries. Width 6 cm (including key), height 5 cm.

Dervish Bowl

Date range: 17th–19th centuries; *Place of manufacture*: Esfahan and Shiraz; *Materials*: steel, brass; *Mechanisms*: bent-spring, shackle-spring; *Size range*: (width) min. 4 cm, max. 8 cm (height) min. 3 cm, max. 7.5 cm.

"Dervish" is originally a Persian word which has entered the English language through the Turkish usage. In the most favorable context, the term signifies someone whose main goal in life is preparation for, and attainment of, a mystical union with the Divine. Traditionally, dervishes came from all classes of society, and were usually associated with a religious order. Some, however, lived a mendicant way of life and wandered far and wide in quest of spiritual guidance and knowledge, or at times in pursuit of more worldly ends. One of the chief symbols of the dervish was his bowl, which served a variety of purposes, especially when he was without a fixed abode.

Closely resembling the shape of the typical dervish bowl are Nos. 229–236. They range in shape from a crescent to a half moon. Nos. 237–239 are exceptional; they are so narrow that they are almost like rings. All but two of these are made of steel, and come mainly from Esfahan and Shiraz.

Locks 229, 230. *Two steel dervish bowl locks with bent-spring mechanisms, 17th–18th centuries. Width (left) 6 cm, height 5.4 cm, (right) width 4.3 cm, height 6 cm.*

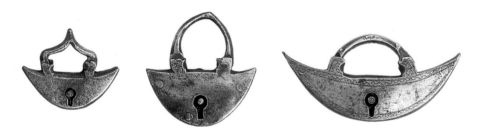

Locks 231–233. *Three steel dervish bowl locks with bent-spring mechanisms, 17th–18th centuries.*

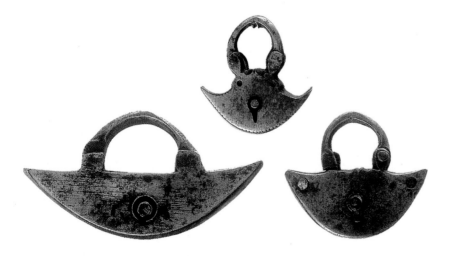

Locks 237–239. *Two steel and one brass dervish bowl locks with shackle-spring mechanisms, 18th century. Width 4.5 cm, height 3.5 cm.*

Locks 234–236. *Three steel dervish bowl locks with bent-spring mechanisms, 17th–18th centuries*

Azerbaijan

Date range: 14th–17th centuries; *Place of manufacture*: Western Azerbaijan; *Material*: steel; *Mechanism*: barbed-spring; *Size range*: (width) min. 25.5 cm, max. 30.5 cm (height) min. 9 cm, max. 14 cm.

One of the oldest locks in this collection of the type called Azerbaijan, after the large province in northwestern Iran where they were found, is pre-Islamic (p. 43, No. 8), and was discussed in the section on locks of that era. Also in this group is No. 240, a barbed-spring lock of such weight and strength that it must have been meant for a very large door or gate. It's decorated on the surface with punch marks and its pipe body is reinforced by rings which add to the attractiveness of the piece. The other example of this older group (No. 241) is ornamented with and strengthened by double rings around its pipe-shaped body. The key to this lock is made like a human face and the shackle is reminiscent of a man's arm. Although all three locks were found in Tabriz (the center city of the Western Azerbaijan province), their place of manufacture is not known.

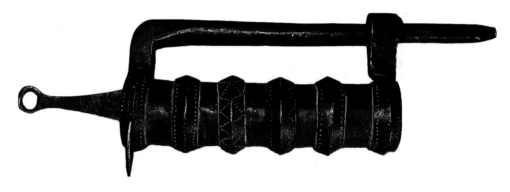

Lock 240. Steel Azerbaijan lock with barbed-spring mechanism, 15th–16th centuries. Width 40 cm, height 15 cm.

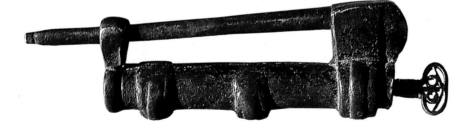

Lock 241. Steel Azerbaijan lock with barbed-spring mechanism, 14th–15th centuries. Width 25.5 cm, height 8 cm.

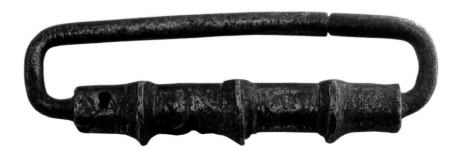

Lock 242. Steel Azerbaijan lock with barbed-spring mechanism, 15th–16th centuries. Width 18.8 cm, height 4.7 cm.

Ardabil

Date range: 19th–20th centuries; *Place of manufacture*: Ardabil; *Material*: steel; *Mechanisms*: multiple-mechanism; *Size range*: (width) min. 13 cm, max. 27 cm (height) min. 7.5 cm, max. 27 cm.

Ardabil in northeastern Azerbaijan is where Shaykh Safi al-Din, the founder of the Safavid Sufi order, and his descendant Shah Isma'il, the first of the Safavid shahs, are buried. Its population, like that of the province of Azerbaijan in general, is primarily Turkish speaking. The locks made in Ardabil in the nineteenth and twentieth centuries are usually recognizable by their pipe-shaped bodies and one or more tubular extensions coming out of them at right angles. The former house the main barbed-spring mechanism that controls the top shackle, and the latter either prevent the push key from entering the central shaft, or the engaged locking piece from being removed. Helical-springs are found in these smaller pipe-shaped locks (p. 32, Fig. 50, 50a). As is true of the other locks with multiple keys and mechanisms, these were most often meant for use by several persons who had an equal share or interest in the locked object, usually a money box or a shop.

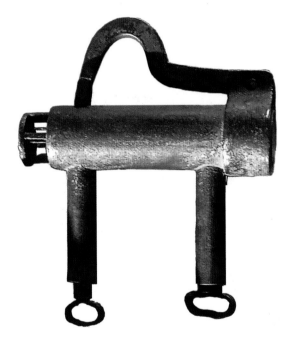

Lock 243. Steel Ardabil lock with multiple-mechanisms, 19th century. Width 17 cm, height 21 cm (including key).

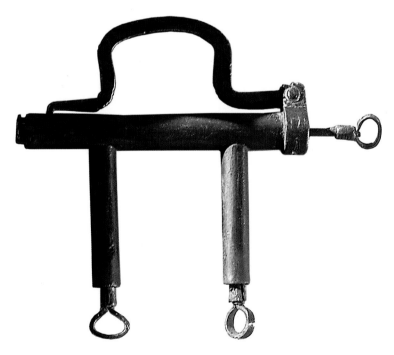

Lock 244. Steel Ardabil lock with multiple-mechanisms, 19th century. Width 22.5 cm, height 27 cm (including key).

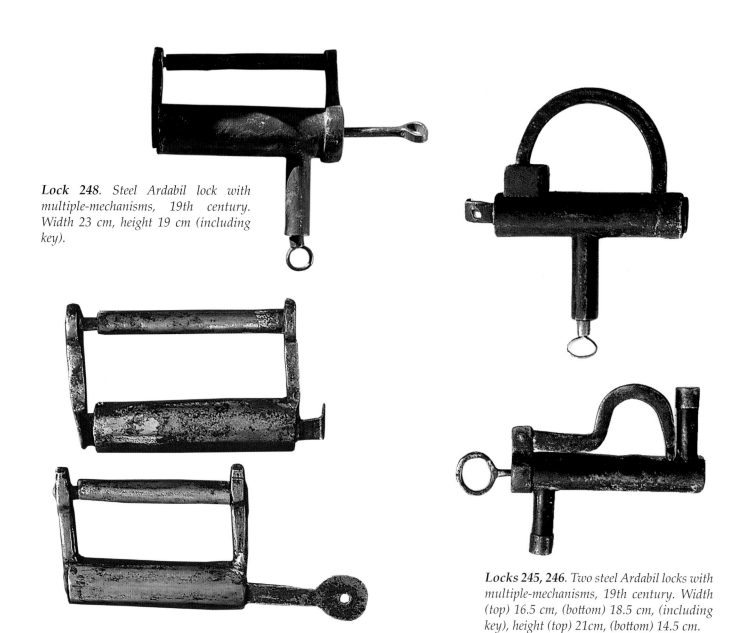

Lock 248. *Steel Ardabil lock with multiple-mechanisms, 19th century. Width 23 cm, height 19 cm (including key).*

Locks 245, 246. *Two steel Ardabil locks with multiple-mechanisms, 19th century. Width (top) 16.5 cm, (bottom) 18.5 cm, (including key), height (top) 21cm, (bottom) 14.5 cm.*

Locks 249, 250. *Two steel Ardabil locks with barbed-spring mechanisms, 20th century. Width (top) 13.5. cm (including key), (bottom) 15.5 cm, height (top) 7.5cm, (bottom) 8 cm.*

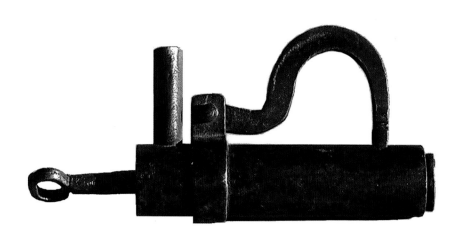

Lock 247. *Steel Ardabil lock with multiple-mechanisms, 19th century. Width 27 cm, height 15 cm (including key).*

99

Esfahan

The contribution of the Esfahani lock-makers in general, and in this book in particular, is greater than that of any other lock-makers in Iran. In fact it is no exaggeration to consider their share, "the lion's share of Iranian lock makers".

In this section three of their distinguished "lock-groups" with their particular features are presented. From the point of artistry, mechanisms, and finishing, they are all praiseworthy. Besides these three groups, it is fair to mention, they have a share in many other non-figural locks too.

Esfahan Shrine

Date range: 15th–19th centuries; *Place of manufacture*: Esfahan; *Materials*: steel, bronze, silver, gold; *Mechanisms*: barbed-spring, hook and revolving catch and multi-mechanisms; *Size range*: (width) min. 3 cm, max. 27 cm (height) min. 2.5 cm, max. 15 cm.

From the year 1599 until the overthrow of the Safavid dynasty in 1722, Esfahan was the political and artistic capital of Iran. The fame and mastery of its craftsmen, however, were by no means limited to the period when the Safavid shahs were in residence there. The name of Esfahan has been associated with artistic excellence long before and after that.

During the sixteenth and seventeenth centuries much attention was bestowed by the Safavid dynasty upon the various shrines of the country, especially those of Mashhad in northeastern Iran, and Qom, south of Tehran. This support came as a result of the shahs' own religious convictions as well as their efforts to establish the Twelver Shi'a form of Islam as the official religion of the Safavid state. One of the ways they expressed their devotion and furthered their political policy was through sending gifts to these shrines. It was thus that some of the finest of the Esfahan-made shrine locks and key boxes (see fig. 15) came into the possession of Iran's major centers of pilgrimage.

One outstanding example of such a lock is seen in No. 251. Its mechanism (of the hook-and-revolving-catch type) was discussed in an earlier section (p. 29, Fig. 44). This solid-silver lock could be early Safavid or even pre-sixteenth century.

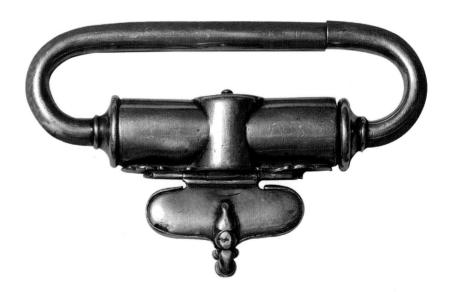

Lock 251. *Silver Esfahan shrine lock with hook-and-revolving-catch mechanism, 15th–16th centuries. Width 14 cm, height 9 cm.*

Lock 252. Silver Esfahan shrine lock with barbed-spring mechanism, 17th–18th centuries. Width 21cm (including key), height 9.5 cm.

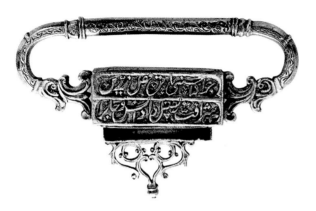

Another solid silver lock from a later period is No. 252. Besides these silver locks, two solid gold locks are also known; one is in the Imam Reza Shrine Museum of Mashhad (Fig. 63) and the other is on a door of Ma'suma Shrine, now in Ma'suma Shrine, Museum of Qom (Fig. 64). Another important lock from the Imam Reza Shrine Museum of Mashhad is a steel lock with gold inlaid decoration and multiple mechanisms (Fig. 65).

Fig. 63. Esfahan shrine lock, solid gold, with barbed-spring mechanism and slide key; made by a craftsman named Mohammad and given to the Shrine of Imam Reza in Mashhad by Javad Al-Hosayni; mid-17th century. Width 14.5 cm, height 9 cm, weight 481 g.

Inscribed on the lock are four lines of poetry which give the date of manufacture:

"With [the ordering] of this gold lock Javad al-Hosayni
Gave all creatures [the opportunity of gaining] honor by kissing [it]
Concerning the date of its fashioning Hashem said
'With this lock solve the problems of the soul'."

Depending on how one interprets the last line, the date of manufacture of this lock, revealed by means of a chronogram based on the numerical value of each letter of the Persian alphabet, can be either 1337 A.H./1918–1919 A.D. or 1064 A.H./1653–1654 A.D. Given the style of this lock, the latter is to be considered the more likely of the two.

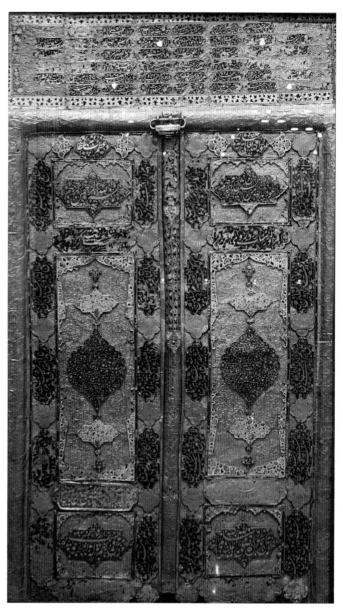

Fig. 64. The main entrance door to the Shrine of Ma'suma with a solid gold lock, order of Fath-Ali Shah Qajar (r.1797–1834). The door is now in the Qom Museum.

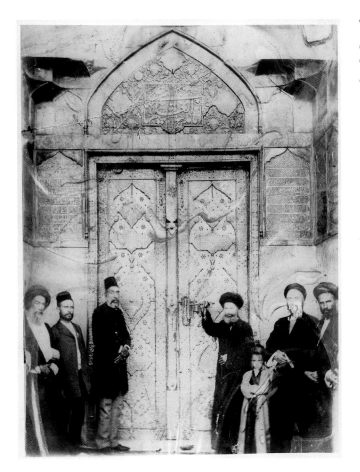

Fig. 65. *The entrance door of Imam Ali with a shrine lock. Kabala, circa 1900.*

The other shrine locks in this collection are made entirely of steel, or steel with some gold inlay. These fall into three groups.

The first and most typical is the barbed-spring, side-shackle type with a slide key which fits into an open slit (Nos. 253–255). The second group (Nos. 256–259) consists of locks with the same mechanism and key type as above but with the exception that the key slot is hidden by a plate with three teeth jutting out of it. One of these teeth unscrews to permit the opening of this bottom plate and the use of the slide key. The third type (Nos. 264–266) works with a turnkey. Many of the Esfahan shrine locks are decorated with arabesque designs, Persian poetry, and religious inscriptions, and at times also carry the maker's name. Some also have animals and flowers engraved on them.

Fig. 66. *Esfahan shrine lock with steel and gold inlaid decoration, multiple mechanisms, and push key; made by Aqa Kuchek; 17th–18th centuries. Width 20.5 cm, height 8 cm. In order to reach the central barbed-spring mechanism, the four flies and the seven birds on the sides and ends must first be turned to the proper position. Inscribed on both sides of the lock are four verses of Persian poetry:*

*"The fashioning of a lock like this
Requires effort and skill. All crafts when compared to lock-making are nothing.
Whoever sees this lock would say: [illegible] like the locks
Of the beloved is intertwined".*

Lock 253. *Steel Esfahan shrine lock with barbed-spring mechanism, 16th–17th centuries. Width 30.6 cm, height 32 cm (including key).*

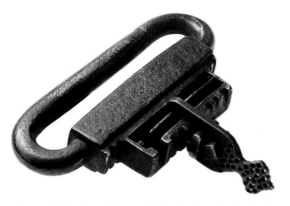

Lock 254. *Steel Esfahan shrine lock with barbed-spring mechanism, 16th–17th centuries. Width 13.5 cm, height 17.5 cm (including key).*

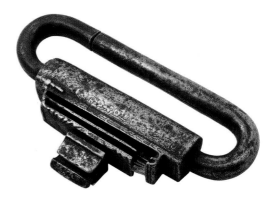

Lock 255. *Steel Esfahan shrine lock with barbed-spring mechanism, 16th–17th centuries. Width 21 cm, height 11.5 cm.*

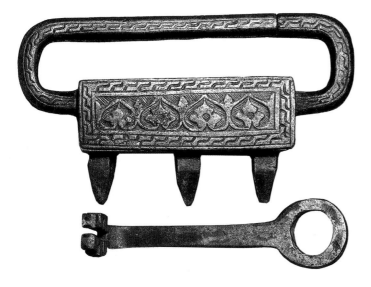

Lock 256. *Steel Esfahan shrine lock with barbed-spring mechanism, 16th–17th centuries. Width 12 cm, height 6.5 cm.*

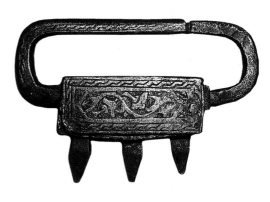

Lock 257. *Steel Esfahan shrine lock with barbed-spring mechanism, 16th–17th centuries. Width 10.5 cm, height 6 cm.*

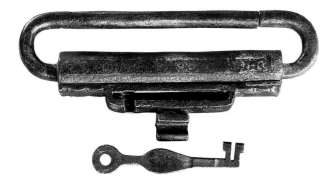

Lock 258. *Steel Esfahan shrine lock with barbed-spring mechanism, 17th–18th centuries. Width 39 cm, height 14 cm.*

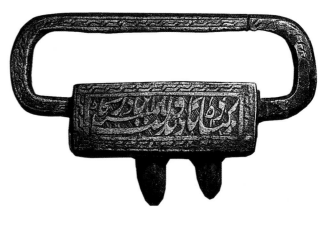

Lock 259. *Steel Esfahan shrine lock with barbed-spring mechanism, 16th–17th centuries. Width 9.5 cm, height 5.5 cm. Inscription: "May the wealth of this doorway be open forever".*

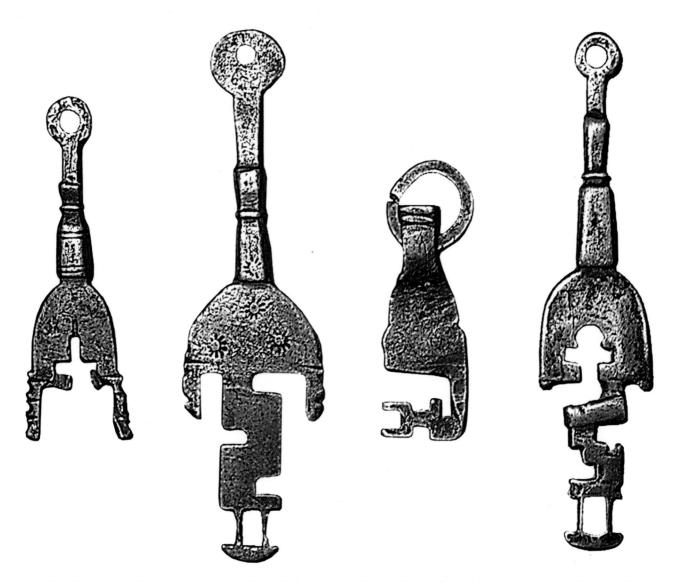

Keys 260–263. *Four steel Esfahan shrine keys, 16th–17th centuries. Height (from left to right) 9 cm, 13.3 cm, 7.2 cm, 13.5 cm.*

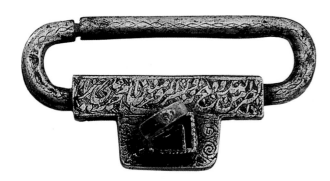

Lock 264. *Steel Esfahan shrine lock with barbed-spring mechanism, 17th–18th centuries. Width 15 cm, height 8 cm.*

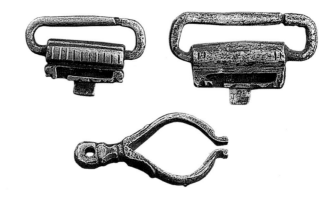

Locks 265-266. *Two steel Esfahan shrine locks with barbed-spring mechanisms, 17th-18th centuries.*

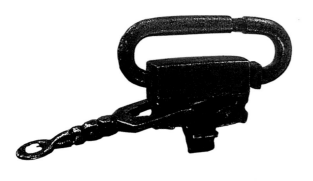

Lock 269. *Steel Esfahan shrine lock with barbed-spring mechanism, 17th–18th centuries. Width 5 cm, height 4.5 cm (excluding key).*

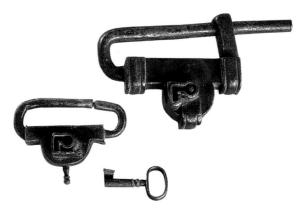

Locks 267, 268. *Two steel Esfahan shrine locks with barbed-spring mechanisms, 17th–18th centuries.*

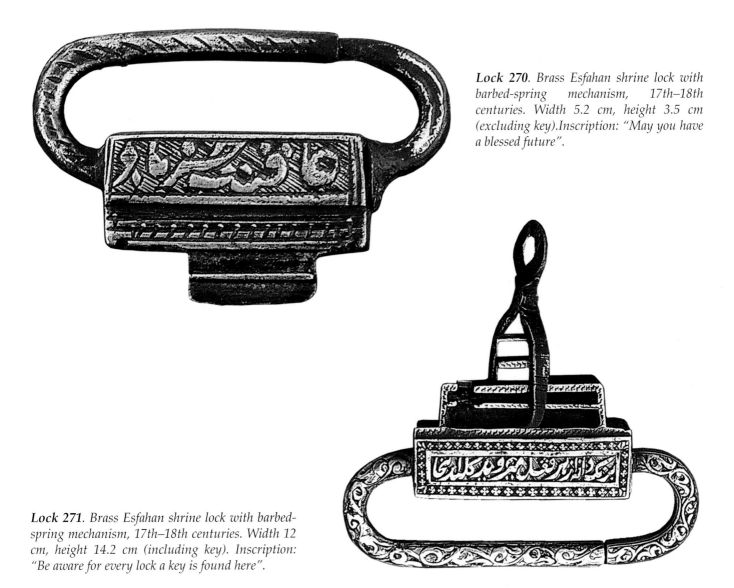

Lock 270. *Brass Esfahan shrine lock with barbed-spring mechanism, 17th–18th centuries. Width 5.2 cm, height 3.5 cm (excluding key).Inscription: "May you have a blessed future".*

Lock 271. *Brass Esfahan shrine lock with barbed-spring mechanism, 17th–18th centuries. Width 12 cm, height 14.2 cm (including key). Inscription: "Be aware for every lock a key is found here".*

Shah Abassi-Esfahan

Date range: *16th–17th centuries;* **Place of manufacture**: *Esfahan;* **Materials**: *brass, steel;* **Mechanisms**: *bent-spring, helical-spring;* **Size range**: *(width) min. 4 cm, max. 5.5 cm (height) min. 2.5 cm, max. 5.5 cm.*

Shah Abbas I, 1588–1629, was a famous patron of the arts. *Shah Abbasi* became a term applied in Iran to certain classical designs and motifs commonly seen in the art of the Safavid period (sixteenth to early eighteenth centuries) or in later art that is derived from, or inspired by, this high point in the Iranian artistic tradition. The locks in this category qualify as *Shah Abbasi* by virtue of their shapes, chiseled surface decoration, and age (sixteenth to seventeenth centuries). The lock bodies were sand cast in two pieces, provided with a bent-spring or helical-spring, and joined together. This type of lock is usually very flat and thin (Nos. 272–276, while No. 277 is an exception). No. 275 has an inscription on both sides; the side seen below reads *aqebat kheyr bad* (may you have a blessed future) and the other, *dowlat ziyad* (may you prosper greatly).

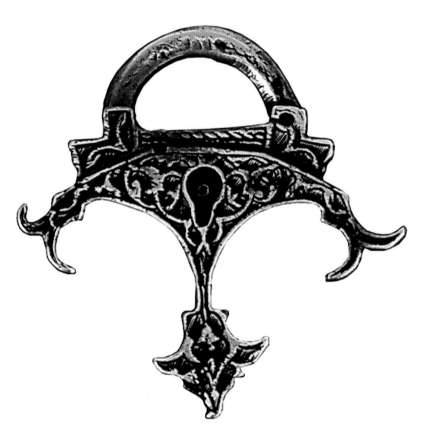

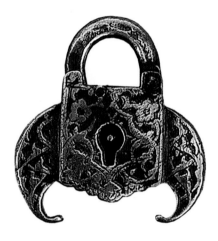

Lock 273. Brass Shah Abbasi lock with bent-spring mechanism, 16th–17th centuries. Width 4.1 cm, height 4.5 cm.

Lock 272. Brass Shah Abbasi lock with bent-spring mechanism, 16th–17th centuries. Width 6 cm, height 6 cm.

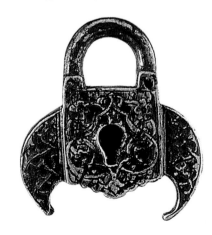

Lock 274. Brass Shah Abbasi lock with bent-spring mechanism, 16th–17th centuries. Width 4 cm, height 4 cm.

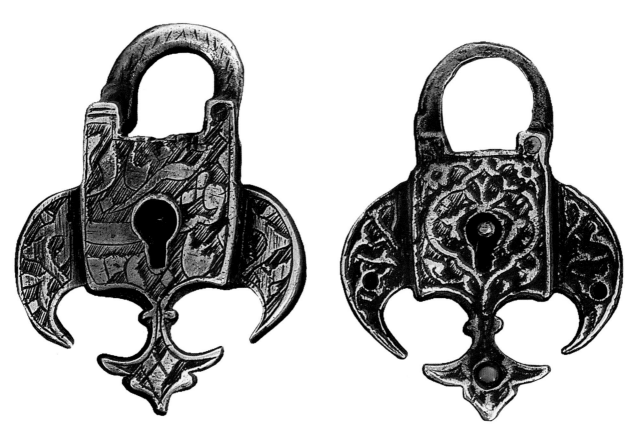

Locks 275, 276. *Two brass Shah Abbasi locks (right; brass, steel and turquoise) with bent-spring mechanisms, 16th–17th centuries. Width 4 cm, height 5.2 cm.*

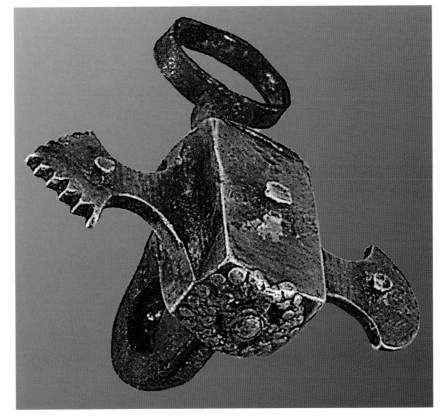

Lock 277. *Brass and steel Shah Abbasi lock with bent-spring mechanism, 16th–17th centuries. Width 4.5 cm, height 2.5 cm.*

Classic Esfahan, Botteh Medallion

Date range: *17th–19th centuries;* *Place of manufacture*: *Esfahan;* *Material*: *steel, brass ;* *Mechanisms*: *bent-spring;* *Size range*: *(width) min. 2 cm, max. 4.5 cm (height) min. 2.5 cm, max. 7.5 cm.*

These are very plain with no surface decoration and have classical designs, traditionally associated with the Safavid period. Their shape seems to be derived from classic Persian carpets with the well known botteh medallion motifs (Nos. 282–285) and fish designs (Nos. 292–294). One example (No. 280) is in the form of two birds back to back (the birds are upside down). The high quality craftsmanship, characteristic of Esfahan steel locks, helps to distinguish these products from those of other parts of Iran. As was true in the case of many of the heart-shaped locks made in Esfahan, the keyhole is often protected by an interior spring (No. 279).

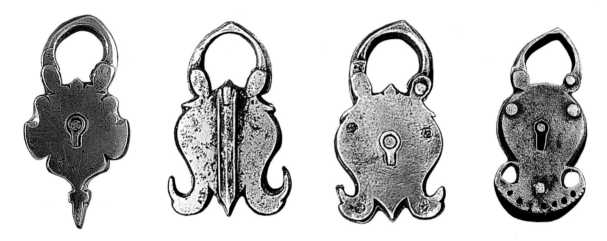

Locks 278–281. Classic steel Esfahan locks with bent-spring mechanisms, 17th–18th centuries.

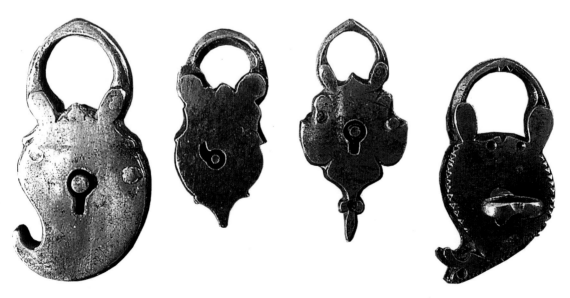

Locks 282–285. Four classic steel Esfahan locks with bent-spring mechanisms, 17th–18th centuries.

108

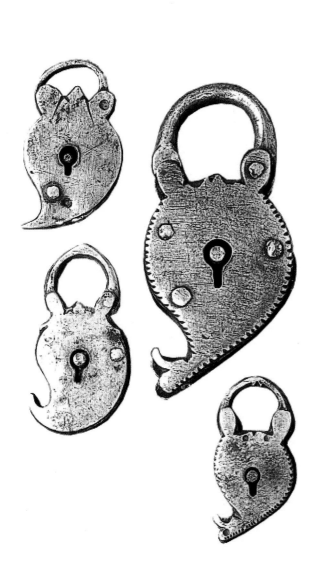

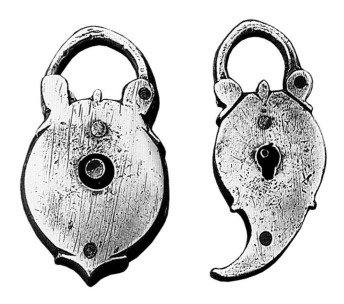

Locks 286, 287. *Two classic brass Esfahan locks with bent-spring mechanisms, 17th–18th centuries. Width (left) 5.5 cm (right) 3.2 cm, height (left) 5.5 cm, (right) 6cm.*

Locks 288–291. *Four classic steel Esfahan locks with bent-spring mechanisms, 17th–18th centuries.*

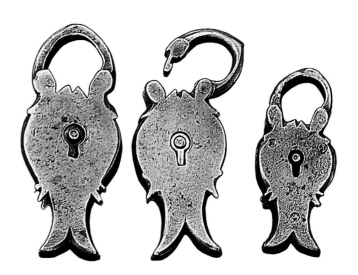

Locks 292–294. *Three classic steel Esfahan locks with bent-spring mechanisms, 17th–18th centuries. Width (left) 2.6 cm, (center) 2.6 cm, (right) 2.2 cm, height (left) 6 cm, (center) 6 cm, (right) 5.1 cm.*

Chal-Shotor

*Date range: 19th–20th centuries; **Place of manufacture**: Chal Shotor; **Materials**: steel, silver, gold; **Mechanism**: helical-spring; **Size range**: (width) min. 2 cm, max. 29 cm (height) min. 3 cm, max. 25.5 cm.*

Chal-Shotor is a walled village 32 kilometers west of Esfahan and seven kilometers from Shahr-e Kord, capital of Chahar Mahall and Bakhtiyari province. As mentioned previously, up to not long ago, Chal-Shotor was one of the lock-smithing centers of Iran. The locks made in Chal-Shotor are easily recognizable by their horseshoe-shape top shackles which appear to be connected to a small lock body through which a pipe runs. This center section, or "small lock body," usually has oval (Nos. 301–303) or octagonal (No. 297) grooves.

No. 295 is particularly noteworthy among the locks in this group. Its surface is covered with designs and inscriptions in inlaid gold done by a craftsman in Esfahan. These inscriptions include verses from the poet Hafez and the holy names Allah, Mohammad, Ali, Fatima, Hasan, and Hosayn on one side, and a verse from the Koran on the other. Such a lock was unquestionably meant for a shrine in Esfahan.

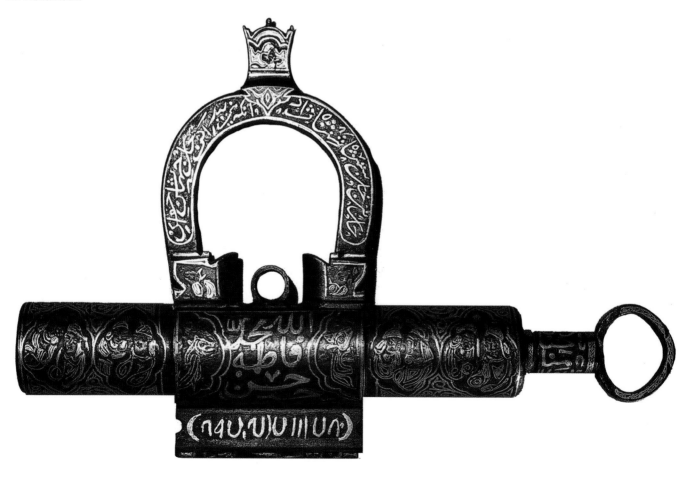

Lock 295. Steel Chal-Shotor lock with helical-spring mechanism, 19th century. Width 29 cm (including key), height 25.5 cm.

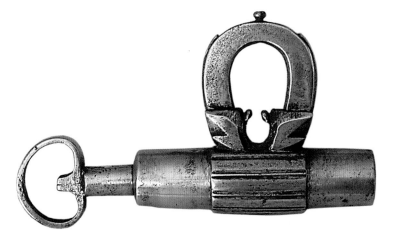

Lock 296. Steel Chal-Shotor lock with helical-spring mechanism, 19th century. Width 17 cm (including key), height 9.5 cm.

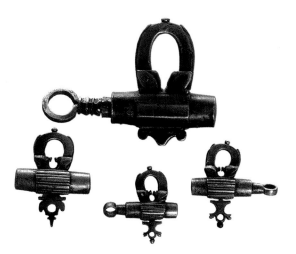

Locks 297–300. Four steel Chal-Shotor locks with helical-spring mechanisms, 19th–20th centuries.

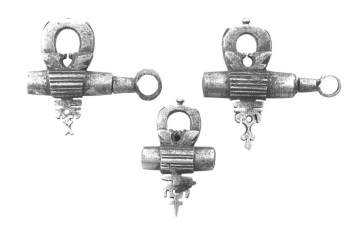

Locks 301–303. Three steel Chal-Shotor locks with helical-spring mechanisms, 20th century.

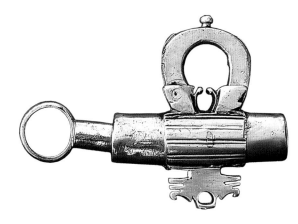

Lock 304. Silver Chal-Shotor lock with helical-spring mechanism. Width 10 cm (including key), height, 7.5 cm, 19th century.

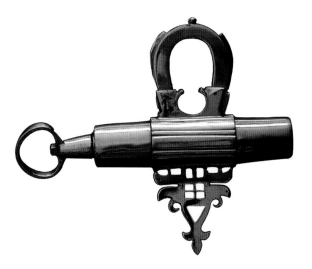

Lock 305. Gold Chal-Shotor lock with helical-spring mechanism, work of master locksmith Nikzad, 1975. Width 15.5 cm (including key), height, 13 cm.

111

Octagonal and Rectangular

Date range: *18th–19th centuries*; **Place of manufacture**: *western Iran, mainly Zanjan*; **Material**: *steel*; *Mechanism*: *helical-spring*; **Size range**: *(width) min. 2 cm, max. 14 cm (height) min. 1.5 cm, max. 9 cm.*

For the bodies of some of the larger octagonal locks, parts of gun barrels have been used (Nos. 306–308); while for the bodies of rectangular locks, steel sheets were used (Nos. 309–319). No. 315 has a bird on one end, and No. 316 has something that resembles two feet. Two keys are needed to operate the helical back spring of No. 309.

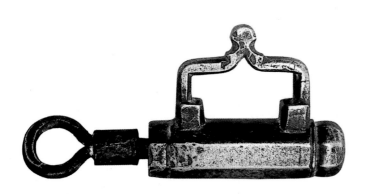

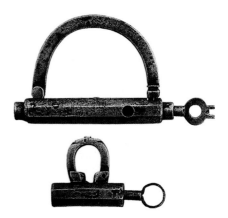

Lock 306. Steel octagonal lock with helical-spring mechanism, 18th–19th centuries. Width 11 cm (including key), height 5 cm.

Locks 307, 308. Two steel octagonal locks with helical-spring mechanisms, 18th 19th centuries. Width (top lock) 17 cm (including key), height 9.3 cm, (bottom lock) width 9.3 (including key), height 5.5 cm.

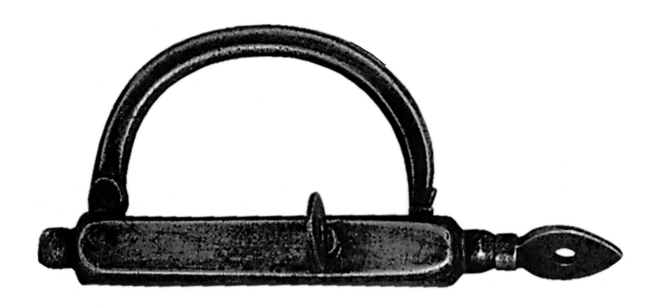

Lock 309. Steel rectangular lock with helical-spring mechanism, 19th century. Width 8.5 cm (including key), height 5 cm.

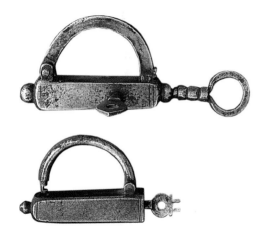

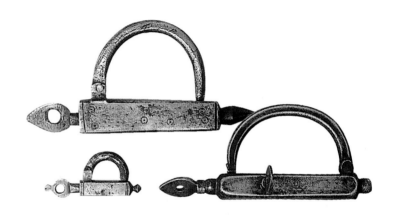

Locks 310, 311. Two steel rectangular locks with helical-spring mechanisms, 19th century. Width (top lock) 10.5 cm (bottom lock) 6 cm (including key), height (top lock) 5 cm, (bottom lock), 4.5 cm.

Locks 312–314. Three steel rectangular locks with helical-spring mechanisms, 19th century.

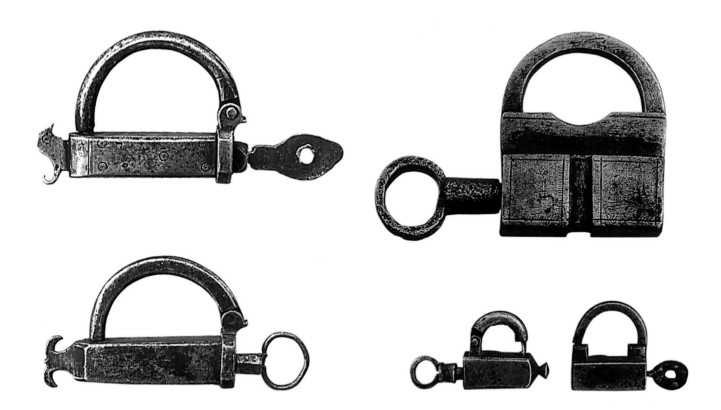

Locks 315, 316. Two steel rectangular locks with helical-spring mechanisms, 19th century. Width (top lock) 9.7 cm (bottom lock) 8 cm (including key), height (top lock) 4.7 cm, (bottom lock), 3.8 cm.

Locks 317–319. Three steel rectangular locks with helical-spring mechanisms, 19th century. Width (top lock) 10.5 cm (bottom left) 4.8. cm, (bottom right) 4.2 cm (including key), height (bottom left) 2.8 cm, (bottom right) 3.1 cm.

Pipe

Date range: *18th–20th centuries;* **Place of manufacture**: *all regions of Iran;* **Materials**: *steel, silver;* **Mechanisms**: *helical-spring, barbed-spring, multiple spring, removable female screws and solid male screws;* **Size range**: *(width) min. 2.5 cm, max. 20.5 cm (height) min. 2 cm, max. 16 cm.*

Locks in the shape of a length of pipe are the most commonly found type in Iran, especially examples from the nineteenth and twentieth centuries. These were made throughout the country, often from pieces of machine-made pipe imported for industrial purposes. They also used machinery for thread and die (No. 322, 322a). During this period, the locksmiths used sections of old gun barrels and parts of used machinery. Small pipe locks made of silver, were for jewelry and bridal boxes (Nos. 329, 330).

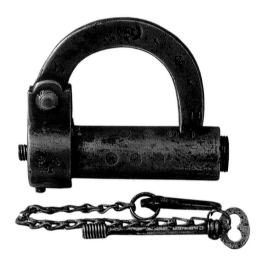

Lock 320. Steel pipe lock with revolving female screw, solid male screw, 20th century. Width 15.5. cm, height 12.5 cm.

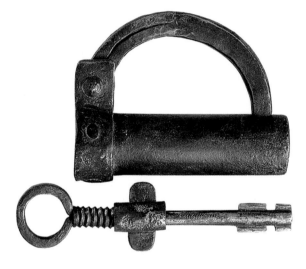

Lock 321. Steel pipe lock with barbed-spring and revolving female screw, solid male screw, 20th century. Width 15.5 cm, height 12.5 cm.

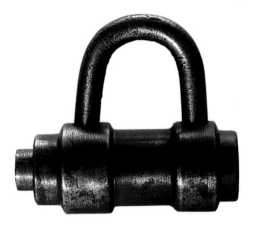

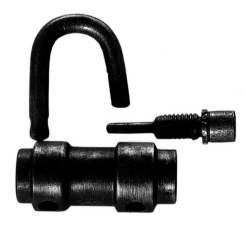

Lock 322, 322a. Steel pipe with removable shackle, female and male screw mechanism, no key, 20th century. Width 9 cm, height 8.5 cm.

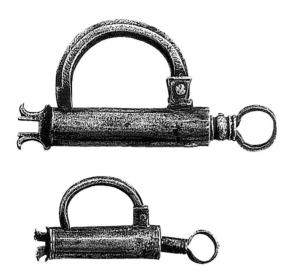

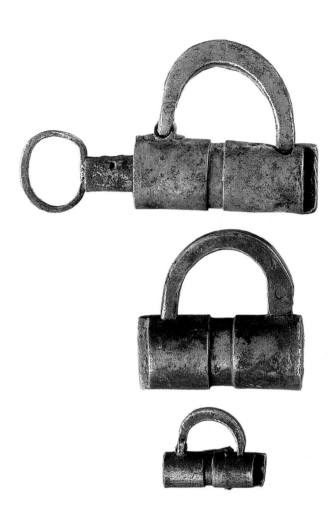

Locks 323, 324. *Two steel pipe locks with helical-spring mechanisms, 19th–20th centuries. Width (top lock) 16 cm (including key), height 8 cm, (bottom lock) 11 cm (including key), height 5 cm.*

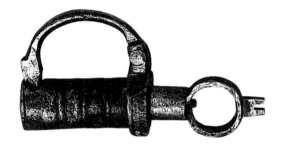

Lock 325. *Steel pipe lock with helical-spring mechanism, 19th–20th centuries. Width 11.3 cm (including key), height 5.5 cm.*

Locks 326–328. *Three steel pipe locks with helical-spring mechanisms, 19th–20th centuries. Width (top lock) 12 cm (including key), height 7.5 cm, (middle lock) width 8 cm height 7 cm, (bottom lock) width 6.5 cm, height 4 cm.*

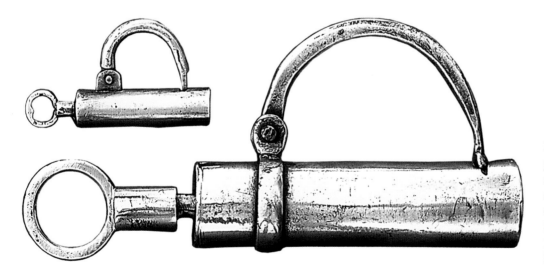

Locks 329, 330. *Two silver pipe locks with helical-spring mechanisms, 19th century. Width (top lock) 4.5 cm (including key), height 3 cm, (bottom lock) 12 cm (including key), height 5.5 cm.*

Ball and Half-Ball

Date range: *18th–19th centuries;* **Place of manufacture**: *Fars;* **Material**: *steel;* **Mechanism**: *bent-spring;* **Size range**: *(width) min. 1.8 cm, max. 2.8 cm (height) min. 3.2 cm, max. 4.5 cm.*

The ball-shaped locks from the Fars area remind one of the steel weights used on the ends of beam balances in Iran in former years. Some are spherical (Nos. 331–333 and 336) and others are semi-spherical (Nos. 334, 335). European locks very similar to this type are found in various private collections and museums.

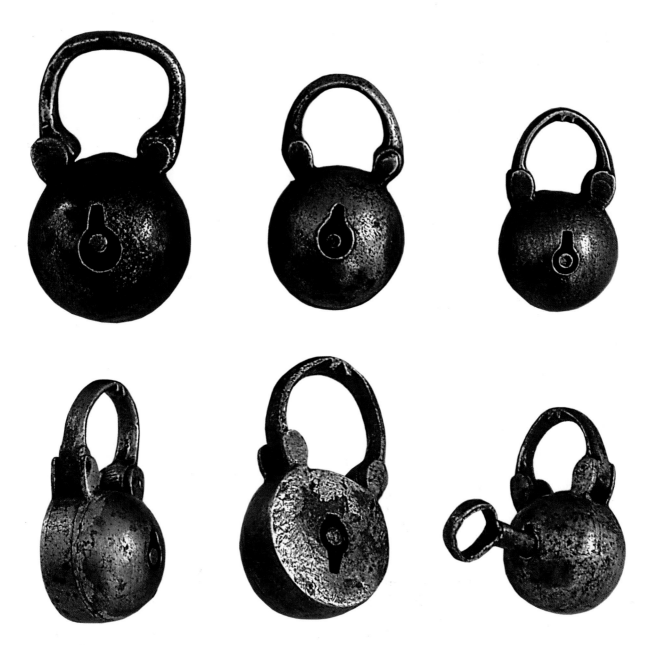

Locks 331–336. Six steel ball and half ball locks with bent-spring mechanisms, 18th–19th centuries. Width from 1.8 cm to 2.5 cm, height from 3.2 to 4.5 cm.

Circle and Semi-Circle

Date range: 18th–20th centuries; *Place of manufacture*: West and Central Iran; *Material*: steel, brass; *Mechanism*: bent-spring, multiple-spring; *Size range*: (width) min. 2 cm, max. 4.5 cm (height) min. 2.6 cm, max. 6.5 cm.

Circle and semi-circle locks are one of the largest groups and they are made in various sizes and for diverse purposes. The small ones were made for bridal cosmetic and jewelry boxes (Nos. 340–343) and the larger ones for wooden chests and money boxes (Nos. 346–348). Although their mechanism is the bent-spring type, some had variations on this mechanism. While most of them have ordinary bent–spring mechanisms, No. 343 is a bent-spring with no key (see p. 24, Fig. 33, 33a). Lock No. 345 opens with two bent-spring keys and No. 346 has a removable shackle.

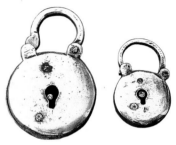

Locks 338, 339. Two brass circle locks with bent-spring mechanisms, 18th–19th centuries. Width (left) 6.5 cm, (right) 2.6, height (left) 4 cm, (right) 2.6 cm.

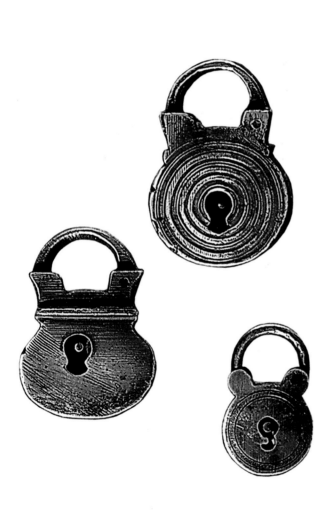

Locks 340–342. Three brass circle locks with bent-spring mechanisms, 19th century. Width (from top lock going counterclockwise) 2.8 cm, 2.6 cm, 1.8 cm, height 3.8 cm, 3.6 cm, 1.7 cm.

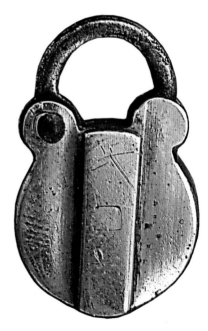

Lock 343. Brass and steel circle lock with bent-spring, no key mechanism, 18th–19th centuries. Width 1.7 cm, 3.2 height cm.

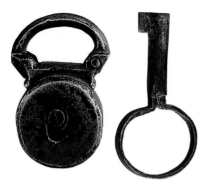

Lock 337. Steel circle lock with bent-spring mechanism, 18th–19th centuries. Width 5 cm, height 9.5 cm.

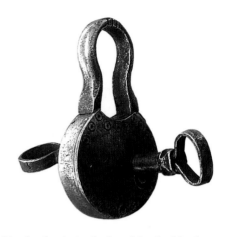

Lock 345. Steel circle lock with double bent-spring mechanism, 18th–19th centuries. Width 4 cm, height 7.5 cm.

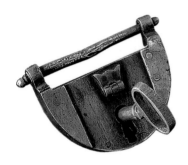

Lock 344. Brass, semi-circle lock with bent-spring mechanism, 19th century. Width 7.2 cm, height 4.7 cm.

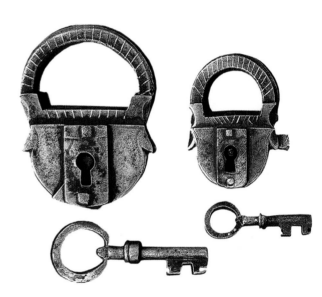

Locks 347, 348. Two steel semi-circle locks with barbed-spring mechanisms, 17th–18th centuries. Width (left) 7.5 cm, (right) 6 cm, height (left) 10, (right) 7.3 cm.

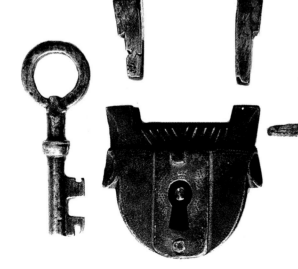

Lock 346. Steel semi-circle lock with barbed-spring mechanism, 17th–18th centuries. Width 5 cm, height 7.5 cm.

Heart

Date range: *16th–20th centuries;* ***Place of manufacture****: central and southeastern Iran;* ***Materials****: steel, brass;* ***Mechanisms****: bent-spring, helical-spring, multiple spring;* ***Size range****: (width) min. 1.25 cm, max. 7.5 cm (height) min. 3 cm, max. 13.5 cm.*

Locks in the shape of a heart come mostly from central Iran (Esfahan and Abarqu in particular) and southeastern Iran. Especially noteworthy in that region is the small town of Rayen, near Kerman, which long ago was a center of metalwork and is still active today. The hearts range from heart shaped (Nos. 349–360), to triangular (Nos. 361, 362). No. 349 is covered in the front by a pierced-brass plaque, and No. 359 is inlaid with small turquoise stones. All of the others are of plain steel. The craftsmanship in No. 350 and Nos. 351–358, which were made in Esfahan, is of particularly high quality.

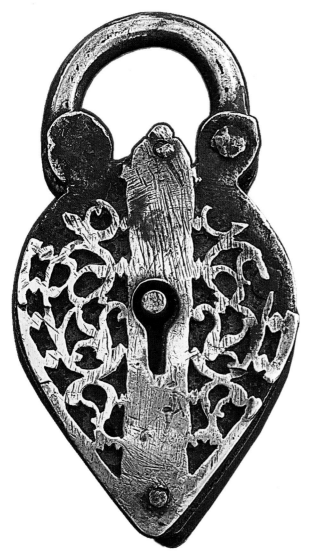

Lock 349. *Steel heart lock with multiple mechanisms, 18th–19th centuries. Width 4.5 cm, height 8.7 cm.*

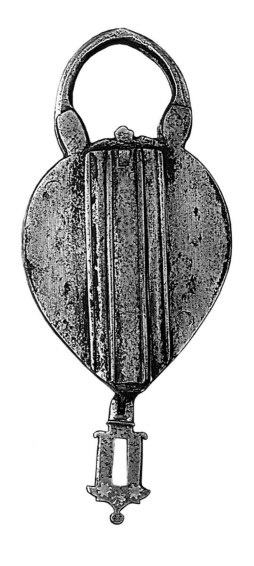

Lock 350. *Steel heart lock with multiple mechanisms, 17th–18th centuries. Width 8 cm, height 16.5 cm.*

No. 350 has a keyhole cover that is held down by a notched-shackle with a spring behind it. The arm-like cover must be pried open, whereas in No. 351 a similar cover is released by the pendant that functionally resembles a permanently engaged key of a helical-pull-spring. A downward pull opens the cover. Once the cover has been opened, the user confronts another obstacle: a very strong spring fills the area of the keyhole around the drill pin and inhibits the entry of the pipe key. Considerable pressure is needed in order to push the key in. The back sides of these locks are made identical to the front. When the keyhole cover is closed, it is not immediately apparent how one obtains access to the interior mechanism. Of much interest is the multiple-mechanism and multiple-key lock No. 355. Like No. 350 and No. 351, it has a notched cover over the keyhole of its bent-spring mechanisms. Nos. 354 and 355 have additional locking mechanisms and keys: there are four in No. 355 and two in No. 354. Besides bent–spring mechanisms, all of these have helical-spring mechanisms too. Such locks were used primarily for securing money boxes and similar containers to which several persons, usually business partners, had access. Each person had one key; the lock could be opened only when all were present.

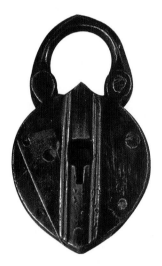

Lock 351. Steel heart lock with multiple mechanism, 18th–19th centuries. Width 5.6 cm, height 10 cm.

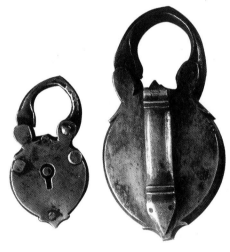

Locks 352, 353. Two steel heart lock with multiple mechanisms, 18th–19th centuries. Width (left) 4 cm, height 6.8 cm, (right) 5.6cm, height 12 cm.

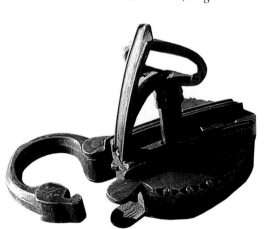

Lock 354. Steel heart lock with multiple mechanisms, 18th–19th centuries. Width 5 cm, height 11 cm.

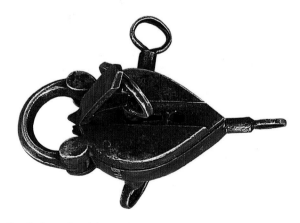

Lock 355. Steel heart lock with multiple mechanisms, 18th–19th centuries. Width 7.5 cm, height 14 cm.

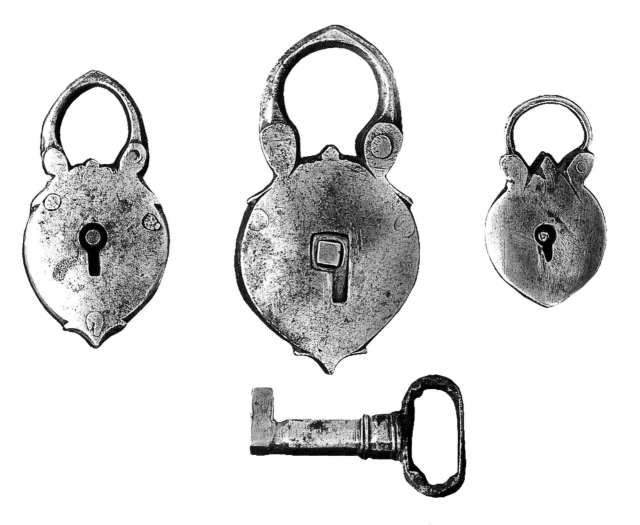

Locks 356–358. *Three steel heart locks with multiple mechanisms, 18th–19th centuries.*

Locks 359, 360. *Two steel heart locks with bent-spring mechanisms, 19th century. Width (left) 1.8 cm, height 3.9 cm, (right) 1.6 cm, height 3 cm.*

Locks 361, 362. *Two steel heart locks with bent-spring mechanisms, 19th century. Width (left) 4 cm, height 6 cm, (right) 4.3 cm, height 6.7 cm.*

Brass

Date range: 19th–20th centuries; *Place of manufacture*: western Iran, Persian Gulf area, Shiraz, Bushehr, Zanjan, Hamadan, Kermanshah; *Materials*: brass, steel; *Mechanism*: helical-spring; *Size range*: (width) min. 3 cm, max. 7.5 cm (height) min. 3 cm, max. 5.5 cm.

As seen before, in most groups of locks one or two are made of brass. These locks follow the shape, style and the mechanism of the locks, but the lock body, instead of steel, is made of brass.

There are, however, two exceptional groups in which all of them are made of brass, and no steel locks like them have been found.

One of these groups, in shape, resembles hand bag and chest locks (for comparison see Nos. 200–204), but their surfaces are decorated with engravings. The brass chest-like examples have decorated side panels with grooves in the middle (Nos. 363 and 365). In the purse-like examples a border frames an engraved central field. Islamic names and expressions are found on most of these. It is not known whether the names relate to the makers of the locks or to those for whom they were made.

In many ways the style of decoration and quality of engraving in these locks remind one of the work done in India.

Locks 363–367. Five brass locks from southern Iran with helical-spring mechanisms, 19th–20th centuries. Width from 3.3 cm to, 4.3 cm, height from 3.5 cm to 5.5 cm.

Shiraz had important trade connections with India through the Persian Gulf port of Bushehr in the eighteenth and nineteenth centuries, and the possibility that these are Indian in origin cannot be discounted. They could also have been made in Shiraz by locksmiths copying Indian models. The second group of brass locks are from western Iran, mainly Zanjan, Hamadan and Kermanshah. These in shape are like the steel rectangular locks (Nos. 309–314), but their surfaces are almost always decorated with attractive designs composed of dots and circles (Nos. 368–376). Another point of difference is the interesting projections on the side opposite the keyhole (Nos. 372–376). The peculiar dot-and-circle ornamentation seen here brings to mind that of the brass plate and dice (*raml-e ostorlab*) used in Iran for geomancy (Fig. 64). The shape of a group of them (Nos. 374–376) seems to be inspired by the stone *kohl* bottle (Fig. 65).

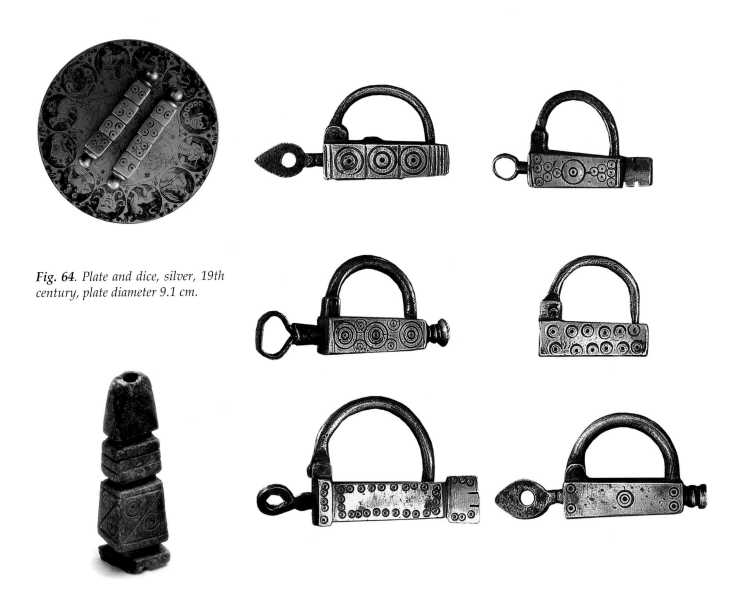

Fig. 64. Plate and dice, silver, 19th century, plate diameter 9.1 cm.

Fig. 65. Kohl bottle, limewstone, 16–17th century, height 6.8 cm

Locks 368–373. *Six locks from western Iran with helical-spring mechanisms, 19th–20th centuries. Width from 5.5 cm to, 7.5 cm (including key), height from 3.5 cm to 5.5 cm.*

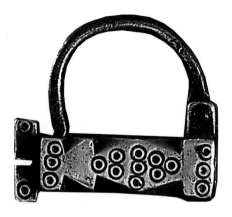

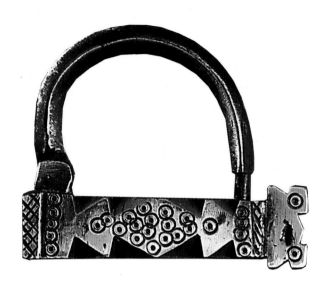

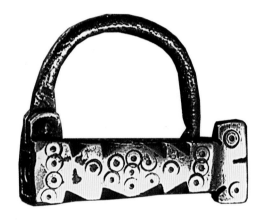

Locks 374–376. Three locks from western Iran with helical-spring mechanisms, 19th–20th centuries. Width from 5.4 cm to 6.2 cm, height from 5 cm to 5.5 cm.

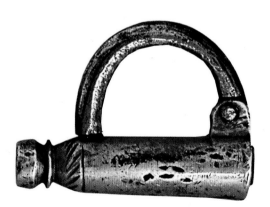

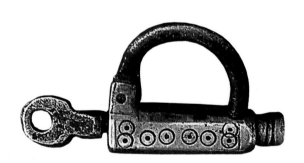

Locks 377–379. Three locks from western Iran with helical-spring mechanisms, 19th–20th centuries. Width from 3.6 cm to 4 cm, height from 3.2 cm to 4.2 cm.

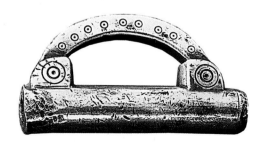

Wheel Plaque and Pierced-Steel Pendant

Date range: 16th–17th centuries; *Place of manufacture*: Shiraz, Esfahan; *Materials*: steel; *Mechanism*: helical-spring; *Size range*: (width) min. 3 cm, max. 5.5 cm (height) min. 3.5 cm, max. 3.5 cm.

Made up of only two locks, this is the smallest group. Both have wheel-like plaques attached to them. One of them has a pierced-steel pendant (No. 381). The shackle of this lock works from the back in conjunction with a helical-spring mechanism, similar to the mechanism found in two figural birds (Nos. 108, 109). This particular combination of mechanism and shackle seems to have been the product of Shiraz locksmiths of the seventeenth and eighteenth centuries.

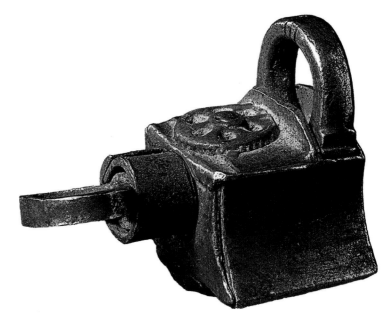

Lock 380. Steel wheel plaque lock with helical-spring mechanism, 16th–17th centuries. Width 3 cm, height 3.5 cm.

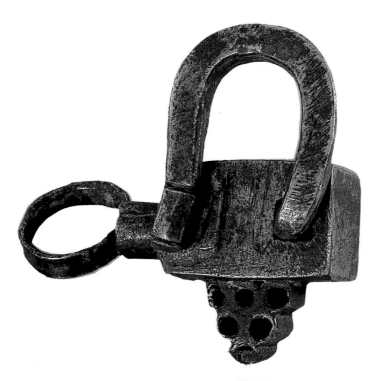

Lock 381. Steel wheel plaque lock with helical-spring mechanism, 16th–17th centuries. Width 5.5 cm (including key), height 3.5 cm.

Twisting Puzzle

Date range: 17th–19th centuries; *Place of manufacture*: western Iran (uncertain); *Materials*: brass, steel, copper, silver; *Mechanism*: helical-spring; *Size range*: (width) min. 2.5 cm, max. 4 cm (height) min. 4.5 cm, max. 8.5 cm.

These should be divided into two groups. The first group resembles lanterns (Nos. 382–386). The locks in the second group resemble breasts (Nos. 387–389). Both groups are made of two parts. The first group has a brass shell with surface decoration, sometimes in silver and copper (No. 389). In the second group both parts are made of brass (Nos. 387–389). In both groups, the shell covers the lock body and keyhole and must be twisted downward in order to reveal the second part; the lock body with a helical-spring inside and a top shackle.

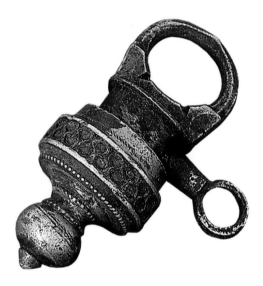

Lock 382. Brass and steel twisting puzzle lock, with helical-spring mechanism, 17th–18th centuries. Width 3.5. cm (including key), height 6 cm.

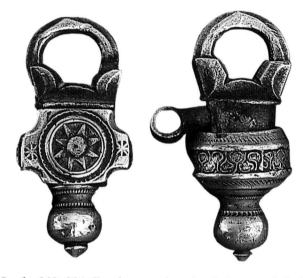

Locks 383, 384. Two brass and steel twisting puzzle locks, with helical-spring mechanisms, 17th–18th centuries. Width (left) 2.5. cm, height 5.5 cm, (right), width 3.3 cm (including key), height 5.5 cm.

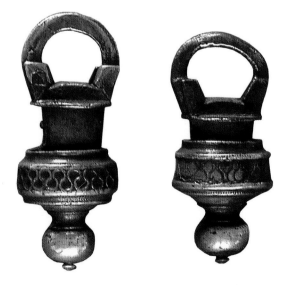

Locks 385, 386. Two brass and steel twisting puzzle locks, with helical-spring mechanisms, 17th–18th centuries. Width (left) 2.5. cm, height 5.5 cm, (right), width 3.3 cm (including key), height 5.5 cm.

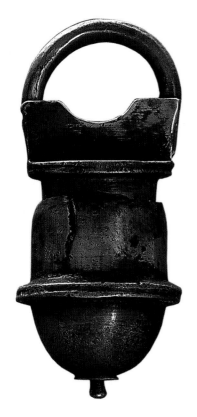

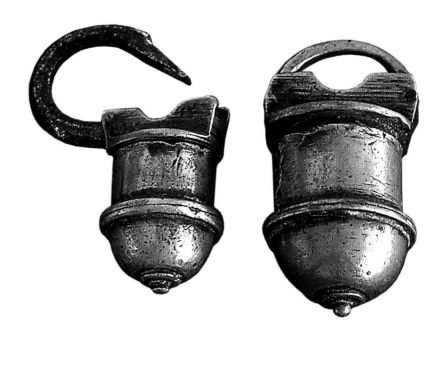

Lock 387. Brass twisting puzzle lock, with helical-spring mechanism, 17th–18th centuries. Width 3.8 cm, height 8.5 cm.

Locks 388, 389. Two brass twisting puzzle locks, with helical-spring mechanisms, 17th–18th centuries. Width (left) 2.8 cm, height 5.3 cm, (right) 3.2 cm, height 5.3 cm.

Puzzle Key

Date range: 15th–19th centuries; Place of manufacture: central Iran; Materials: steel, brass, copper; Mechanisms: notched-shackle, helical-spring; Size range: (width) min. 2.5 cm, max. 4 cm (height) min. 6.5 cm, max. 8 cm.

Shaped like a key, these puzzle locks work in much the same way as the twisting puzzle locks discussed previously (Nos. 382–389). However, instead of a brass shell covering the lock body and keyhole, there is a steel female screw that has an exterior like a key. When this is unscrewed, the keyhole is revealed (No. 391). Nos. 393, 394 are of particular interest because in these the exterior cover is in two parts. The bottom part, which has right-handed interior threads, must be screwed down first before the second part, with left-handed interior threads, can be opened to give access to the keyhole. All except Nos. 397, 398 have notched-shackle mechanisms, with the shackle opening in the middle of what appears to be the key handle. Nos. 397, 398 are shaped like keys, but have a helical-spring inside with the key fitting into the end.

A pierced and engraved bronze "key" from tenth-century Bojnurd (in Khorasan), and now in the Victoria and Albert Museum, may in fact be a puzzle-key lock rather than a conventional key. No. 390, from the 14th–15th centuries, shows this type of lock and has a much older history than the eighteenth to nineteenth-century examples in this collection.

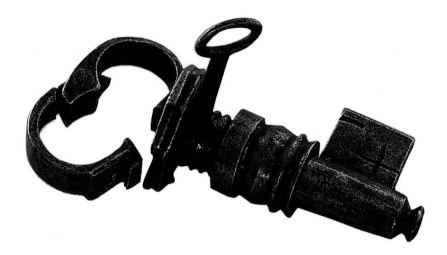

Lock 391. Steel puzzle "key" lock, with notched-shackle mechanism, 18th century. Width 3.8 cm, height 7.2 cm.

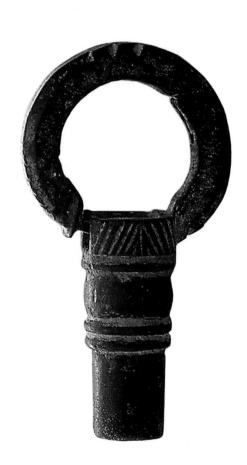

Lock 390. Brass puzzle "key" lock, with helical-spring mechanism, 14th–15th centuries. Width 4.5 cm, height 8.5 cm.

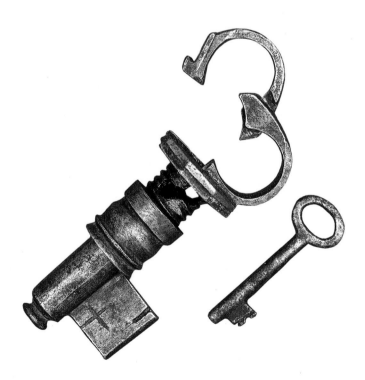

Lock 392. Steel puzzle "key" lock, with notched-shackle mechanism, 18th century. Width 5.5 cm, height 9 cm.

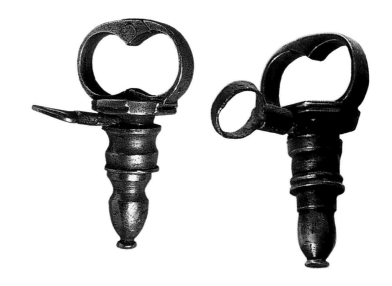

Locks 393, 394. Two steel puzzle "key" locks, with notched-shackle mechanisms, 18th–19th centuries.

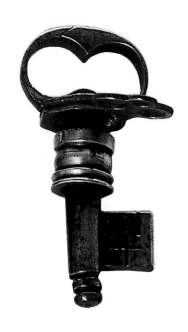

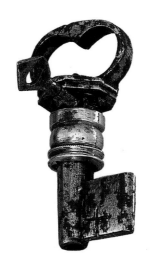

Locks 395, 396. Two steel and brass puzzle "key" locks, with notched-shackle mechanisms, 18th–19th centuries.

Lock 397. Steel puzzle "key" lock, helical-spring mechanism, 18th–19th centuries. Width 3.5 cm, height 7 cm.

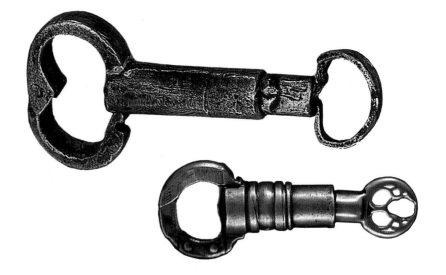

Lock 398. Brass puzzle "key" lock, with helical-spring mechanism, 18th–19th centuries. Width 3.5 cm, height 9 cm.

Combination Locks

Date range: 16th–20th centuries; *Place of manufacture*: all regions of Iran; *Materials*: steel, brass, copper; *Mechanisms*: ring combination, dial combination; *Size range*: (width) min. 2 cm, max., 6.5 cm (height) min. 4 cm, max. 9.5 cm.

The construction and mechanisms of the horizontal and vertical ring combination locks and those of the dial combination lock were discussed earlier. The rings of the first two types are usually made of bent and hammered brass sheets, or sometimes, of steel. On the rings are found letters, names, or numbers. Very often the combination spells a religious word or name, such as that of Ali, the first of the Twelve Imams (or divinely guided spiritual leaders) of Twelver Shi'ism. The oldest combination lock in this collection is from the sixteenth century. No. 402 has six rings, the most of any piece in the collection. The Latin alphabet is written on one end while the Hebrew alphabet is written on the other. The center rings all have Persian characters. Newest of all the locks in this group is No. 408. It was made and signed by Ebrahim of Kerend, a master locksmith who died in the late 1970s somewhat over the age of ninety. This lock was purchased from the maker by Parviz Tanavoli in the early 70s.

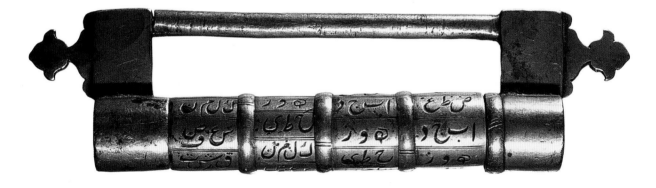

Lock 399. Brass ring combination lock, 16th century; width 13 cm, height 3.5 cm.

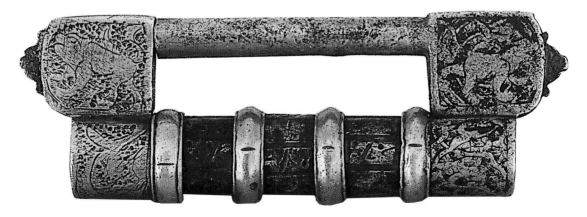

Lock 400. Brass and steel ring combination lock, 16th–17th centuries; width 12 cm, height 4 cm.

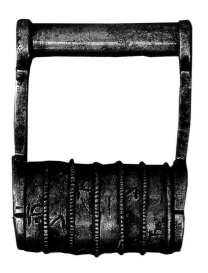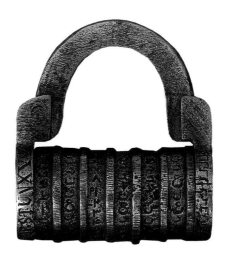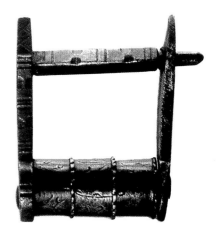

Locks 401–403. *Three steel ring combination locks, 18th–19th centuries.*

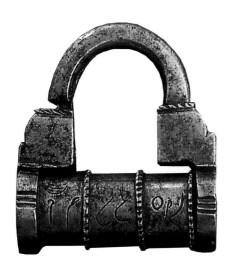

Lock 404. *Brass ring combination lock, 18th–19th centuries; width 3.8 cm, height 4.5 cm.*

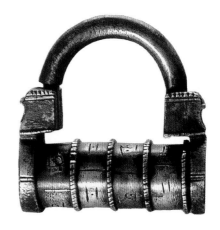

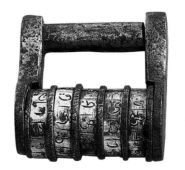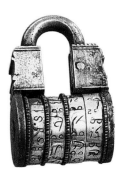

Locks 405–407. *Three brass and steel ring combination locks, 18th–19th centuries.*

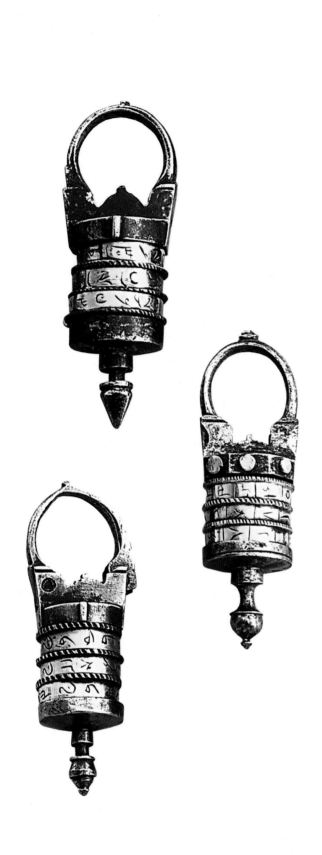

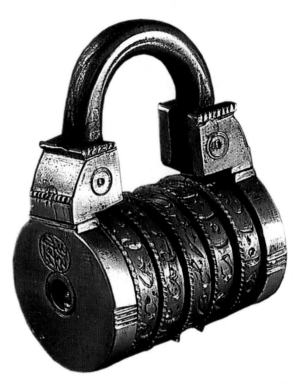

Lock 408. *Brass and steel ring combination lock, 20th century; width 4.7 cm, height 6 cm.*

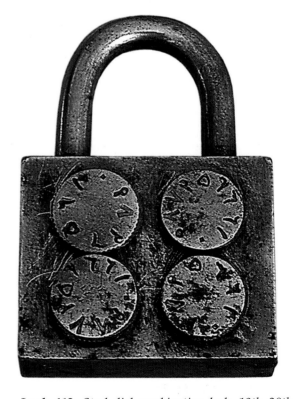

Locks 409–411. *Three brass and steel ring combination locks, 18th–19th centuries; width from 2 cm to 2.5 cm, height 7 cm.*

Lock 412. *Steel dial combination lock, 19th–20th centuries; width 6.5 cm, height 9.5 cm.*

Talisman

Date range: 18th–20th centuries; *Place of manufacture*: all regions of Iran; *Materials*: silver, steel, brass; *Mechanisms*: barbed-spring, bent-spring, helical-spring; *Size range*: (width) min. 1 cm, max. 2.5 cm (height) min. 2.5 cm, max. 6.5 cm.

Locks meant to be used as talismans were made in the past by town and village locksmiths all over Iran, as well as by itinerant metalworkers such as gypsies. Most of these talismanic locks are made of silver or steel or, occasionally, of brass. The usual mechanism is a single barbed-spring attached to the free end of the top shackle (see p. 22, Fig. 26, 26a). Due to the smallness of these locks, their keys are often nothing more than a pin.

The purpose of such locks is to protect the owner from evil and to assure success and well-being through the religious formulas engraved by the locksmith (for more information on other talismanic objects see: Tanavoli, *Talisman*, 2006). Inscriptions are made in two ways: one in the characters of Persian writing, the other using the ancient *abjad* system in which a numerical value is assigned to each letter of the alphabet. Writing can therefore be done by the use of conventional letters or by numbers. When "encoded" in the latter fashion, the special wish or hope of the owner is more easily concealed. Fig. 8 (page 13) is interesting because of the two human figures, side by side, engraved on it in addition to the usual numbers. This was often done to gain the affection, friendship, or goodwill of another party.

Those locks with barbed-springs seem to have been meant as talismans from the beginning, while those with bent-springs (Nos. 413–420) appear to have been engraved for this purpose later.

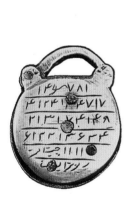 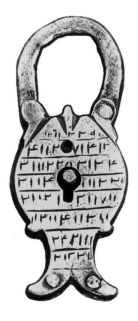 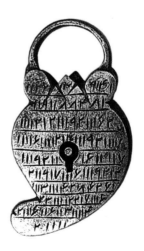 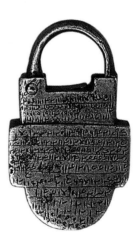

Locks 413, 414. Two brass talisman locks with bent-spring mechanisms, 19th–20th centuries. Width 2.8 cm, height (left) 3.7 cm (right) 6.5 cm.

Locks 415, 416. Two steel talisman locks with bent-spring mechanisms, 17th–18th centuries. Width 2.6 cm, height (left) 4.7 cm (right) 4.5 cm.

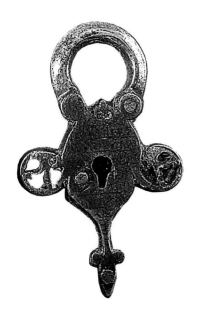

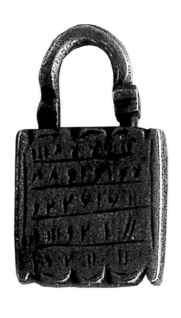

Locks 417, 418. Two steel talisman locks with bent-spring mechanisms, 17th–18th centuries. Width (left) 2.5 cm, (right) 2 cm, height (left) 4.5 cm (right).

Locks 419, 420. Two steel talisman locks with bent-spring mechanisms, 18th–19th centuries. Width 2.7 cm, height (left) 4.4 cm (right) 4.5 cm.

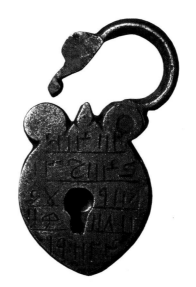

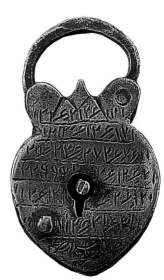

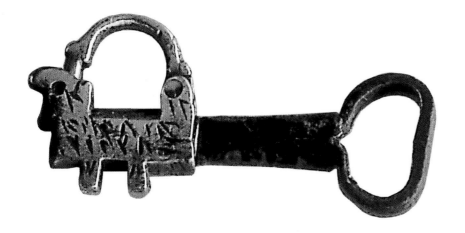

Lock 421. Brass and steel talisman lock with helical-spring mechanism, 18th–19th centuries. Width 4.3 cm (including key), height 1.8 cm.

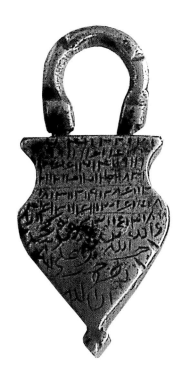

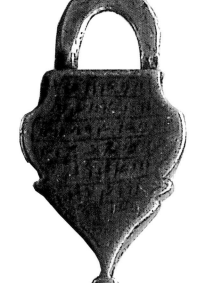

Locks 422–425. *Four steel talisman locks with barbed-spring mechanisms, 18th–19th centuries.*

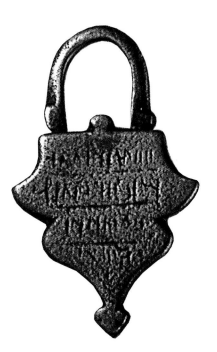

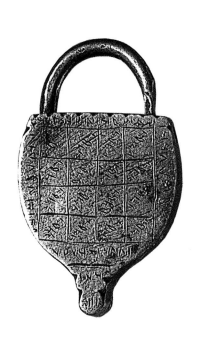

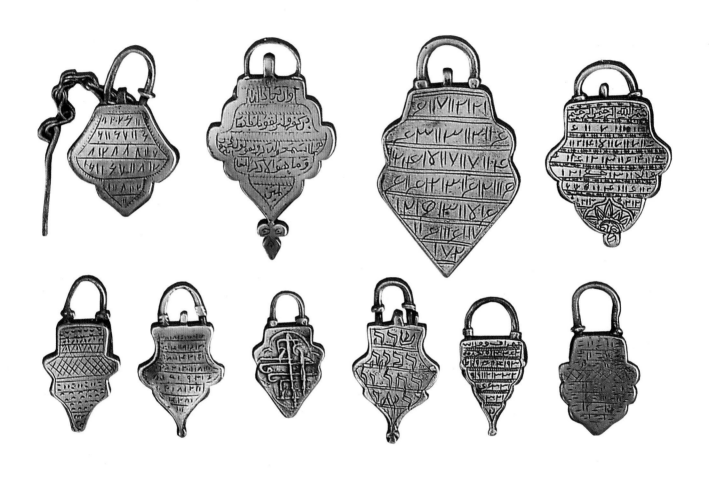

Locks 426–435. *Ten silver talisman locks with barbed-spring mechanisms, 19th–20th centuries. Width from 1 cm to 3 cm, height from 2.5 cm to 5.5 cm.*

Miscellaneous

No. 436 resembles a barbell with one detachable end and was most likely used with the hasp and staple of a door or large trunk. It was made in central Iran sometime during the seventeenth or eighteenth centuries. A description of the mechanism and mode of operation of this steel lock is given on p. 27, Fig. 40, 40a. The mechanism of No. 437 was described and illustrated on p. 33, Fig. 52, 52a, 52b. This lock was probably made in southern Iran sometime during the seventeenth or eighteenth centuries. It is all steel except for the pierced-brass plates that adorn the sides.

No. 439 resembles a cucumber. It has a top shackle and is operated by two keys which work helical-springs. This all-steel lock was probably made in Esfahan sometime during the eighteenth or nineteenth centuries. Lock No. 438 has a cross-shape body. It was made and purchased in a village near Kashan. Small crowns stamped on No. 440 seem to indicate royal ownership at one time. Its size would have made it suitable for some kind of storeroom or treasury. The steel of the shackle and body must have come from abroad, as there are Western-style numbers on it that might represent a serial number. Lock No. 441 has an odd shape. Who knows what was in the mind of the locksmith who made it—a bell?, a trumpet?

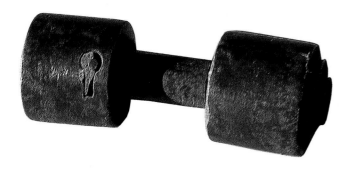

Lock 436. Steel miscellaneous lock with barbed-spring mechanism, 17th–18th centuries. Width 12 cm, height 4.5 cm.

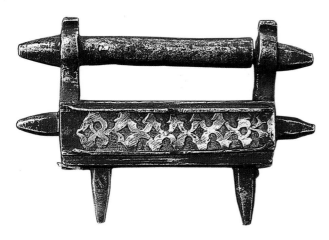

Lock 437. Steel and brass miscellaneous lock with multiple spring mechanisms, 17th–18th centuries. Width 11.5 cm, height 8 cm.

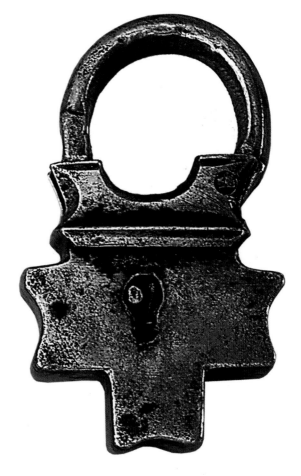

Lock 438. Steel miscellaneous lock with bent-spring mechanism, 18th–19th centuries. Width 5 cm, height 8 cm.

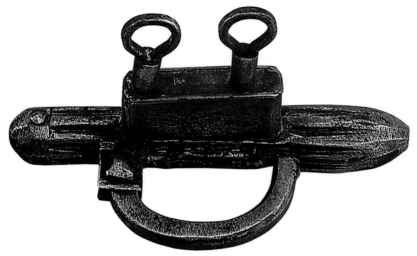

Lock 439. Steel miscellaneous lock with multiple spring mechanism, 18th–19th centuries. Width 14 cm, height 6 cm.

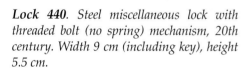

Lock 440. Steel miscellaneous lock with threaded bolt (no spring) mechanism, 20th century. Width 9 cm (including key), height 5.5 cm.

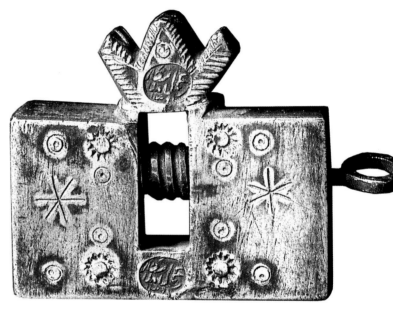

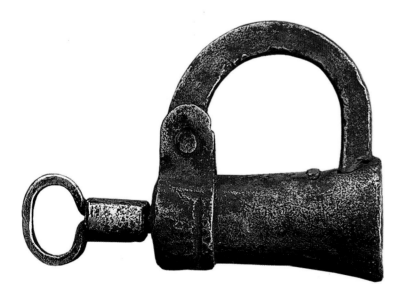

Lock 441. Steel miscellaneous lock with helical-spring mechanism, 19th century. Width 9.5 cm, height 7 cm.

Bibliography

d'Allemagne, Henry René, Decorative Antique Ironwork, ed. and transi, from Ferronnerie ancienne, Paris, 1924, by Vera K. Ostoia. New York, 1968.

--------------, *Du Khorassan ou pays des Backhtiaris: Trois mois de voyage en Perse*, Vol. II. Paris, 1911.

Atil, Esin, *Art of the Arab World*, Washington, D. C., 1975.

Baer, Eva, *Sphinxes and Harpies in Medieval Islamic Art, An Iconographical Study*. Jerusalem, 1965.

Browne, Edward Granville, *A Literary History of Persia, Vol. IV: A History of Persian Literature in Modern Times*, A.D. 1500–1924. Cambridge, England, 1924.

Butter, Francis J., *An Encyclopaedia of Locks and Builders Hardware*. Willenhall, England, 1958 (1st ed., 1926).

Curtil-Boyer, Charles, *L'Histoire de la clef*. Paris, n.d.

Donaldson, Bess Allen, *The Wild Rue; a Study of Muhammadan Magic and Folklore in Iran*. London, 1938.

Egger, Gehart, *Beschidge und Schlosser an alten MobeJn*, Munich, 1973.

Eras, Vincent J., *Locks and Keys throughout the Ages*, (reprint) USA, 2019.

Fehérvâri, Géza, *Islamic Metalwork*, London, 1976.

Fox-Pitt-Rivers, Augustus Henry Lane, *On the Development and Distribution of Primitive Locks and Keys*, London, 1883.

Harari, Ralph, "Metalwork after the Early Islamic Period," in *A Survey of Persian Art*, ed. by Arthur Upham Pope, Vol. Ill, pp. 2466–2529. London, 1938.

Hedayat, Sadeq, *Nirangestan*, Tehran, 1953.

Hommel, Rudolf P., *China at Work*, New York, 1937.

Hopkins, Albert A., *The Lure of the Lock*, New York, 1928.

MacCulloch, J. A., "Locks and Keys," in *Encyclopedia of Religion and Ethics*, ed. James Hastings, John A. Selbie, Louis H. Gray, Vol. Ill, pp. 120–125, New York, 1916.

Mayer, L. A., *Islamic Metalworkers and Their Works*, Geneva, 1959.

Najmi, Naser, *Dar al-Khalafeh-ye Tehran*, Tehran, 1976.

Needham, Joseph, *Science and Civilisation in China*, Vol. 4, Part II, pp. 236–243. Cambridge, England, 1965.

Neuburger, Albert, *The Technical Arts and Sciences of the Ancients*, transl. from *Die Technik des Altertums*, Leipzig, 1921, by Henry L. Brose. New York, 1930.

Pankofer, Heinrich, *Schlüssel und Schloss*, Munich, 1974.

Price, George, *A Treatise on Fire and Thief-Proof Depositories and Locks and Keys*, London, 1856.

Pritchett, R. T., "Oriental Puzzle Locks," in *Magazine of Art*, pp. 643–646. London, 1898.

Prochnow, Dieter, *Schönheit von Schloss, Schlüssel*, Beschlag, Düsseldorf, 1966.

Sam Mirza, *Tohfeh-ye Sami* (mid-sixteenth century), ed. by Rokn al-Din Homayunfarrokh. Tehran, n.d.

"Shi'a," *Encyclopedia of Islam*, Vol. IV, pp. 350–358. Leyden, The Netherlands, and London, 1934.

Sourdel-Thomine, Janine, *Clefs et serrures de la Ka'ba*, Paris, 1971.

Tanavoli, Parviz, *Lion Rugs from Fars*, Washington, D. C., 1974.

Tanavoli, Parviz and John T. Wertime, *Locks from Iran: Pre-Islamic to Twentieth Century*, Washington DC., 1976.

Tanavoli, Parviz, *Talisman* (in Farsi), Tehrran, 2006

Tomlinson, Charles, *Rudimentary Treatise on the Construction of Door Locks for Commercial and Domestic Purposes*, London, 1858–1859.

Wulff, Hans, *The Traditional Crafts of Persia*, Cambridge, Massachusetts, 1966.

Author's Biography

Parviz Tanavoli, the renowned and foremost Iranian artist, is known not just because of his role in Iranian modern art but for his very wide range of activities in history, art, culture and Iranian heritage. More than six decades of working as sculptor, painter, printmaker, writer, collector, researcher and patron of modern and contemporary art makes him the "Renaissance Man" of his motherland, Iran.

Most of his research and collections are focused on tribal and commoners' art, their beliefs and its role in people's everyday lives. His books on subjects such as Talismans, Persian Locks, Kohl Containers, Scales and Weights, and more than 10 books on Persian tribal rugs and carpets, shows his knowledge, understanding and interest in the importance of people's art.

Tanavoli had an important role in the founding of Saqakhaneh, the most important Iranian artistic movement begun in the early 1960s. His intellectual support and his ideas of importing popular culture and common people's life elements into art which, back in those days was limited to the elites of society, the highly educated and aristocrats, shows his deep feeling of culture and cultural heritage as well as modern art movements all over the world.

Locks have played an important role in Tanavoli's sculpture to an extent that they have become part of the anatomy of his art. For more info see: **www.Tanavoli.com**

Credits

All photographs by Parviz Tanavoli, except:

Nos. 17, 67, 74, 79, 84, 140, 155, 251, 295 by Feridoun Zarringhalm

Nos. 253, 254 by Tooka Ahmadjou

Figs. 16, 17, 19, 20, 21, 22, 23 unknown Photographers

Drawings: Houshang Adorbehi

Antique Locks and Keys: Their History, Uses and Mechanisms

For over 25 years the author, Ulf Weissenberger, has been collecting and restoring antique locks and keys. This extraordinary book is based on his experience and features many of the most interesting pieces from his extensive and impressive collection.

In this large-sized hardcover (12-1/4" x 9-1/4") Ulf Weissenberger's text and explanations are accompanied by over 850 extraordinary high-quality, full-color photos and illustrations.

This is the largest and most beautiful book on antique locks we have ever seen.

From the Roman period and even earlier, up through the nineteenth century, the author explores, with great attention to detail, a wide variety of locks and their keys which were used for various types of chests, doors, cabinets, jewelry boxes, and more.

An important feature of this book which locksmiths, lock collectors and other readers will greatly appreciate is that the locks' internal mechanisms are shown in crisp, high resolution photos – as are the keys.

The measurements of each lock are provided as are their (sometimes estimated) dates of manufacture, and also their provenance when known.

Hardcover, 300 pages, 850 full color photos, 12-1/4 x 9-1/4", ISBN 9780997979893.

Locks and Keys Throughout the Ages

"*I am asked many lock questions in the course of a year. The most common one is: 'where can I learn more about locks and keys?'. This book is what I recommend to collectors to go to first. I personally feel all lock and key collectors should have this book. It contains a mixture of European and American locks and keys across time. It includes lock mechanisms too. This is a quality book in every way; an impressive work*" - **Robert Dix, Journal of Lock Collecting, (a Publication of the American Lock Collectors Association) Vol 51, N.1, March 2020.**

Locks and Keys throughout the Ages is widely considered the **best book ever written on the history of locks.** It is illustrated throughout with photos from the extensive Lips' Collection.

It was written in 1957 by Vincent J.M. Eras, the director of one of the most respected and important lock manufacturing companies in the world at that time - the Lips' Safe and Lock Manufacturing Company (now part of the Assa Abloy Group, along with Yale, Chubb, and many others).

The author was not only a master locksmith who developed several important patents but he was also an avid collector and was passionate about the history and development of locking mechanisms. His extensive knowledge of the field comes across on every page. In fact, Eras had been in the lock manufacturing business for 58 years before he wrote this book.

In over 280 black-and-white photos and drawings Vincent Eras brings us on a grand tour of the development of locks from pre-historic to modern times and he also explains to us, in words and illustrations, how their mechanisms work.

This is a high-quality hardcover reprint of the 1957 edition of the book, done by special arrangement with ASSA ABLOY. The typeface has been completely re-done and the photographs have been corrected using the latest digital correction technology. The quality of the photos is equal to and, in many cases, better than the original 1957 edition. A reprint of this book was done in the UK in the 1970s but the quality was poor.

Artisan Ideas is very glad to be able to make this exceptional book available to the public again.

Hardcover, 184 pages, 284 black-and-white photos and designs, ISBN: 9780997979862